THE ART OF
LANDSCAPE
PHOTOGRAPHY

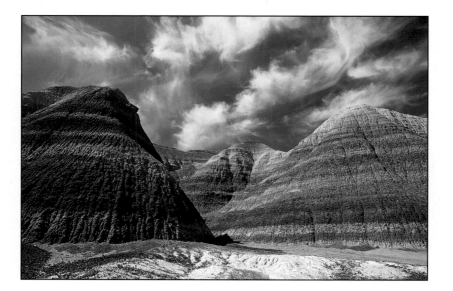

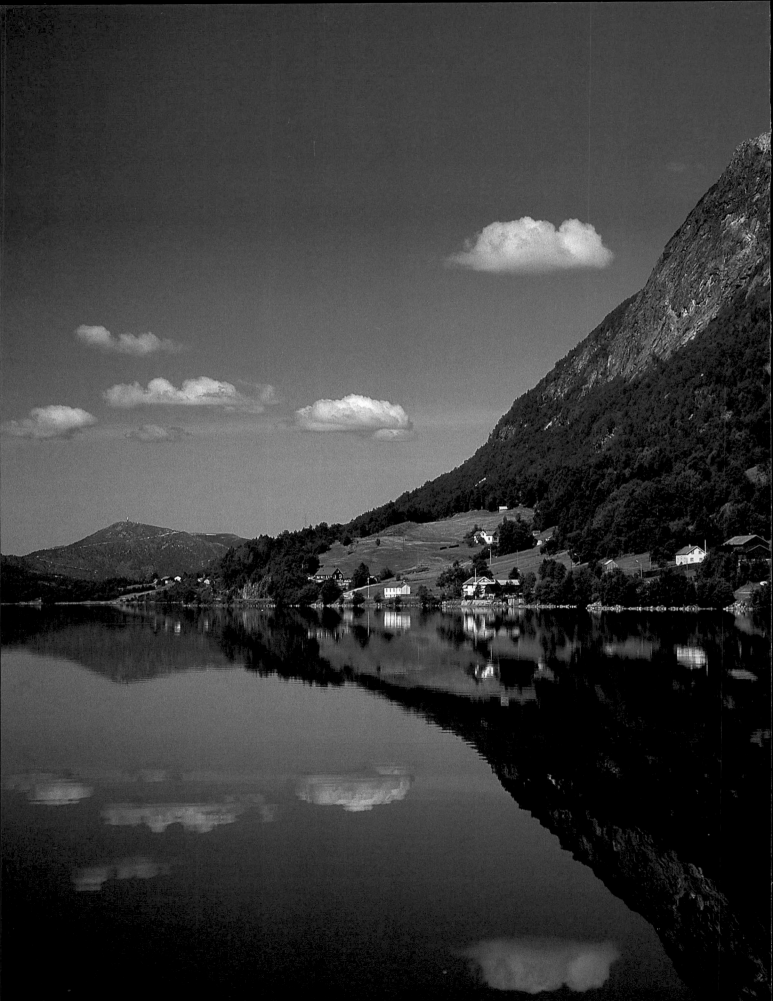

THE ART OF LANDSCAPE PHOTOGRAPHY

TEXT & PHOTOGRAPHS
Chris Coe

DESIGNER
Grant Bradford

FOUNTAIN PRESS

To Mary for helping me to realise my dream, to Sara for encouraging me to write and to my parents for always being there when it matters.
Thank You.

Published by
Fountain Press Limited
Fountain House
2 Gladstone Road
Kingston-upon-Thames
Surrey KT1 3HD

© Fountain Press 1998

ISBN 0 86343 337 5

Text & Photographs
Chris Coe

Designed by
Grant Bradford

Page Planning
Rex Carr

Diagrams
Alisa Tingley

Reproduction
Setrite Digital Graphics
Hong Kong

Printed in Hong Kong

Frontispiece
Mountain pass near
Nystolen,Norway.

CONTENTS

INTRODUCTION

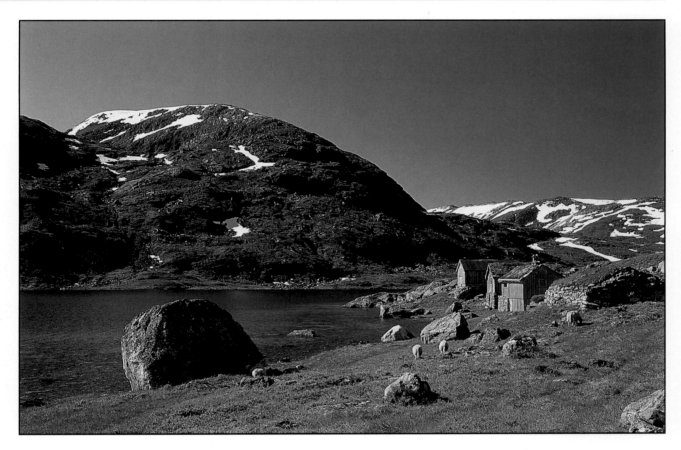

Above: Mountain Pass near Nystolen, Norway.
Nikon F5, 35-70mm, Fujichrome Velvia.

Monet was a great artist. What is it that makes his paintings so good? Like so many other artists, his technique was excellent, but technique is simply a platform for creativity. The crucial element in his work, and that which set him apart, was his imagination and flare for interpreting the interaction between light and his subjects. This allowed him to translate what he saw onto a two dimensional canvas. His paintings are more than a record of a subject. They appeal to all the senses, not just the visual, and allow us to experience rather than merely view each scene.

Photography, like art, is a creative medium which relies on the translation of a three dimensional scene into a two dimensional image. At the time of taking a photograph the scene is set by the light but also by the other senses which create an atmosphere. How well an image works depends on the photographer's creativity in capturing, or sometimes creating, the mood of the scene rather than just photographing the subject. As with Monet, a great landscape photographer, such as Ansel Adams, showed more than good technique in his photographs. The images are his own personal view of the world, but a view which has immediate impact and a more sustaining interest. Every time you look at one of his photographs you feel as if you are there, and can experience what he experienced at the time the picture was taken.

Too often the keen photographer attaches too much importance to equipment and technique. Both are just tools which allow the creative work to succeed. Many photographers fall into the trap of thinking that they have to use the best and latest equipment to be able to take good photographs. Nothing could be further from the truth. Monet needed only paints and a canvas, not the best paints and the latest canvas. Of course good technique is important but it is a basic skill in the range of skills needed to become a good photographer. Its importance will become most apparent when you are trying to take a photograph in rapidly changing light. The photographer with poor technique will almost certainly spend so much time deciding which lens and settings to use that the moment will be lost. To an experienced photographer basic technique is second nature, allowing efforts to be concentrated on the creative process of capturing the subject itself.

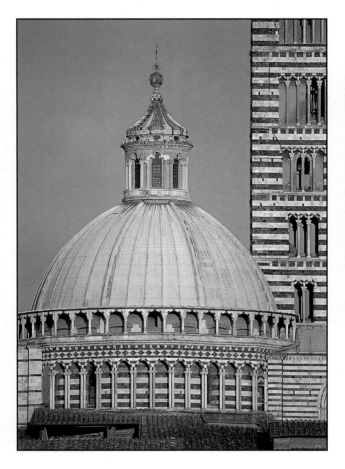

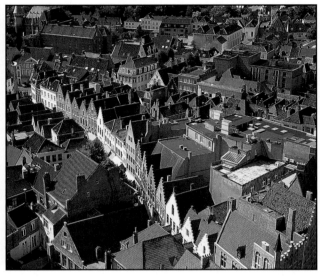

Above: Bruges, Belgium.
Nikon F90X, 80-200mm,
Fujichrome Velvia.

Left: Il Duomo, Siena, Italy.
Nikon F5, 500mm mirror,
Fujichrome Velvia.

CREATIVITY AND STYLE

Creativity is something which we all possess. In this book I will help you to discover your own creativity. This starts with learning to see photo-opportunities. If you place 100 people in front of a grand panorama, say a lake with mountains behind, the landscape which most people will see and photograph will be just that, mountains and a lake. A good photographer, however, will also see other landscapes within this scene. As you progress through this book we will look at various types of landscape and examine the photographic opportunities which they present.
To guide you I will discuss some of the rules, or rather guidelines, which will help you to improve your photography. It is important to realise that there is no right way to photograph a landscape, only an individual view based on sound technique.
Use these guidelines to help you see potential photographs and evolve your own individual style. My own photographs illustrate the discussion points. These are only my individual view of a landscape as I experienced it at the time, my view of the world. Try to develop your own style rather than copying

other photographers, but learn from the way others see things. As you progress through the book look at the photographs and think how you would approach taking each one, then go out and try it. The guidelines are there to be broken and in doing so you will develop a style which will make your photographs unique.

A DEFINITION OF LANDSCAPE

When we hear the word 'landscape' most of us think of a scenic view, perhaps snow-capped mountains or glistening lakes. This is, of course, landscape but it immediately limits our view of the world.
So what is landscape? The simple answer is anything your imagination allows it to be, other than a portrait, a product or a studio still life. The grand panorama is indeed a landscape photographer's paradise but within each landscape are many more waiting to be discovered, and many ways to photograph them. Seeing something more will make your photographs unique. Look at the detail within a landscape. There will almost certainly be smaller landscapes within it, both real and abstract. Urban

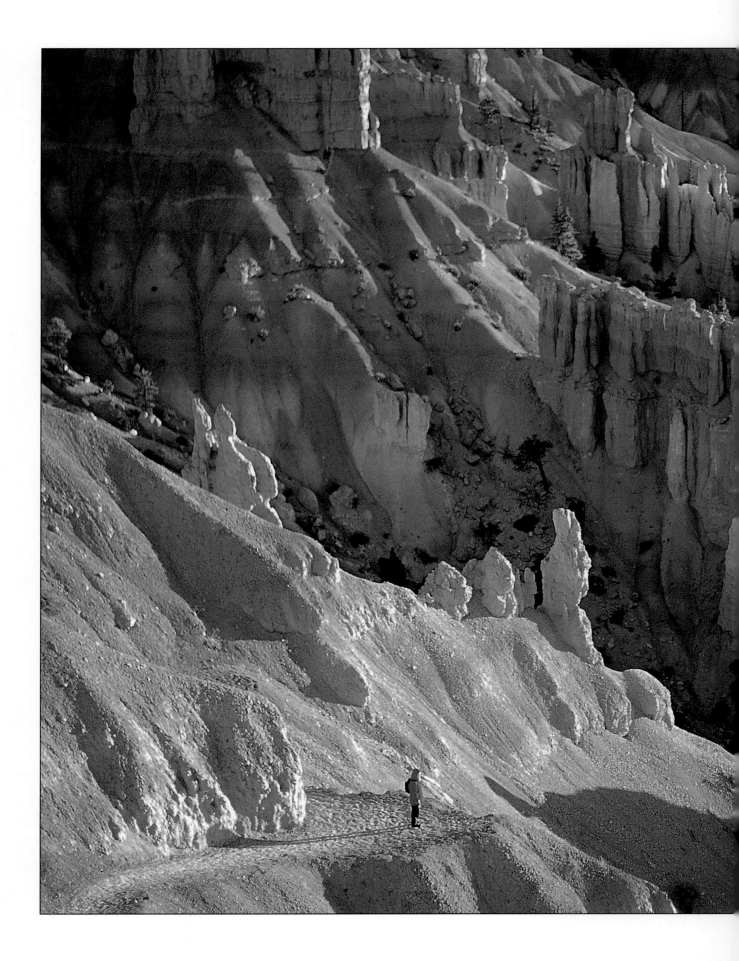

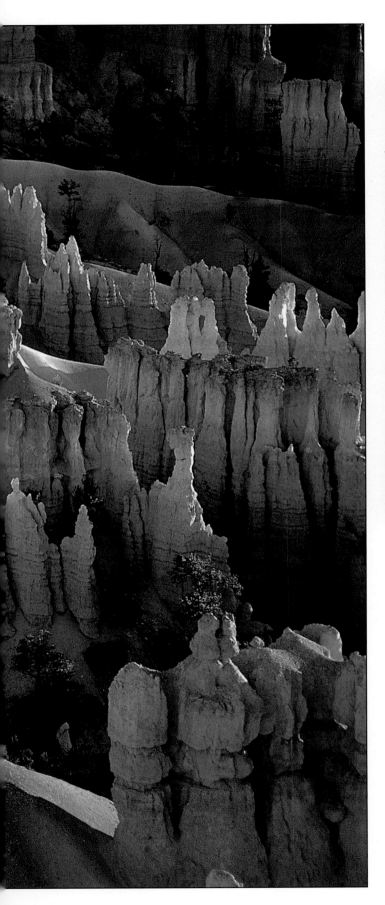

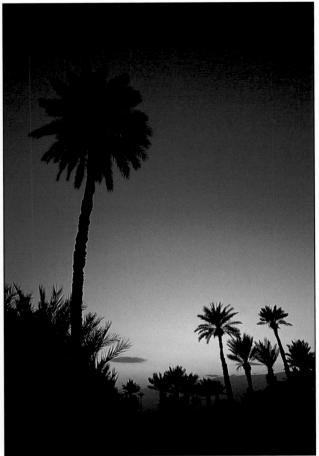

Left: Bryce Canyon, Utah, USA. *Nikon F4, 80-200mm, Fujichrome Velvia.*

Above: Sahara Desert, Risani, Morocco. *Nikon F4, 24mm, Fujichrome Velvia.*

and industrial areas can also provide dramatic landscapes, and seeing them may open up new areas of photography to you.

As you develop as a landscape photographer you will experience some failures. I have had many! Never be afraid to experiment with your photography. The cheapest piece of equipment a photographer uses is a roll of film. It is important though to learn from your mistakes. Often the photographs which end up in the bin will tell you more about your technique and creativity than the ones which work.

Photography is a relatively new art form. Two hundred years ago it was only possible to capture a landscape with paints or pencils. Now we can use this exciting medium to produce creative landscapes in ways undreamt of by our ancestors.

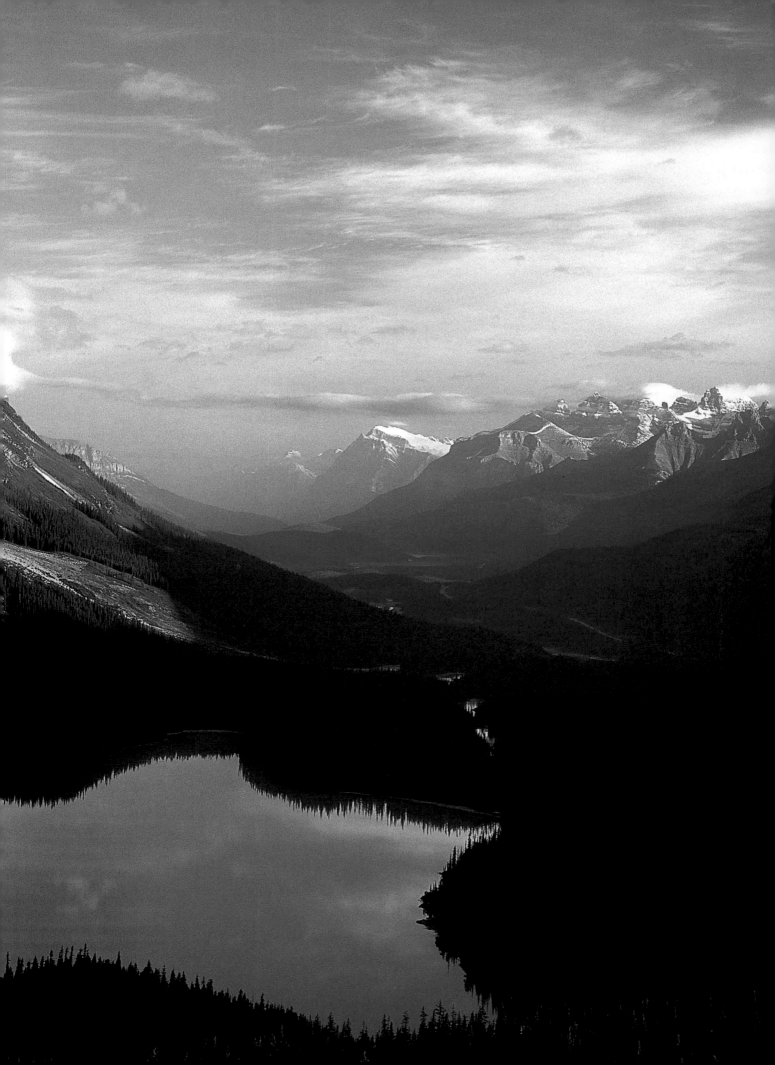

THE CHANGING LANDSCAPE

Natural light is changing light. Unlike artificial light its intensity and angle of illumination change throughout the day as the light source, the sun, arcs through the sky. It is obvious to the naked eye that there is a difference between the light at noon and at sunset, but between these extremes there are subtle changes from moment to moment which produce a constantly changing landscape. Understanding how light interacts with weather, latitude and time of year to transform the landscape is fundamental to mastering landscape photography.

TIME OF DAY

Landscape begins with the view outside your window. It is worthwhile using the scenery around you to enhance your skills and understanding of the interplay between natural light and a landscape. The simplest way to start is to face north and choose an uncomplicated view, perhaps a tree, a flower or a nearby building which is sunlit all day long. Set up your camera on a tripod and compose your shot. Photograph the scene just before and after dawn, then mid-morning, mid-day, mid-afternoon and again just before and after sunset. Use the same f-stop for each shot, preferably a large one such as f4 or f2.8 to minimise the effects of long exposure, varying the shutter speed accordingly to give the correct exposure. From this sequence of photographs you will be able to see how the lighting changes throughout the day.

Once the film is processed put the photographs side by side in the shooting sequence. The effects of the changing light is evident in two ways. First the direction of light is important in determining the shadows. Early in the morning and late in the day the shadows are much longer, giving the landscape depth. Towards the middle of the day the shadows shorten and the scene tends to look flat. Note this effect as the sun rises and sinks in the sky. The second effect is

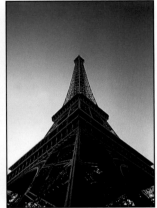

In the early morning, soft, low sunlight hits the subject from the right of the frame. By late afternoon the sun has completed two thirds of its arc through the sky. Only the last few rays catch the *front of the subject before moving behind to create a silhouette.*

Location: Eiffel Tower, Paris, France. Nikon F5, 24mm, Fujichrome Velvia

on the colour of the light. It has a blue hue before dawn. This disappears briefly at sunrise when the light is warm and orange for about 10 minutes. At this time of day the light is soft and diffused, giving the scene a warm feel, enhanced by the long shadows. It becomes slightly blue again as the sun climbs above the horizon. Note also how many subtle hues and colours are present. Compare this to the shot taken at noon when the sun is high in the sky. The light is harsh and intense, bleaching out colours while those subtle hues disappear into a single colour. Combined with the minimal shadows, the scene looks flat and lacks vibrancy. At the end of the day the scene regains the warmth and depth apparent in the early morning. For a few minutes at sunset the light is once again orange, but for a while before and after it has a pink, rather than blue, hue until the sun is well below the horizon.

This simple experiment demonstrates why most landscape photographers prefer to take photographs in the early morning and late afternoon or evening, dependent on the time of year. At these times of the day the light is most evocative, the shadows and

Early morning light has a blue hue, giving the shot a cool feel. This hue is especially noticeable in the valley where the warm sunlight has not yet reached.

Location: Peyto Lake and Rocky Mountains at dawn, Alberta, Canada. Nikon F4, 35-70mm, Fujichrome Velvia

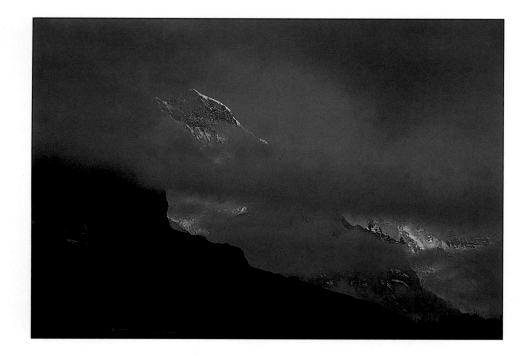

When I arrived in Grindelwald the mountains were shrouded in grey cloud but often the wind increases just before sunset so I found a viewpoint across the valley and waited. This wind caused a momentary break in the clouds revealing the snowcapped peak of the Jungfrau as it caught the pink light of sunset. Within 30 seconds the shot had disappeared but it illustrates the importance of understanding how local weather conditions can change very quickly. On this occasion patience and preparation were rewarded.

Location: Jungfrau, Grindelwald, Switzerland. Nikon F4, 500mm mirror, Fujichrome Velvia

colour giving both depth and subtlety to the landscape. The best light, though, lasts only a matter of minutes so it is essential to be prepared, ready to capture the moment. The rest of the day need not be wasted. There are techniques for reducing the harshness of the midday sun by using filters and these will be discussed in the next chapter. Some subjects, for example a cityscape where the tall buildings create their own shadows, are often best photographed when the sun is higher in the sky.

THE COLOUR OF LIGHT

Early morning light has a blue hue, while late in the day it is pink. On film colour shifts are more pronounced than they appear to the naked eye. Slight colour shifts are not immediately obvious to the naked eye because the human brain makes allowances for these small changes in our colour perception. Our eyes see exactly the same light as the film but our brain compensates, interpreting colours as we expect to see them rather than exactly as they are. Only when this shift is very marked, for example at sunrise or sunset, is it beyond the brain's ability to accommodate and the light appears different in colour. Photographic film, however, cannot make this compensation and records the colour of the light as it is. It is for this reason that the photographs in the dawn to dusk sequence often show a colour shift which was not apparent to the naked eye. The characteristics of film can also be used by extending the length of expose to exaggerate or manipulate this colour shift.

The colour shifts at different times of day are caused by diffusion of sunlight by the earth's atmosphere. The colour is determined by the angle of the rays of sunlight relative to the earth's atmosphere as the sun climbs in the sky. The most dramatic colour shifts at sunrise and sunset are produced by diffusion and absorption of light by atmospheric pollution, both natural and man-made, when the sun is low in the sky. The effects of diffusion tend to be most noticeable in the more industrialised parts of the world where man-made pollution is greatest, but the winds also disperse it and carry airborne dust particles around the world. Ambient temperature can also exacerbate these effects, especially in built up areas, by producing a heat haze which diffuses colours.

The most dramatic atmospheric effect on the colours in the sky can be seen near the north and south poles. The northern and southern lights illuminate the night sky especially during the summer months. These light spectacles are a remarkable illustration of the interplay between light and nature.

Although a landscape may have changed little in form for millions of years, it is never the same on any two occasions because there are so many factors which affect its appearance. Understanding these factors gives you the ability to create a different perspective, even when photographing the most popular landscapes.

WEATHER

There are few weather conditions which are not suitable for landscape photography. Different weather conditions create different moods. Of course sunny, bright, blue skies make photography simpler but a stormy sky can produce both dramatic and unusual images of even the most photographed panoramas. Even the rain can be effectively captured. The biggest enemy, though, is a grey toneless sky when the light is

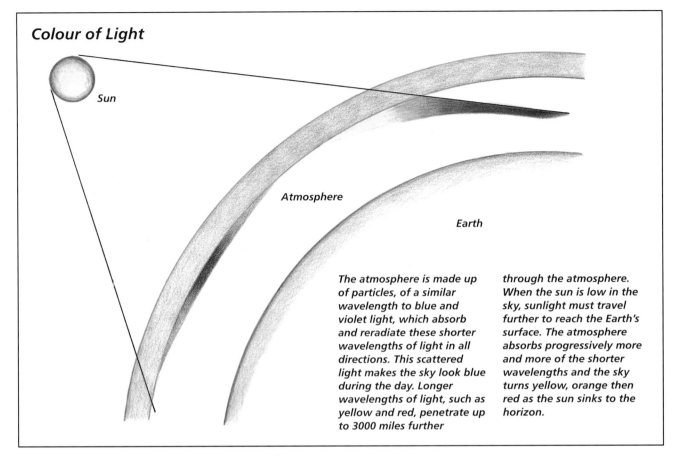

Colour of Light

Sun

Atmosphere

Earth

The atmosphere is made up of particles, of a similar wavelength to blue and violet light, which absorb and reradiate these shorter wavelengths of light in all directions. This scattered light makes the sky look blue during the day. Longer wavelengths of light, such as yellow and red, penetrate up to 3000 miles further through the atmosphere. When the sun is low in the sky, sunlight must travel further to reach the Earth's surface. The atmosphere absorbs progressively more and more of the shorter wavelengths and the sky turns yellow, orange then red as the sun sinks to the horizon.

flat and colours muted. Occasionally these conditions are good for close up work but in my experience you are better off putting the camera away and doing something else!

Use the weather as an element of composition, for example, clouds to create depth or contrast. A shaft of light through storm clouds can look dramatic if carefully positioned, and light reflected off water adds brightness to a dull landscape. It is important to choose the subject carefully, and a film to complement both subject and weather conditions.

LATITUDE

Geography is an important, though less obvious, factor to be considered. The climate is cooler the further you travel north or south from the equator. The positioning of the world's land masses also means that Northern Europe, North America and Northern Asia experience much less predictable weather than the more southern continents of Australasia, Africa and South America, where the changes between

The opportunities to take photographs in driving rain are obviously limited. Here the monochromatic light and layering of the picture gave depth to what is essentially in silhouette.

Location: Sienna, Italy.
Olympus OM1N, 80-200mm,
Fujichrome RD100

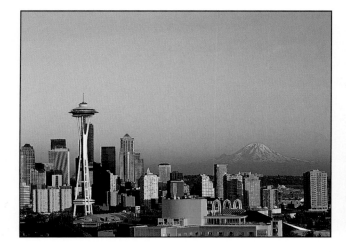

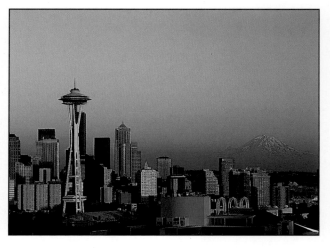

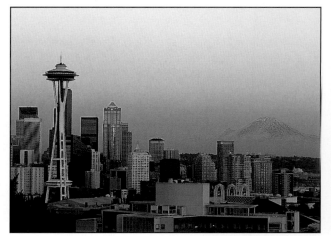

This sequence of three shots taken before, during and after sunset clearly shows how light changes colour. The first shot was taken an hour before sunset. The light is already softening and the shot looks warm until you compare it with the second shot taken at sunset. All the white buildings take on an orange hue. Notice also that the colours, particularly in the sky, are more saturated. Most cities suffer from pollution problems and in both these shots the band of smog on the horizon has a yellowish cast. After sunset the skyline is shaded from direct sunlight but the snow on Mt Rainier in the distance still catches the soft pink light. Contrasting with the darker skyline it is a much more prominent feature of the composition. The smog on the horizon also catches this light changing from yellow to a soft pink.

Location: Seattle and Mt Rainier, Washington, USA. Nikon F4, 35-70mm, Fujichrome Velvia

seasons are less marked. This is because these southern regions are nearer to the equator.

The most important factor relating to latitude is its effect on the length of the day. Near the equator the number of hours of daylight change very little from summer to winter. Further from the equator the days are much longer in summer and shorter in winter. Obviously shorter days mean less opportunities to take photographs.

You must be aware of the way a landscape will be lit and when the shadows will produce the most impressive effect. In the northern hemisphere the sun rises in the east and arcs southwards in a clockwise direction to set in the west. However in the southern hemisphere, while the sun still rises and sets in the same direction, its arc through the sky is anti-, or counter-clockwise, producing shadow from the opposite direction. I found out the importance of this difference when photographing a landscape in South Africa. I worked out that the light and shadows on a particular landscape would be best in the afternoon. Returning at this time I found that I'd calculated the light change according to the arc of the sun as if I'd been in the northern hemisphere and the subject was in shadow.

In the middle of the day sunlight reaches street level in big cities. Although the light is harsher at this time of day, cityscapes are easier to photograph because large areas of shadow and stark contrasts are reduced. The difference in height, building materials and colour of the buildings adds both depth and texture to the shot.

Location: Old and new skyscrapers, Toronto, Ontario, Canada. Nikon F4, 35-70mm, Fujichrome Velvia

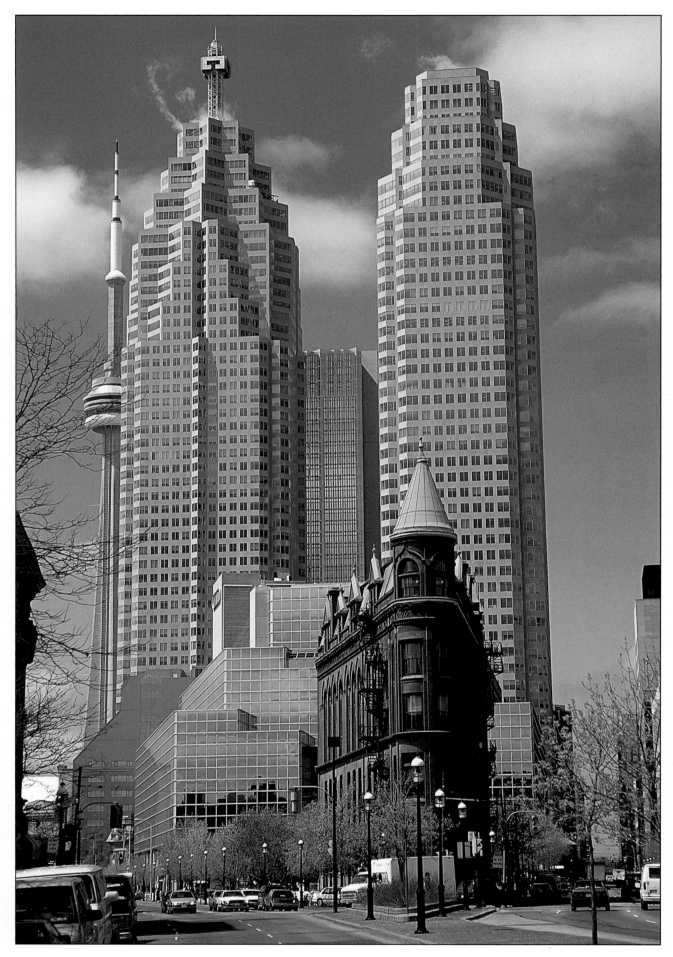

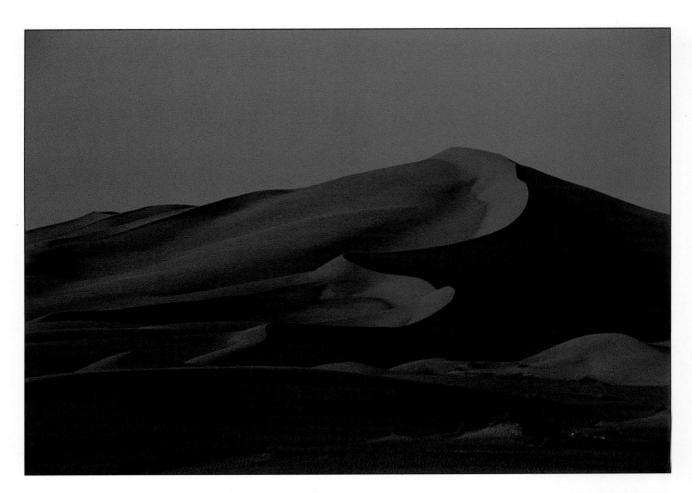

In normal daylight the dunes are sand coloured but at sunset (top) the scene is saturated with warm light and takes on a red hue. To the naked eye this red hue is not so intense because the brain partially compensates for the shift in the colour of light. However film cannot make this compensation.

Location: Sand dunes in Dubai, United Arab Emirates. Nikon F4, 35-70mm, Fujichrome Velvia

Airborne particles diffuse light. During this sand storm at midday in the Sahara, dust and sand carried by the wind produced a soft light. Taking this shot presented practical problems. The weather conditions act like a diffuser, softening the definition of the camels and making focusing difficult.

The strong wind meant that the camera had to be on a tripod and protected from the driving sand. I used my car as a windbreak.

Location: Camels in the Sahara Desert, Risani, Morocco. Nikon F4, 500mm mirror, Fujichrome RD100

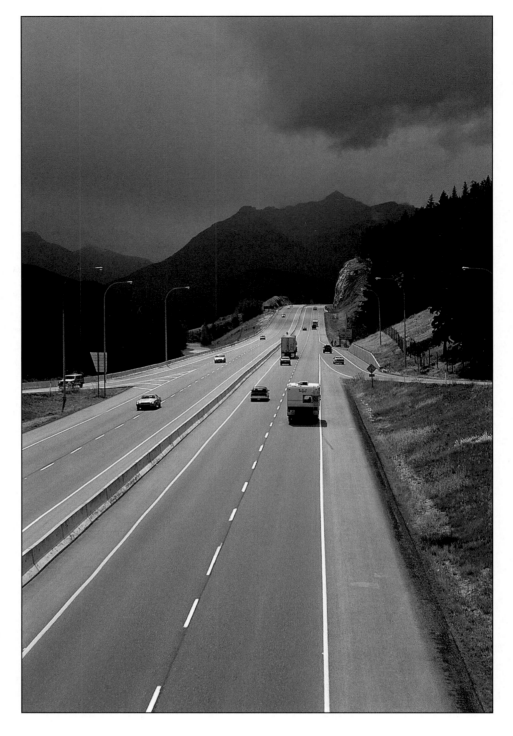

The combination of sunshine and storm clouds produce drama. This shot would not have had the same impact with blue skies.

Location: Highway through the Rockies, Alberta, Canada. Nikon F4, 35-70mm, Fujichrome RD100

TIME OF YEAR

The changing seasons produce some of the most dramatic transformations of the landscape. These changes are marked most vividly when the leaves of deciduous trees take on their autumnal colours, and when brilliant white snow brightens a bleak winter landscape. In equatorial regions the seasons are less distinct. Spring and autumn last only a few weeks and, rather than the extremes of summer and winter, the seasons are characterised more as dry or rainy.

Each season presents different photo-opportunities and with them different challenges. Spring is a vibrant season when flowers bloom and new iridescent green foliage appears to bring colour back to the dull winter landscape. Given good weather, this season is full of changing landscapes but foliage soon loses its most vivid colouration and many flowers, for example bluebells, last only a week or two. It is therefore important to be aware of how the spring landscape changes and to look for the peak time to photograph each element of the landscape as it changes.

In summer the landscape changes tend to be more gradual. As the days get hotter and drier the sun has

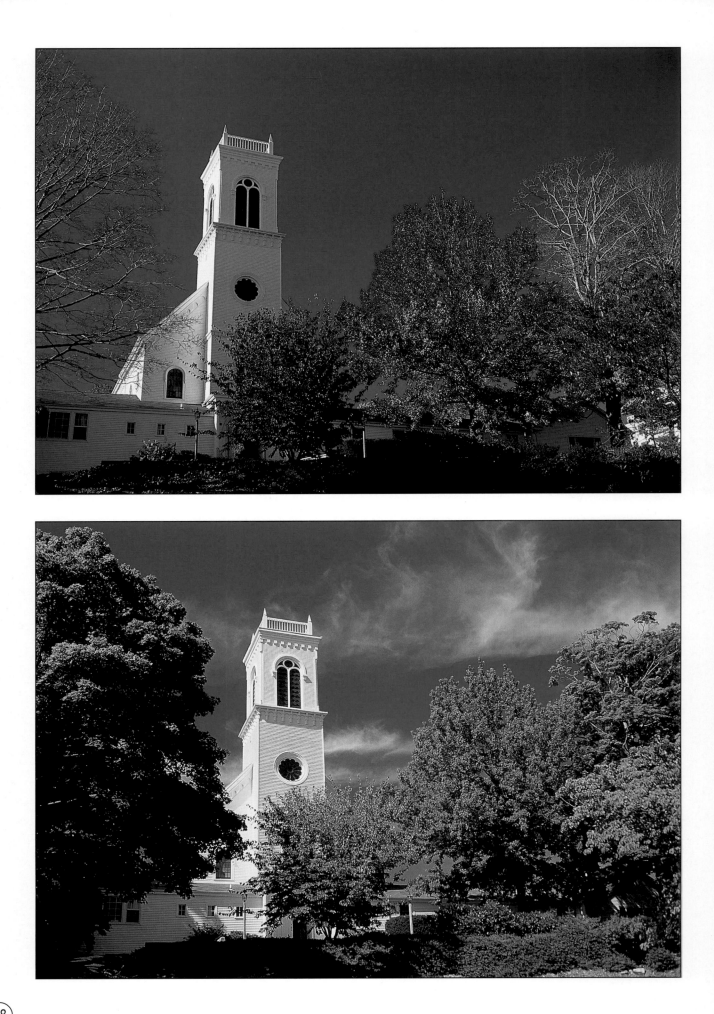

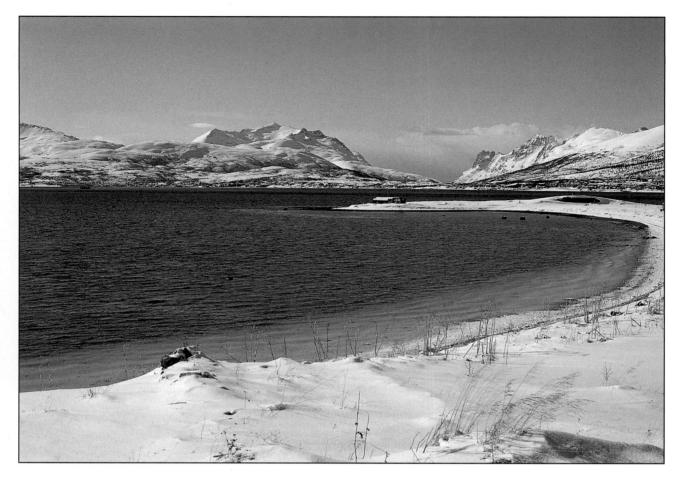

Left: In autumn the landscape changes dramatically. These two shots were taken just three weeks apart at approximately the same time of day yet it would be easy to mistake them for completely different places. The foliage has not only changed in colour but already fallen on some of the trees in the autumn shot. Note also how the sun has already disappeared from the front of the church as the daylight hours shorten.

Location: Village church, Essex, Connecticut, USA. Nikon F4, 35-70mm, Fujichrome Velvia

Winter snow transforms a dull landscape. It reflects light, making even the dullest day much brighter, but it presents problems with exposure. Fast, grainy films can be used to add texture to snow scenes.

Location: Tromso, Norway. Olympus OM1N, 35-80mm, Fujichrome RD100

a bleaching effect, causing grassland to lose its green colouration becoming burnt and brown. This season does, however, offer the most predictable weather with long sunny days, blue skies and cloudless sunrises and sunsets.

Autumn is undoubtedly the most colourful as leaves change from green to yellow, orange and red, but despite the mass of colour it is a difficult season to photograph well. With so much colour it is especially important to clearly define the main subject of a photograph. Colour can be very distracting and it is easy to photograph an autumnal scene because of the lovely colours only to find out later that you have a pretty picture rather than a strong, well composed photograph.

Snow splits winter into two distinctly different landscapes. On a sunny day, early winter, just after the leaves have fallen, is a beautiful time. The trees without their foliage take on a lilac-grey hue. This

quickly disappears and with the deteriorating weather the landscape looks bleak and colourless. During this time black and white film has clear advantages over colour and even on an overcast day some stunning images can be taken if the subject is chosen carefully. The first snowfall dramatically changes the grey winter landscape into a bright one of high contrasts, though it is still largely monochromatic. These high contrasts can present their own problems and it may be necessary to use filters to reduce the contrast range, and grainy films to add texture to an expanse of white.

Whatever the season you must be prepared for the weather conditions which you will encounter. There is nothing worse than trying to hold a cold metal camera still in an icy wind on a winter's day without a tripod or a pair of gloves. I know that I'm unlikely to take a good photograph under those conditions and I certainly wouldn't be smiling!

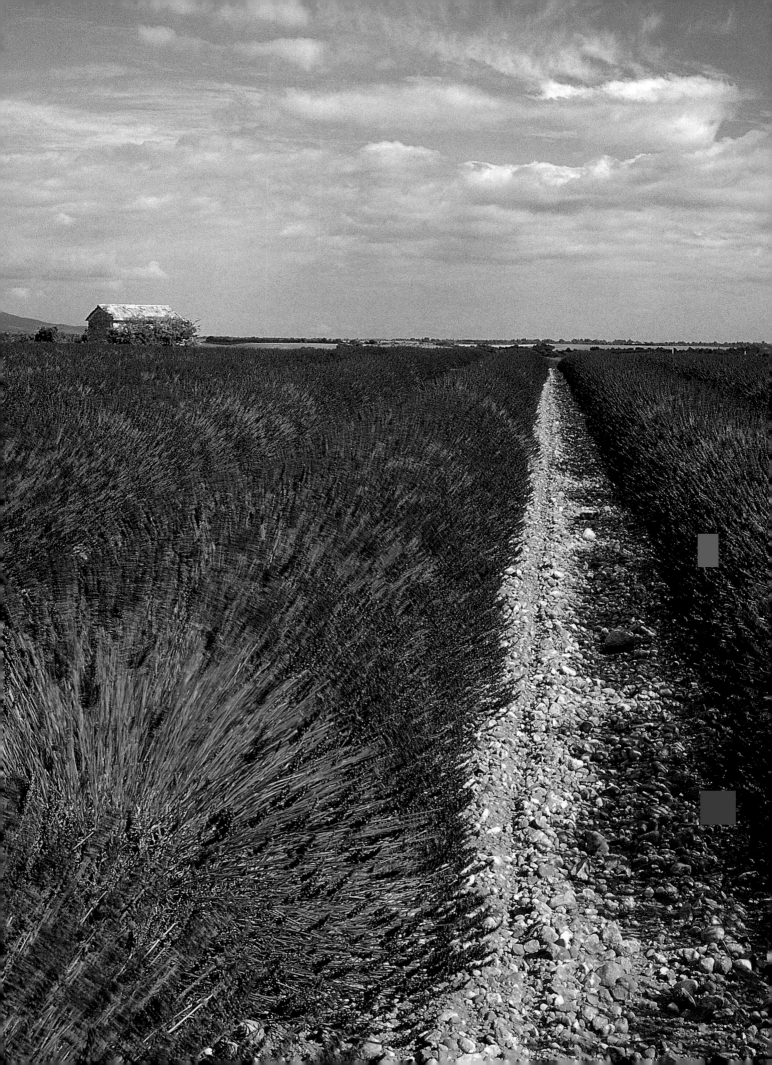

EQUIPMENT & EXPOSURE

There is a common myth that you can only take great photographs if you have the latest, most expensive equipment, or worse still that because you have this equipment you will take great photographs. Neither, of course, is true. At its simplest level a camera is only a black box which allows film to be exposed in a controlled manner. It is the photographer who controls this process and therefore makes the photograph. A bad photographer with the best equipment will not take a great photograph, but a good photographer will take a good photograph with any equipment.

The essential equipment for the serious landscape photographer consists of a camera body with an all-manual option, a range of the best lenses you can afford, polarising and neutral density filters, a sturdy tripod and cable release, a hand held incident lightmeter and a strong waterproof camera bag which can be comfortably carried.

CHOOSING A CAMERA SYSTEM

There are many brands of camera available on the market. Great photographs can be taken with any of them. The factors determining choice are the reliability, ruggedness and the features essential to landscape photography. It is worth checking the options available to you before you buy, even if you initially only intend to buy a body and a single lens. This first purchase will form the basis of your system so once you've made it, you are effectively locked into a make of camera and changing brand involves starting again with a new body and lenses, rather than just adding to your current system.

The camera body is the foundation on which you will build your camera system. Choose a body which offers the features you will need. Manual metering, exposure compensation and depth of field preview are all essential features for landscape photography.

THE CAMERA BODY

Choosing a camera body is the first, and probably the most important decision you will make as this will determine the range of accessories available. In practice most brands offer an appropriate range of lenses, made either by the camera manufacturer or an independent lens maker, so this decision is less critical than for some other areas of photography.

The features which the camera body offers are important. I recommend a camera which offers full manual control of exposure. This gives you complete control of the photographic process, which is especially important in difficult lighting conditions. It also forces you to think about the process of taking a photograph. This is essential when you are developing your skills as a photographer but there will always be occasions when this discipline will be a real asset no matter how experienced you are.

As camera manufacturers incorporate more sophisticated metering systems into their camera bodies these meters become increasingly useful in landscape photography. Any metering system must offer flexibility and an auto-exposure system should

A wide angle lens is the conventional lens choice for landscape photography. It is useful for creating depth but distant objects appear very small. A range of different focal length lenses will give you more flexibility.

Location: Lavender fields, Valensole, Provence, France. Nikon F5, 24mm, Fujichrome Velvia

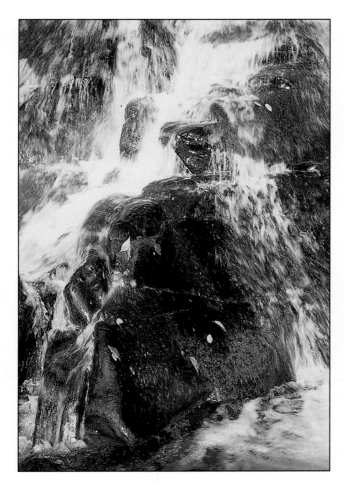

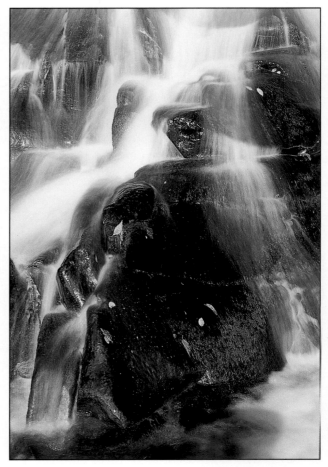

provide an exposure compensation facility of at least plus or minus two stops. One third stop increments are preferable but a minimum one half stop is acceptable. Anything less will limit its use and not permit the fine control of exposure which optimises results with colour transparency film.

Most auto-exposure cameras offer several mode options including aperture priority, shutter priority and programmed mode. With aperture priority, as the name suggests, the photographer chooses the required aperture, or f-stop, and the camera automatically sets the shutter speed. Similarly with shutter priority the shutter speed is selected and the aperture automatically set. Of these two options aperture priority is of the most use to the landscape photographer, providing full control of depth of field. On occasions shutter speed becomes important, for example when photographing water. A slow shutter speed will give a soft, blurred almost dream-like effect which can be very effective, while a faster shutter speed will freeze motion for a more dramatic effect. Even so the fast shutter speeds required will be considerably less than those which would be used by, say, a sports photographer. The fastest speed you will use is probably $^1/_{500}$ sec.

In the programmed mode, the camera sets both aperture and shutter speed, giving the photographer almost no control over the photographic process. This is therefore the complete antithesis of the landscape

Shooting a moving subject in bright light may mean using a fast shutter speed.
This results in motion being frozen (left). I encountered this problem when photographing the waterfall. I wanted to show movement in the water to give the picture a dream-like feel (right). To achieve this I used a ND filter which increased *exposure by +4 stops.*
This allowed me to decrease the shutter speed from $^1/_{15}$ sec to 1 sec while keeping the aperture the same.

Location: Kattersgill Falls, Catskill Mountains, New York, USA.
Nikon F4, 80-200mm, Fujichrome Velvia, NDx4

photographer's objectives. If you are serious about developing as a photographer don't use this mode.

Another useful feature for landscape photography is depth of field preview. When looking through a camera viewfinder most cameras provide an image at maximum aperture for the selected lens so that it is as bright as possible to aid composition and focusing. When the photograph is taken the camera stops down the lens to the chosen aperture. As depth of field changes with aperture it is useful to be able to view the scene at the chosen aperture prior to taking the picture. The depth of field preview button will allow this. The previewed image will appear darker than at maximum aperture but this has no effect on exposure. Depth of field is a key factor in good landscape photography and it is therefore essential to have control over it.

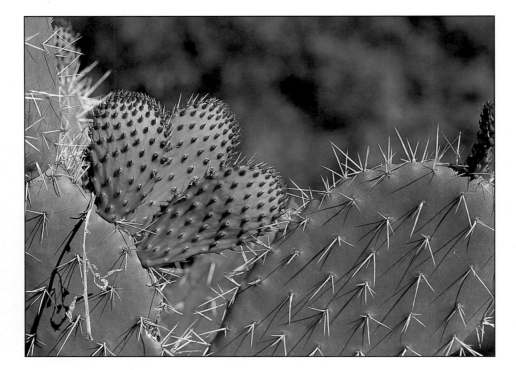

Depth of field is a useful tool to make a subject stand out against a background. Here I shot the cactus at maximum aperture. The result is a sharply focused cactus against a background which is blurred. This adds emphasis to the subject.

Location: Cactus, Oukameiden Valley, Morocco.
Nikon F4, 105mm macro, Fujichrome Velvia

The major differences between cameras which offer similar features at widely different prices are in build quality and robustness. The requirements of a professional whose camera system gets heavy use, often in adverse conditions, are different from those of an amateur. The knocks and bumps which equipment inevitably takes with regular usage require a sturdy, durable and reliable camera body. The professional must pay a premium for these features. As an amateur your camera is unlikely to get the same amount of use so a cheaper body, often found with exactly the same features, is perfectly adequate.

Robustness does not necessarily correlate directly with reliability, though the better built the camera the more reliable it is likely to be. The best method of checking the reliability of a make and model is to ask a good camera repair centre. They will repair the less reliable cameras more frequently and will therefore be able to tell you which ones to avoid.

THE LENS SYSTEM

Choosing a range of lenses is no longer as difficult, or as expensive, as it used to be because the quality of zoom lenses is now so good. However, expecting one lens to do everything is unrealistic. The wider the focal length range of any given zoom, the higher the price you pay in terms of size, weight, image quality and maximum aperture. While maximum aperture is not a primary consideration in landscape photography, because you should be aiming to shoot for depth of field at f5.6 or smaller, some of your lenses will be used for other types of photography. A wider aperture lens also makes focusing in low light conditions considerably easier.

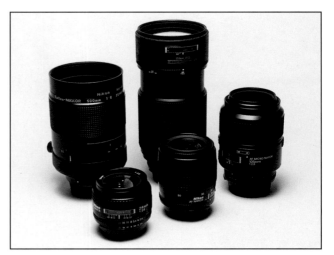

For landscape photography the ideal lens system would cover the range from ultra-wide angle to long telephoto. I built my system over a period of time, starting with a mid-range zoom lens then adding wide angle and telephoto lenses when I could afford them. My current system comprises 24mm, 30-70mm zoom, 80-200mm zoom, 105mm macro, 500mm mirror.

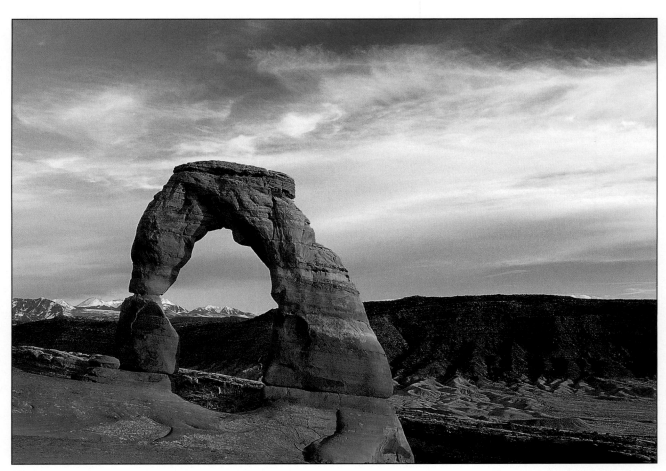

24mm

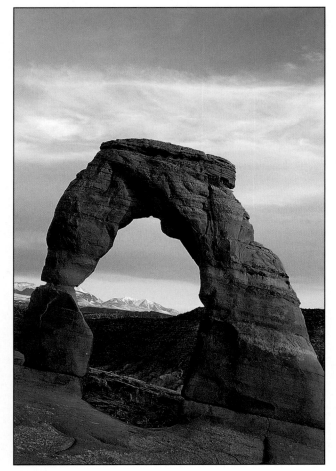

70mm

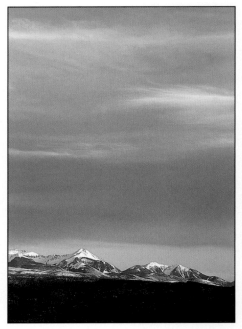

500mm

The focal length of a lens determines the field of view, the area included within the frame. The first shot shows the overall scene shot with a 24mm lens. In the second shot the arch fills the frame with a 70mm lens. With a 200mm lens the field of view is reduced to include only a small area of the arch framing the distant mountains. A 500mm lens excludes the arch completely.

Location: La Sal Mountains and Delicate Arch, Utah, USA. Nikon F4, 24mm, 35-70mm, 80-200mm, 500mm mirror, Fujichrome Velvia

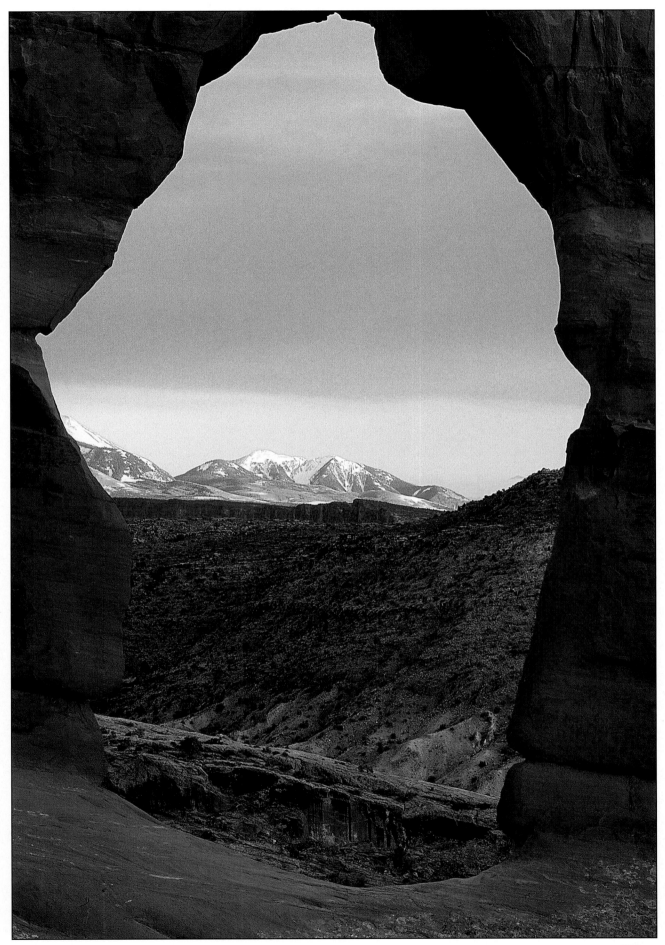

200mm

A good guide when building a lens system specifically for landscape photography is to choose a set of lenses that give good coverage over the range of 24mm to 500mm. For example a 24mm fixed focal length, a 35-70mm zoom, an 80-200mm zoom and a 500mm mirror lens. A mid-range fixed focal length lens, for example a 105mm lens with macro, would be a good supplement for close-up shots.

A shift lens would be an expensive addition to your system but if you take a lot of urban landscapes or shoot from low viewpoints with a foreground subject close to the camera then this lens would be of great value.

In any range of lenses there will obviously be one or two which are used more frequently. Which ones, though, may not be as obvious as you might imagine. Indeed experimenting with the different lenses is part of developing your own style and view of the landscape. Do not be constrained by preconceptions that a wide angle is used for landscape photography, a mid-range lens for portraiture and a telephoto for wildlife or sports photography. The choice of lens for any photograph should be seen as part of the composition and just because a particular landscape is a grand panorama does not mean that you have to photograph it as that.

With landscape photography the speed of a lens is not of primary concern, especially if you get into the habit of using a tripod. The speed of a lens is

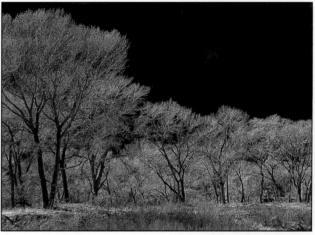

Flare is caused by direct sunlight hitting the front of the lens. A lenshood will shade the lens, reducing the chances of this happening. This shot was taken with a lenshood on but the angle of the sun through the trees meant that even this did not shade the lens sufficiently. There are three ways to solve this problem:
1) Use your hand to shade the lens, taking care not to get your hand in the corner of the frame.

2) Change position to prevent sunlight hitting the lens.
3) Use a longer focal length lens, as I have done in the second shot, because it has a narrower field of view and a longer lenshood.

Location: Zion National Park, Utah, USA. Nikon F4, 35-70mm and 80-200mm, Fujichrome Velvia

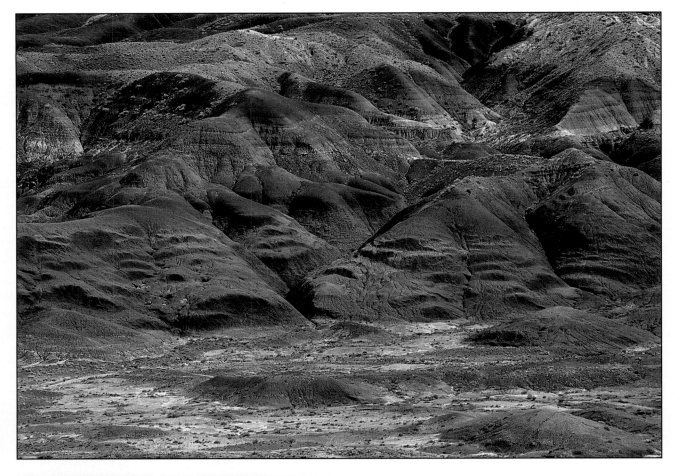

Polarising filters cut out the glare which reduces colour saturation. Compare these two shots of the Painted Desert. Without a polarising filter the colours look washed out and contrast is reduced. However with the polarising filter (top) the colours are richer with increased contrast between them.

Location: Painted Desert, Arizona, USA. Nikon F4, 80-200mm, Fujichrome Velvia

determined by its widest aperture i.e. how fast a shutter speed can be used under a given set of light conditions. However, faster lenses do have advantages: easier focusing in low light, when some of the moodiest shots can be obtained, and less occasion to use them at the limit of their aperture range, where diminution in image quality is most apparent. Sometimes a limited depth of field can be used to great effect, and you may occasionally want to take a photo in high winds when the wide aperture allows a faster shutter speed, preventing camera shake even on a tripod.

Probably the most important factor when choosing a lens system is to buy the best that you can afford. The lens determines the quality of the image on the film. In practice the best way to choose a lens system is to determine the options available within your budget and then go to a camera store and try them on a camera body. The lens should feel comfortable, have a smooth focus and give a bright viewfinder image. Use the lenses which you have chosen and see how your style develops. You can always add another lens later. If you prefer using a wide angle you may wish to add an ultra-wide or fisheye lens.

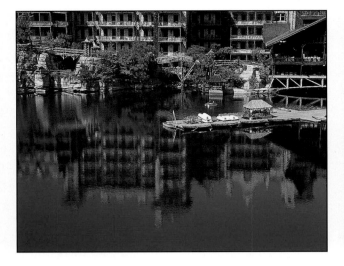

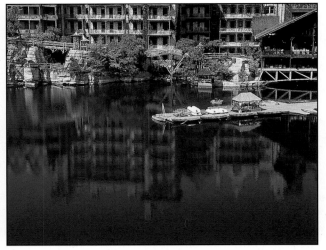

LENSHOODS AND FILTERS

The accessories which you fit to your lenses are every bit as important as the lenses themselves. Lenshoods should be considered as permanent fixtures. They reduce flare and come into their own in bright, sunny conditions. They can be the difference between a great photograph and one which ends up in the bin. Flare is caused when direct sunlight hits the front of the lens and is then reflected internally. A lenshood shades the front element, reducing the possibility of this happening, but it is important to ensure that the right lenshood is used to avoid restricting the field of view of the lens and causing vignetting.

Filters are also an essential tool for every photographer. The one important thing to remember is that the filter, because it is placed in front of or occasionally behind the lens, needs to be of high optical quality if it is not to affect the quality of the image on film. It is pointless spending a lot of money on a good quality lens then putting a piece of low optical quality glass or plastic in front of it!

There are two design options available when choosing a filter. The first is the standard screw-on option which attaches to the front of the lens. Some lenses, usually those with a long focal length, have a rear-mounted filter. However whether mounted front or rear, filters must correspond to the thread size of the lens. Different lenses have different thread sizes so you may need one of each filter type for each lens. The second design option is the type which slots in to a holder mounted in front of the lens. These filters are square or rectangular, usually made of glass, resin or acrylic. Both the holders and the filters are a standard size. Only the holder mount

Polarising filters reduce reflections from glass or water. Note how the reflection of the rich, blue sky is removed in the second shot when a polariser is added.

Location: Mohonk Mountain House, New York, USA. Nikon F5, 80-200mm, Fujichrome Velvia

which screws on to the front of the lens varies according to the lens thread size, so while you may need say, three mounts for your selection of lenses, you will only need one of each type of filter. The filters, rather than the mounts, are more expensive so as your lens system grows this option has the advantage of being less expensive than the screw-on filters. These holder-mounted filters also offer one other feature which makes them preferable to the screw-on type. On occasions you may need to use more than one filter, say a polariser with a graduated neutral density or a warm up filter. With the screw-on type stacking one filter on top of another can cause problems with vignetting, especially with wide angle lenses at larger apertures. This is not a problem with the holder-mounted filters.

In my opinion the most important accessory for a landscape photographer is a polarising filter. Again you will need one for each lens as the thread size will be different if you are using the screw-on type. Polarising filters cut down the reflected light which bounces around causing glare. Most subjects reflect some light and this is increased when the sun is brightest, diffusing the colours. This is the reason why the photograph of a subject taken at noon looks washed out compared to one taken earlier or later in the day. A polarising filter will increase colour saturation by filtering out some of the reflected light and glare. The effect is to make blue skies bluer and the colours of flowers and foliage richer and more vibrant.

There are two types of polarising filters; a linear or fixed polariser and a circular polariser. Both polarisers will polarise light in one fixed plane only, thus

Overpolarising a shot will lead to skies turning inky blue. This usually occurs in strong light and contrasty conditions. In this shot I had to reduce the polarisation to prevent this but even then the sky is almost unnaturally blue.
Location: New England, USA. Nikon F4, 35-70mm, Fujichrome Velvia

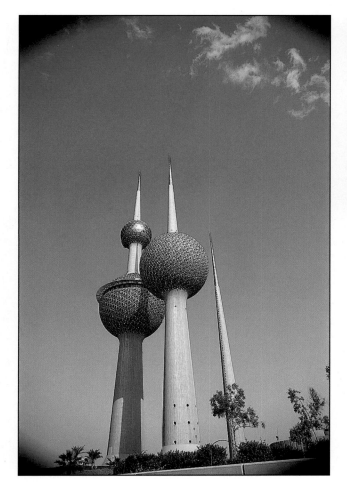

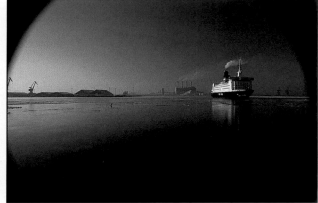

effectively filtering out most of the unwanted reflected light. The advantage of the circular polariser is that the plane may be rotated to produce the maximum polarising effect, rather than being fixed by the filter thread.

The circular polarising filter is more expensive than the linear version but its increased effectiveness and ease of use make it one of the most cost-effective components of the landscape photographer's system. If you are using the holder-mounted filters you need only a linear polarising filter because the holder itself will rotate, effectively making it into a circular polariser.

Polarisers produce the deep blue skies that can be seen in tourist board and travel agents' promotional material. This effect can be easily created by attaching a polarising filter to a lens then looking through the viewfinder at a bright sunny sky. Rotate the polariser slowly and, at the point where it is most effective, you will see the sky darken and the blue colour become stronger. This effect is not even. The sky around the sun is still bleached out. Maximum polarisation, the darkest blue, is seen at 90° to the direction of the sunlight. Clouds make the effect even more noticeable. Repeat this exercise on a grey overcast day, however, and you will see little or no difference. Polarisers will not remove all the glare in the middle of a hot summer's day but they can bring back some colour to the sky as glare builds towards midday, increasing the opportunities to photograph a landscape.

Darkening blue skies is not the only use of a polariser. They can be particularly effective in increasing the colour saturation of foliage and flowers, giving rich vibrant landscapes especially in the autumn. A polariser can also be used to bring out the colours of foliage after it has rained.

Another big advantage of the easier to use circular polariser is the control it provides on those occasions when the lighting conditions can lead to 'over-polarisation', when for example skies become unnaturally dark and begin to look inky blue. By rotating the circular polariser just a little from the point of maximum polarisation the degree of polarisation can be reduced just enough to make the scene look more natural. Of course the question of whether a photograph is over-polarised or not is a subjective one.

All these effects of reducing glare and unwanted reflected light result in less light reaching the film and consequently will increase exposure by at least one stop, sometimes as much as two stops at maximum polarisation. Through the lens (TTL) metering will compensate for this but care should be taken to adjust exposure if you use a hand-held meter. It is worth noting also that linear polarisers do not produce accurate meter readings with some makes

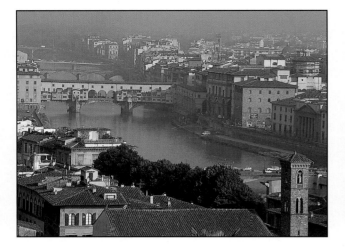 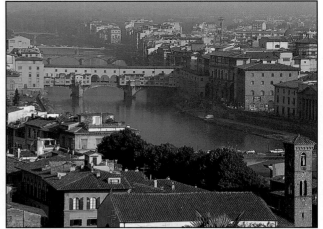

and models of camera. This does not mean that they cannot be used with these cameras but again, as with a hand-held meter, compensation should be made. With the linear polariser this compensation is fixed and quoted as a filter factor by the manufacturer i.e. a filter factor of one means +1 f-stop should be given to the exposure. A word of caution though. The cameras which do not compensate for exposure may also have auto-focus systems which do not function accurately with these filters. Personally I would always advise spending a little extra on a circular polariser for the additional benefits which it offers.

The fact that a circular polarising filter gives the option to polarise or not, makes it an alternative to a UV or skylight filter. However, even when it is not polarising it may still reduce the light which reaches the film by as much as 1 f-stop. Filters should not be combined as this will decrease the optical quality, and hence the quality of the image of the film, and may also cause vignetting. Use a circular polariser if you need to polarise, a UV or skylight if you don't.

Vignetting is a darkening of the corners of the frame caused by an object which restricts the angle of view of lens. It is a common problem with lenshoods and circular polarisers, because of their thickness, particularly when using wide angle lenses. It may not be visible through the viewfinder at maximum aperture. You can check for vignetting by stopping down the lens using the depth of field preview button.

The second kind of filter which is particularly useful in landscape photography is the neutral density (ND) filter. These filters cut down the amount of light which reaches the film without altering its colour composition, and are used extensively in film making for that reason. An ND filter, as its name implies, filters neutrally without affecting colour balance. These filters come in a range of filter factors and can be used to create some interesting effects, especially in bright conditions. For example it may not be possible to capture movement in say, a river or waterfall on a bright sunny day, even at minimum

Compare these two shots taken early in the morning. In the second a graduated coral filter was added to warm up the cool, hazy scene. Here a warm up filter *works well because it enhances the natural colour of the buildings.*
Location: Florence, Italy.
Nikon F5, 80-200mm,
Fujichrome Velvia

aperture. An ND filter can reduce the light, allowing a slower shutter speed to be used to create the blurring effect of movement.

A variation of the ND filter which has a wider usage in landscape photography is the graduated neutral density filter. These filters have a higher density on one edge which graduates to clear on the other. Most film will only register a range of about 5 stops between the highlight and shadow areas. The human eye, however, has the ability to visually accommodate a much broader spectrum of between 12 and 14 stops. This gives us the ability to see both gradation and detail in shadows and highlights which cannot be recorded upon the film. Consequently there are occasions when it is not possible to capture a scene because the contrast between light and dark is too great. If you meter for mid-tones then some detail will be lost in both highlight and shadow. If you meter for highlight then the shadow will be very dark or black. If you meter for shadow detail then highlight will be bleached out. A graduated ND filter will selectively filter part of the picture so that the highlights can be darkened, narrowing the contrast range of the scene thereby effectively stretching the range over which the film can record detail.

This is best visualised by considering a sunset. Metering to bring out the full colour of a sunset will almost certainly mean that the foreground is silhouetted. However, if the same scene is metered to bring out foreground detail the sunset will begin to bleach out. Photographing a snow scene with the foreground in shadow presents a similar problem. Attaching a graduated neutral density filter to the lens and adjusting it so that the line of graduation falls

The filters most commonly used in landscape photography are a polariser, ND, warm up filters 81, and red, orange or yellow filters for B&W. These filters are the type which screw on to the front of the lens.

around the skyline will darken the sky, allowing metering for foreground detail but retaining the colours of the sunset. Both parts of the picture are therefore more accurately exposed, as the contrast range is decreased, to give a balanced exposure for the whole frame. The colours of the sunset are retained and shadow detail is visible. The degree to which this is achieved obviously depends on the density of the filter. For example, a 2 stop ND filter will darken the sky by 2 stops, a 4 stop by 4 stops and so on. Following this example 7 stops and 9 stops respectively are compressed within the 5 stop band of tolerance of the film.

Filter positioning is critical to avoid banding in the sky or foreground. With graduated filters the filter holder mounted type has one major advantage in that the point at which the density changes can be adjusted by varying its position in the holder. Effectively the horizon is movable, whereas with the screw-on type it is always fixed in the middle, restricting composition. The holder version can also be rotated for more selective filtering.

The key to successful use of the graduated ND filter is two-fold; careful positioning and exposure adjustment. Positioning the filter is more difficult than it sounds as the graduation is difficult to see at maximum aperture. The best way to position it is to use the depth of field preview to stop the lens down to a much smaller aperture, as when checking for vignetting. If you still have trouble rotate the filter holder back and forth slightly. The point at which the density changes to clear should be positioned along the edge of the highlights. If it is lower you will get a dark band in the middle of the frame, higher and this band will be light. Always position the filter looking through the lens.

Exposure adjustment will require you to think about the effect that you want to achieve. Always meter for the area that you want to have the most impact. For example, if you have a scene that is part shadow, part light, decide which is easiest to control and meter for this. First let's say that you want the shadow area to have the correct exposure to show all the detail. Meter for this through the clear part of the filter then position it correctly and shoot. However, if you have a scene that has highlights such as snow but with foreground detail in shadow, then meter for the snow through the dark filter and adjust this reading by plus 2 stops to bring the snow back to white. The snow will then be perfectly exposed while maximum shadow detail retained.

One final word of caution. ND filters have their greatest effects at small apertures. Always try to use them at the minimum aperture possible for the available light.

There are many other types of filters available on the market. Other than warm up filters and yellow, orange, green or red filters for black and white photography, these do not have a role in photographing landscapes. It can be argued that they have their place when a special effect is desired but very few landscapes lend themselves well to this type of manipulation. With computer technology at its current advanced state it may be best to perform these manipulations using this medium, rather than at the origination of the image.

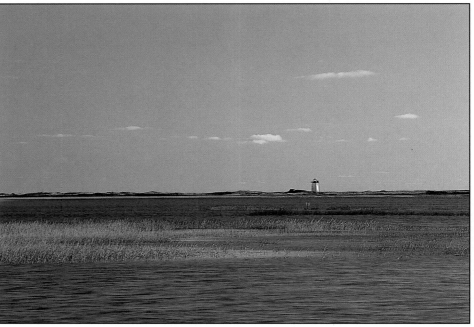

Camera shake occurs when the shutter speed used is too slow. As a rule of thumb the minimum shutter speed, when hand-holding the camera, should be equivalent to the focal length of the lens. In this shot I used a the zoom lens at 200mm but with a shutter speed of $1/30$ sec. As a result I was unable to hold the camera steady enough. In the second shot I put the camera on a tripod to hold it steady and used the same shutter speed. Windy conditions can cause camera shake even when using a tripod, so I use my body as a windbreak to shield the camera.

Location: Lighthouse on Cape Cod, USA. Nikon F4, 80-200mm, Fujichrome Velvia

TRIPODS AND MONOPODS

Without a tripod the landscape photographer may miss the opportunity to take good landscape pictures in all but the brightest light. As the most interesting light is usually early or late in the day, a tripod is an essential piece of equipment if you are to produce sharp images.

When hand holding a camera the general rule is that the fastest acceptable shutter speed is numerically equivalent to the focal length of the lens i.e. for a standard 50mm lens this is a $1/50$ sec, for a 200mm lens this is $1/200$ sec and so on. Therefore the longer the lens the brighter the light required to shoot at a given aperture when hand holding it. A tripod will prevent the need to resort to wide apertures,

which decrease the depth of field, or fast films, which increase grain and reduce image quality and colour saturation.

It is important to choose a sturdy tripod. Check sturdiness by extending it to its maximum height. If it shakes with even the smallest vibration then it will not be suitable. Inevitably any choice for landscape photography will involve a degree of compromise because the need for portability dictates that it must not be too heavy. However, many tripods on the market are just too flimsy to be of much use. I would always advise investing a little more in a well made tripod. The first time you try to use it on a breezy day it will pay dividends.

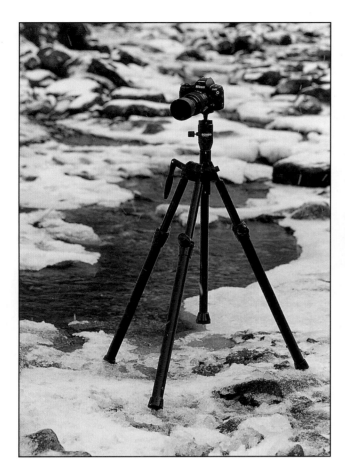

A sturdy tripod is an essential piece of equipment for landscape photography.

Many tripods have interchangeable heads. A multi-angle head is the most useful in landscape photography.

Holding the camera steady is especially important with long focal length lenses. Any movement will be magnified as you increase focal length. Shake which may seem insignificant with a 28mm lens may look like an earthquake through a 500mm lens.

A good tripod should offer the option to shoot from both low and high view points for maximum control of perspective, but take care not to over-extend it because the higher it goes the less stable it will become. Independently adjustable legs are also important as most use will be on uneven ground. An alternative to a tripod is a monopod. Although these provide a degree of stability they do still require a steady hand to prevent movement. Whilst they have their uses to a landscape photographer they are very much the poor man's, or lazy man's, option.

Finally two handy tips when using a tripod. There is little point in using it if you are then going to create shake when releasing the shutter, so use a cable release or electronic timer. Most electronic cameras have a vibration-free electronic self-timer which can be activated for minimum delay times of 3 or 4 seconds to release the shutter. Secondly, if you have the option, always mount the lens on the tripod rather than the camera body as this will minimise any movement. Some lenses come with a tripod mount attached, or you can buy a collar for some longer focal length lenses.

CAMERA BAGS

Landscape photography often means long walks to get to a location, inevitably carrying more equipment than you will use, just in case! A high priority must therefore be a strong, lightweight camera bag which can be comfortably carried. For protection against the extremes of weather it should also be insulated and waterproof. Of the many different types of camera bag on the market I find that the rucksack type is the most suited to this purpose. They are available in a range of sizes and putting the weight on your back means that your equipment seems lighter because the weight is evenly distributed and your balance is easily maintained. It also leaves both hands free at all times. A surprising amount of equipment can be packed into one of these bags and the construction means that both equipment and film are kept at a constant temperature, free from dust and moisture. A variety of designs are available with either a single large internal compartment and external pockets or divided into smaller individual compartments, each of which is accessible without opening up the whole bag. Both types have movable dividers attached by velcro which allow customised positioning to suit your camera system.

For small pieces of equipment, which I need quick and easy access to, such as a cable release, a spare film or a filter, I wear a multi-pocketed vest. These

vests are ideal for photographers as they leave your hands free and mean that you don't have to open up your camera bag every time you want something.

FILM

Colour saturation and sharpness are essential characteristics of a film for use in landscape photography, and it is in these two areas that transparency film scores over its negative counterpart. In recent years film technology has progressed rapidly with the latest range of films offering excellent colour rendition and fine grain structure.

Film comes in a range of speeds. The speed of a film, denoted by its ASA or ISO, is simply an indicator of its sensitivity to light. The higher the ASA, the quicker the film reacts to light, and the shorter the exposure needed under given lighting conditions. There is, however, a price to pay for increased sensitivity. As sensitivity increases so too does the graininess of the film, accompanied by a reduction in colour saturation. A serious landscape photographer should therefore be aiming to use a colour transparency film with an ASA rating of 100 ASA or less.

For many years Kodachrome, 25 or 64 ASA, was considered to be the professional standard. While still popular with many photographers and publishers, Kodachrome has had to make room for a number of newer films which have excellent colour saturation, in particular, Fujichrome's 50 ASA Velvia.

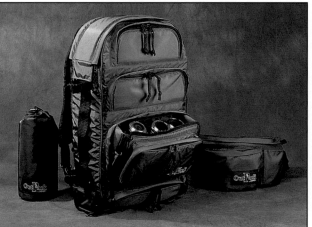

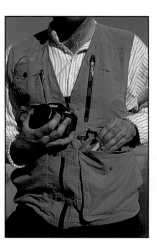

A rucksack camera bag allows you to carry your equipment more comfortably and leaves your hands free. The Tamrac bag has one large internal section while the Domke bag has individual sections which open up separately.

A multi-pocket vest is useful for spare film and smaller items which are frequently used, such as filters or a cable release, removing the need to keep opening your camera bag.

Fujichrome Velvia 50

Fujichrome 400

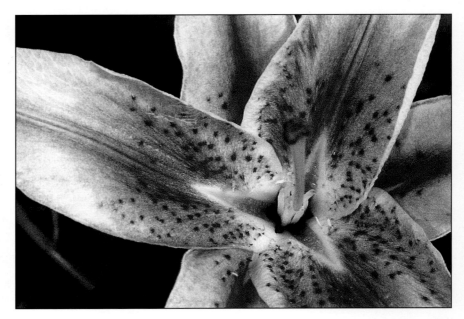

Fujichrome 1600

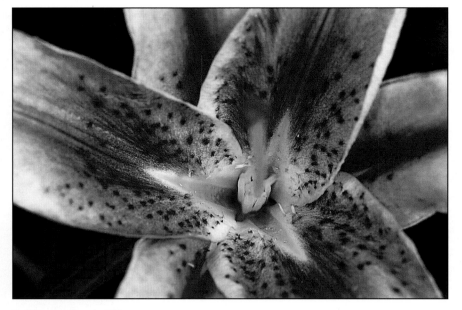

Fujichrome Provia 100

25 ASA/ISO ──────────────── **GRAIN SIZE INCREASES** ──────────► 1600 ASA/ISO

Films fall loosely into three categories: slow, medium and fast. Slow films have an ASA rating of between 25 and 64 ASA. These would be the films of choice for landscape photography but they are also the least forgiving. Colour transparency films have a much smaller latitude of exposure than negative films. That is, they are less tolerant of incorrect exposure and therefore accurate metering is vital. As a rule the exposure latitude also decreases with the speed of the film.

Medium films have an ASA rating between 100 and 200 ASA. They are slightly more grainy than the slower films but are useful in lower light conditions. Fast films would generally be considered as unacceptable for general landscape photography and the extra speed is not required when using a tripod. However, they can be used to great effect to enhance mood and create special effects. Personally I prefer to use a slower film, and, if a particular shot lends itself to increased grain or texture, to add this in the darkroom. You will then always have a high quality original with which to experiment. You can always add grain but if it's there on the original you can't take it out. Fast films have an ASA rating of 400 ASA or greater.

Film choice is also determined by end use of the photograph. If you only intend your photography to be a hobby, producing prints for easy viewing in an album, then negative film may suit your purpose. However, the fact that you are reading this book suggests that you want to take the best photographs possible and so your choice should be transparency

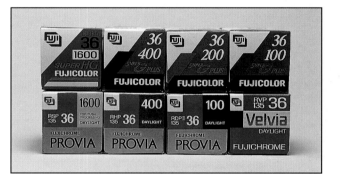

Most manufacturers supply both negative and transparency films in a range of speeds, or ASA/ISO ratings.

film. Certainly if you intend to publish or display your work then this is the only realistic choice, and the slower the film speed the better. I use Fujichrome Velvia whenever the light permits, with Fujichrome 100 RD, Astia or Provia for lower light conditions. In reality the choice of which particular make of film to use, as with many things in photography, is subjective and all the major film manufacturers have films which are suitable. All films have a colour bias which varies from one make to the next. Ektachromes, for example, are known for their bluish hue, whilst Kodachrome has a warmer pinkish hue. Some of the newer finer grain films such as Kodak Ektachrome SW and Fujichrome Provia have a warm balance. For most subjects this is quite pleasing but does not suit all landscapes as blue skies can appear to have a slightly

Above: Slow, fine grain films tend to produce higher contrast images resulting in loss of shadow detail. Fujichrome Astia has the qualities of a low speed film but with reduced contrast.

Note how shadow detail is visible on the tree trunk.

Location: Kew Gardens, London, England. Nikon F4, 80-200mm, Fujichrome Astia

Opposite: Different films have different characteristics. Compare the top shot taken on Fujichrome Velvia, 50 ASA, and Kodak Ektachrome 100S, 100 ASA bottom. Both are excellent fine grain

transparency films but note the better colour saturation on Velvia, while the Ektachrome has a warm hue seen as a purple colour cast in the sky.

purple hue. Slower films tend to produce a higher contrast image resulting in loss of highlight or shadow detail in harsh lighting. Fujichrome Provia and Astia, both rated at 100 ASA, have similar grain size and colour saturation but Astia has been specifically designed as a lower contrast film to address this problem. It is worthwhile experimenting with a few different films to see which you prefer. Choose a subject with a good range of colours, including white and the three primary colours of light: red, green and blue. Take identical photos of the subject with each film, using the same shutter speed and f-stop, then directly compare the results by placing the transparencies side by side on a light box. Any colour cast will be most noticeable in the white or neutral areas. Film speeds can also be experimented with; Fujichrome Velvia, for example, produces better results when exposed at 40 ASA and can also be comfortably pushed one stop to 80 ASA.

While there are black and white transparency films available, the widest choice of film in this medium is negative film. There are some excellent films offering fine grain and a good tonal range. They too, differ

slightly so experiment with a few to choose the one which you prefer. One B&W transparency film which is worth trying is Agfa Scala. This comes in a range of ASA ratings and can produce some interesting results, especially when combined with a red filter.

There is a benefit in standardising on the film which you use. Different films respond slightly differently, with varying tolerances to exposure. As you become familiar with a particular film you will get to know how it responds to different conditions and this can be used to enhance your photography. All films suffer from reciprocity failure to varying degrees. That is, as exposure gets longer, usually above a second or two, the film becomes less and less sensitive to light, resulting in underexposed shots. To compensate for this reduced sensitivity you must overexpose. The longer the metered exposure, the proportionately longer you must expose the film to compensate for reciprocity failure. The recommended exposure compensation is usually quoted in the technical information supplied by the manufacturer for a particular film. As with ASA, though, the quoted figures do not necessarily produce the optimum

Fujichrome Velvia

Kodak Ektachrome

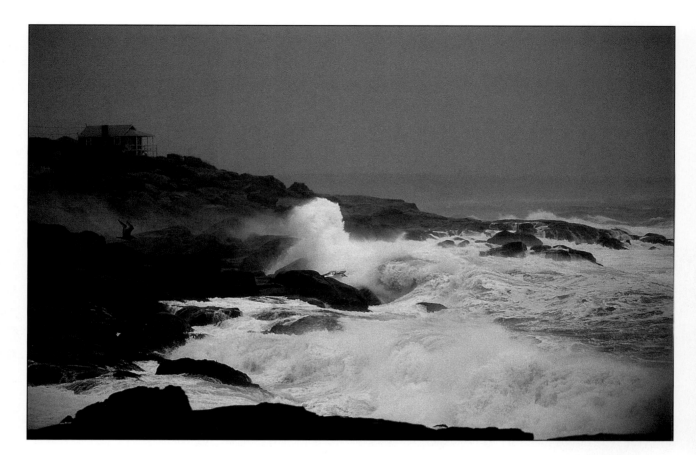

results so use a roll of your preferred film to experiment. With long exposures most films will experience some colour saturation shift. With Fujichrome Velvia, for example, this can easily be seen in sunset photos. Reds particularly become much more richly saturated as exposure lengthens. If this effect is not desired, it can be corrected with filters.

Agfa Scala is a B&W transparency film. It gives excellent results but it requires a special process. This shot was taken in low light and pouring rain but still produced a good tonal range and contrast.

Location: Storm on Maine coast, USA. Nikon F4, 80-200mm, Agfa Scala 200

METERING LIGHT

With such sophisticated metering options available in modern cameras it is easy to forget the basic principles by which all metering systems operate. They all meter for a standard mid-tone grey by averaging the light coming through the lens. The simplest of these metering systems will just average all the light. More common is a centre weighted system which averages the light but biases the reading for the light coming from the central portion of the image. The latest matrix and multi-segment metering systems take this a stage further by biasing the reading according to a more complex pattern and integrating all this information to give the exposure reading. With spot metering the light reading is simply taken from a small area, usually that positioned in the centre of the viewfinder, to allow precise exposure for a single element of the composition. Regardless of how complex the TTL metering system, it can still be fooled by the subject being photographed if it does not conform to the pattern of tones for which it is calibrated. To prevent this you should always stop and

think about the metering process before pressing the shutter. Remember the camera cannot think and the meter sees only average grey whether you are photographing a snow covered mountain or a pile of coal. If you just take the meter reading with these subjects average grey is what you will get – grey snow and grey coal!

TTL meters measure reflected light, i.e. the light reflected back off a subject and through the camera lens. A more reliable method of gauging the appropriate exposure is to use a hand-held meter to measure incident light, i.e. the light which falls onto a subject. This metering method is more reliable because it is independent of the tone or colour of the subject, determined by the amount of light which it absorbs or reflects. This is especially true where the subject has an extended tonal range as is the case with many landscapes. These meters measure the diffused ambient light, integrating it to give the

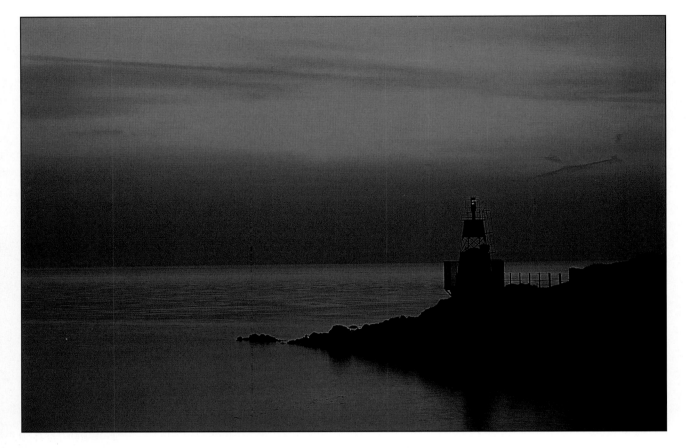

correct exposure for mid-tone grey. However, because they take a broader view of the light, rather than just that in the viewfinder, they are less easily biased by bright or dark subjects within the frame.

It is important to hold the meter in the same light and plane as the landscape which you want to shoot to obtain an accurate reading. Remember that you must also adjust exposure to compensate for any filters you are using.

Film is manufactured for general use in standard lighting conditions. When it is used in low light with long exposures it behaves differently, becoming increasingly less sensitive to light and producing colour shifts (reciprocity failure). These characteristics can be used to good effect. This shot of the lighthouse at dusk was taken with a 20 sec exposure with no filtration. The sky was actually dark pink but the long exposure has intensified the colour, turning it to red.
Location: Portishead Lighthouse, Avon, England. Nikon F4, 80-200mm, Fujichrome Velvia

EXPOSURE COMPENSATION

The latest camera metering systems are so sophisticated that they can meter colour as well as light intensity, comparing a scene to a set of pre-programmed alternatives stored on a memory chip. As yet though, most cameras do not have these highly sophisticated systems and even when they do they are not infallible.

The most important thing to remember when metering a subject is to think about the process, and how the colours and tones of that subject may bias the exposure reading given by your metering system. Understanding exposure means being in control of the photographic process so that the picture you planned to take is the one you end up with. Correct exposure is therefore a scene exposed as you planned, in other words the sky is the same shade of blue or the leaves the same shade of green as you intended, rather than what your camera TTL meter or hand-held meter tells you. Remember that this exposure need not

necessarily be the same as it appears to the naked eye. As the photographer you control the creative process and determine the end result.

I have already described how metering systems work. To determine the correct exposure, first decide which f-stop or shutter speed you need to control depth of field and motion, then meter the scene using your camera TTL or hand held meter. Use this as your starting point. To determine whether you need to make an exposure compensation you will now need to think about the elements which you have included in the frame and how you want them to reproduce on film, but you will need to think about them in terms of tone, or shades of grey, rather than colour or composition.

Every colour has a range of tones, for example light blue, mid blue and dark blue. To help you to visualise colours as tones think of them as shades of that colour. So if you want a mid blue sky to appear on

Exposure compensation

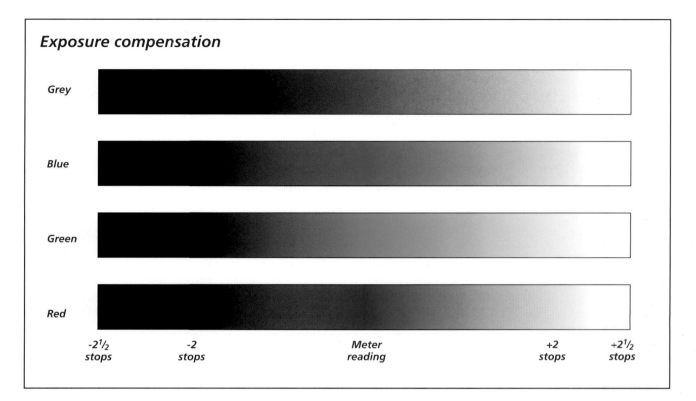

Grey					
Blue					
Green					
Red					
	-2½ stops	-2 stops	Meter reading	+2 stops	+2½ stops

Every colour has a range of different tones. By adjusting exposure any colour can be reproduced in different shades between black and white. Under-expose to make a colour darker, over-expose to make it lighter.

Hand held light meters can be used to meter both incident and reflected light but care must be taken to compensate for filter factors.

the photograph as mid blue then you can shoot as metered. If however you want it to appear as light blue or dark blue then you must over-expose or under-expose respectively. Similarly if you want a light blue sky to reproduce as mid blue then you must under-expose the shot.

Within a landscape there are many different colours and tones so it is important to determine the key elements of a composition and adjust exposure so that they reproduce as you intended. Most films can handle a contrast range of five stops between the darkest and lightest tones so a good way to determine the tonality of a particular colour is to think of it on a scale of tonality between textureless black and white. Mid-tone grey, the metered reading,

is at the middle of the scale with black and white, as -2½ stops and +2½ stops respectively, at the limits. With this scale you can calculate an exposure compensation for any colour. So to reproduce a mid blue as light blue you over-expose by +1 stop; to reproduce it as textureless white by +2½ stops; as dark blue -1 stop and so on. Any shade in between is assigned a graded exposure compensation.

Where any one colour dominates the frame it will bias the meter reading unless it is mid tone. This applies to white and black as well as all the other colours. Remember grey is the mid tone between white and black so if white dominates the frame and you want it to appear as white you must over-expose by 2 stops, otherwise it will reproduce as grey.

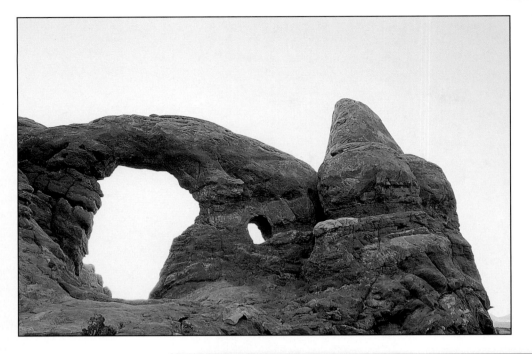

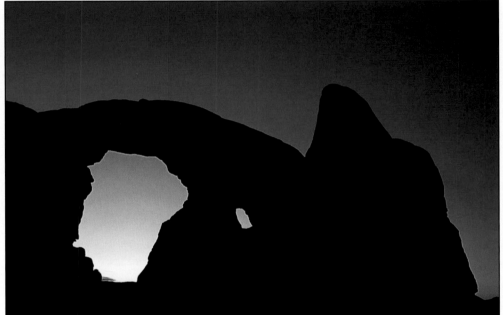

A 2 stop compensation will record as white while retaining some texture.

Understanding exposure and the way light is metered will allow you to correctly expose any scene. Determining the exposure and any compensation required obviously takes practice but although it may seem very confusing when you start, it is worth the effort when you take a picture in difficult lighting conditions which wouldn't have worked if you'd used the metered reading. Although I have been making exposure compensations for years there are still times when I have to stop and calculate the compensation in my head before pressing the shutter. If you are in any doubt then bracket your exposures around the compensation which you've calculated to ensure you get the shot which you intended.

Understanding exposure allows you to determine which subjects require compensation from the metered reading. Predominantly light subjects require over-exposure and dark require under-exposure. In the first shot of Turret arch I have exposed for the arch itself. However, strong backlighting means that the sky is over-exposed. Exposing for the sky in the second shot puts the arch in silhouette.

Location: Turret Arch, Arches National Park, Utah, USA. Nikon F4, 80-200mm, Fujichrome Velvia

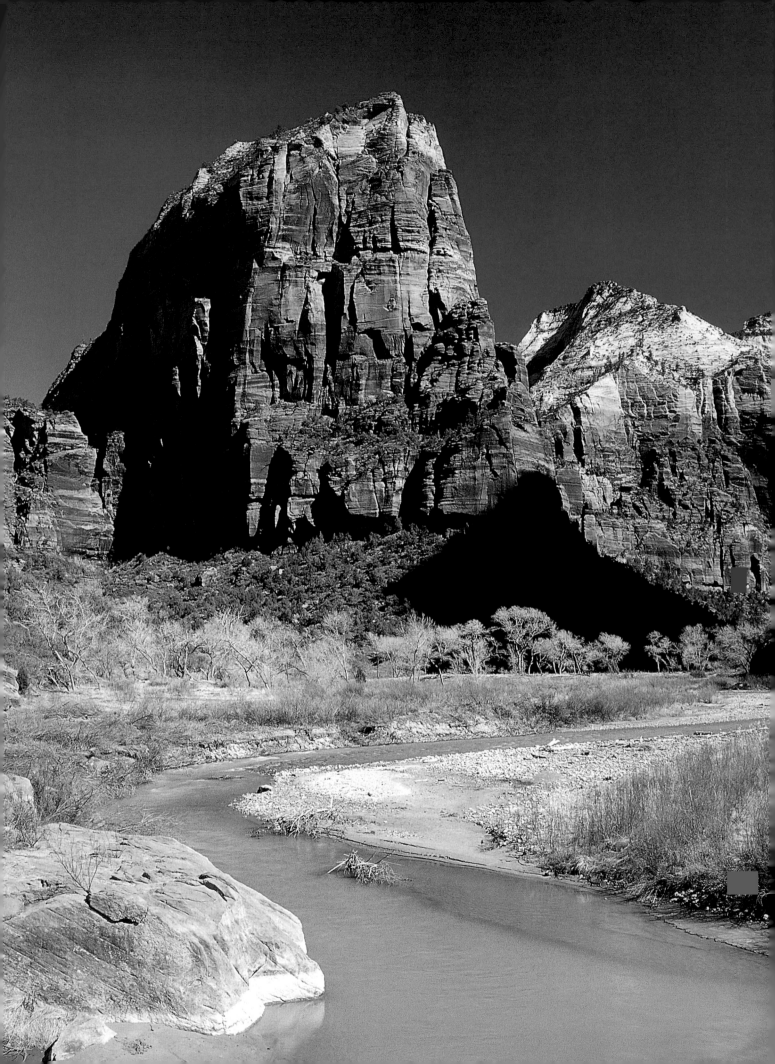

DESIGNING A PHOTOGRAPH

A good landscape photograph doesn't just happen by chance. It depends on a series of decisions made by the photographer in terms of design and composition. These decisions will determine whether it succeeds or fails as an image.

So how do you design a photograph? The answer begins with an interesting subject and ends with an effective composition. Quite simply, composition is the creating of a structure within a picture and the same basic approaches apply to both painting and photography. This structure helps the viewer to explore a picture in an order which tells a story, conveying mood and evoking senses. The viewer can feel involved in a 'living' photograph. This all sounds very grand but a photograph must be more than just a picture if it is to have impact, and deciding what to include or leave out, and where to place the elements within the photograph is an important skill.

The key elements of composition are: framing, a main subject, simplicity, depth and space. To design a photograph which has impact, these elements must be put together in an interesting and creative way.

CHOOSING A SUBJECT

It may sound obvious but choosing an interesting subject is essential to a good photograph. How interesting a subject is, though, is not only determined by the subject itself but also how the photograph is designed around that subject. A common mistake made by many photographers is not to define clearly the main subject. This is a very easy mistake to make as all too often we try to capture too much in a single image. The golden rule is to choose only one main subject and it should be obvious what that subject is. Size and positioning will add emphasis within the frame. Before you take a photograph you should ask yourself what you are taking a photograph of. If there is more than one answer to this question then you

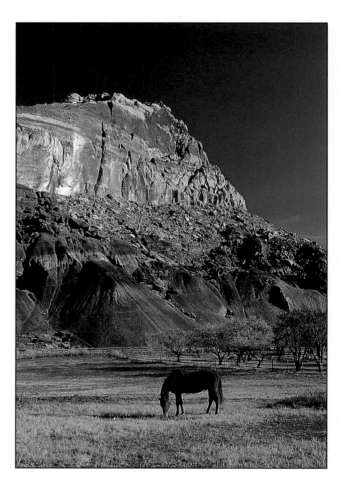

The horse is the subject of this photograph but the vast expanse behind makes it an interesting landscape, rather than just a picture of a horse.

Location: Capitol Reef National Park, Utah, USA. Nikon F4, 35-70mm, Fujichrome Velvia

Lines and curves in the foreground can be used to emphasise the main subject. In this shot I have used the natural curve of the river to create depth and lead the eye toward the cliffs behind.

Location: Angel's Landing, Zion National Park, Utah, USA. Nikon F4, 80-200mm, Fujichrome Velvia

need to simplify it. More than one main subject confuses the photograph so other subjects in the frame should complement rather than compete with the main subject for the viewer's attention. In other words they should be secondary to the main subject.

FRAMING

Having chosen your subject you must now decide how to frame it; where to position it within the viewfinder and what else to include or exclude. Basic composition consists of three elements: a foreground, a subject and a background. The first decision to make is therefore where to place the subject, in turn this defines both foreground and background. Inevitably when composition is discussed the so-called 'rule of thirds' is quoted as all you need to know. In reality this rule is only a guideline but it is extremely useful when developing compositional skills. It provides guidance as to where to place the elements in a photograph for maximum impact. It is a framework on which to hang the structure of a photograph.

The human eye will scan a photograph in the same way as it reads words on a page, moving through the picture to the main subject. From there it explores the rest of the picture to place this subject in context, taking visual cues from the way in which the picture is constructed. If the main subject is centrally placed the

Above left: This is a good example of a photograph taken without thought to design and composition. The sunlit rocks are an interesting subject against the sky but the composition is poor. The main subject has been placed centrally and the large foreground shadow area reduces its size and impact within the frame. Mood is created by the highlighted rocks.

Above right: I used a longer focal length lens to exclude the unwanted foreground shadow, increase the size of the rocks and reposition them within the frame. Only those elements which contribute to the impact and mood of the shot are included.

Location: Cathedral Rock, Sedona, Arizona, USA. Nikon F4, 35-70mm and 80-200mm, Fujichrome Velvia

picture can look static and confused because the eye is uncertain of the direction in which it should move next. However, if the main subject is placed off centre it provides visual cues by creating a path through the frame. Similarly a centrally placed main subject makes the picture look flat and two dimensional but when placed off centre the eye travels through the foreground to the main subject, and then on into the background creating a perception of three dimensions.

Using the rule of thirds as a guide to composition the frame is divided in three equal parts both horizontally and vertically. The lines along which these thirds intersect are the key points in the composition and provide the viewer with reference points from which to explore the photograph.

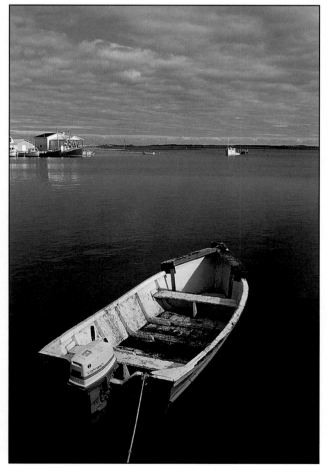

Designing a photograph comprises five key elements: subject, framing, simplicity, depth and space. In this shot I have used all five to create a strong, simple image from an ordinary subject. It was framed so that both the land and canoe roughly divide the frame into thirds, horizontally and vertically respectively, and the angle of the canoe creates depth.

The shot was taken just before sunrise using a long exposure. This creates the soft tones on the water, giving a graded colouration to the space which counter-balances the main subject.

Location: Canoe, Algonquin National Park, Ontario, Canada. Nikon F4, 35-70mm, Fujichrome Velvia

Angling a foreground subject through the frame has a similar effect to using railway lines or roads. Here I have used a low viewpoint to exaggerate the shape of the small boat and maximise the depth in the shot.

Location: Malpeque, Prince Edward Island, Canada. Nikon F4, 35-70mm, Fujichrome Velyia

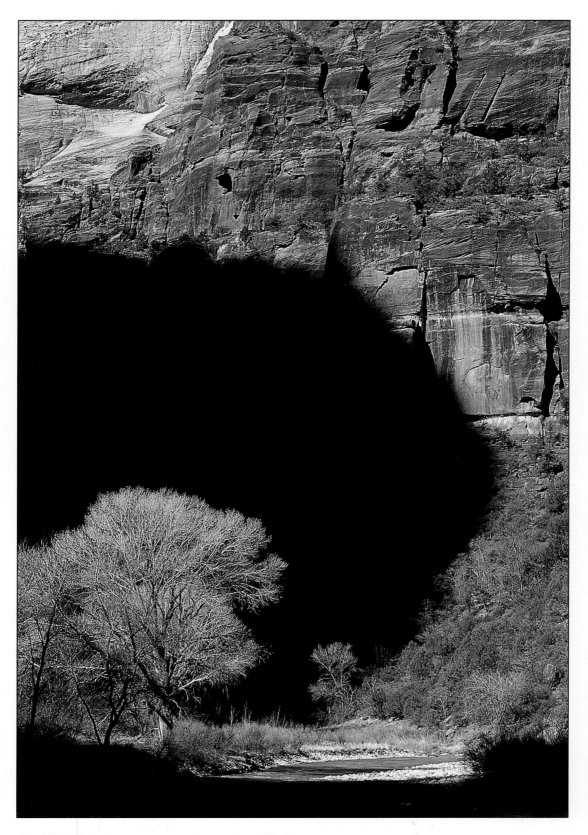

The skill of designing a photograph is to find the most interesting feature, the main subject, and to frame it to include only elements which emphasise this subject. In Zion the walls of the canyon cast deep shadows (above) but I liked the way in which the trees were catching the light so I used these shadows to isolate them. The result is a strikingly simple image (right).

Location: Zion National Park, Utah, USA. Nikon F4, 80-200mm, Fujichrome Velvia

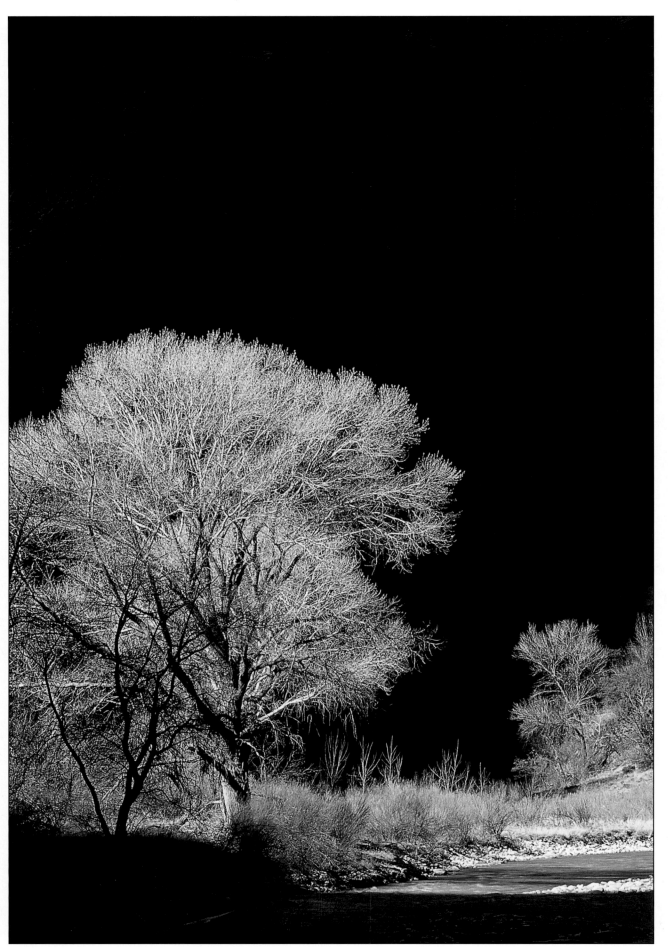

35mm

Every landscape provides an infinite number of framing options. I took the first shot in this sequence with a 35mm lens. This gives an overall view of the harbour. In the next three shots I gradually increased the focal length up to 500mm. Although these shots are all of the harbour, note how the emphasis of elements, such as the small fishing boats, change with the different framing. In the last shot I have used a 24mm lens to include foreground, creating a very different shot from the same position simply by changing what is included in the frame.

Location: Mykonos harbour, Greece. Nikon F4, 24mm to 500mm, Fujichrome Velvia

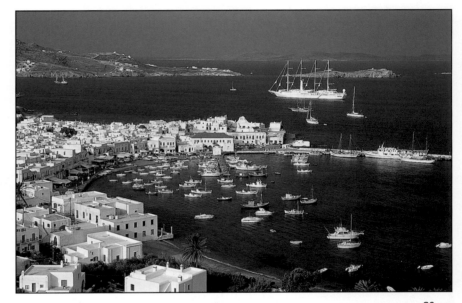

80mm

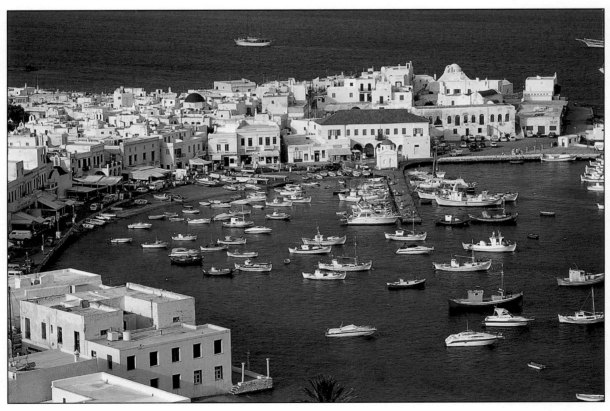

200mm

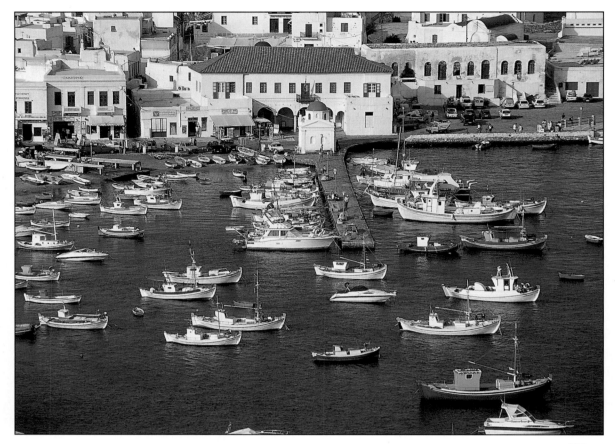

500mm

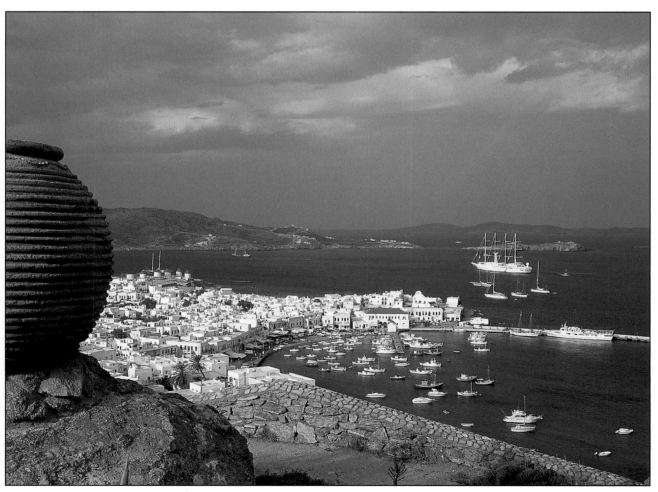

24mm

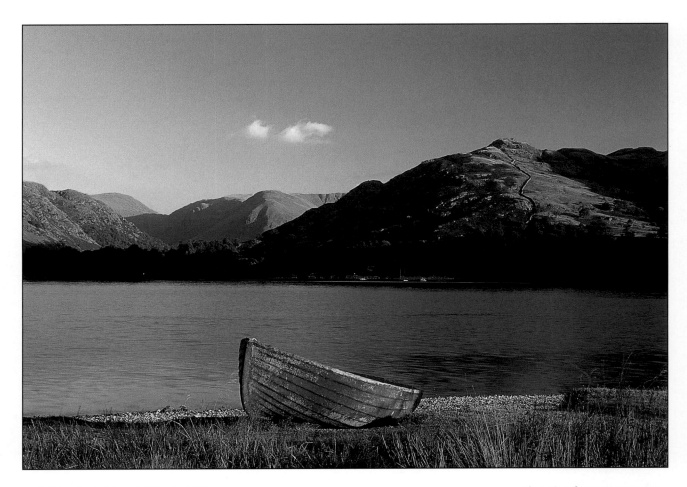

CREATING DEPTH AND SPACE

Applying the rule of thirds it is easy to create depth in a photograph. For example, placing the main subject a third of the way across the frame, i.e. one-third in from the left-hand edge, effectively places it in the foreground and depth is created by the area behind this subject. If, however, this subject is placed two-thirds across from the left-hand side the depth is created by the foreground leading up to the subject. Interestingly, for those people whose native language reads from right to left, the reverse is true.

The same principles apply to the vertical plane of the picture. Placing the horizon in the middle of the picture would at first thought be a good idea as it seems to create a balance between the areas above and below the horizon, but in fact this symmetry about the central axis has the opposite effect, making the picture look flat. Occasionally this composition can be used to convey a feeling of tranquillity in a photograph but more often than not it dramatically reduces impact. Place the horizon roughly one-third from the top of the frame to emphasise the foreground area or conversely one-third from the bottom to emphasise dramatic skies.

It is clear that balance does not mean symmetry and an equally important element of composition is the use of space to create both balance and depth. Effective use of space can add extra emphasis to the main subject, allowing it to breathe. By placing the

Changing format may mean changing position. When I changed this shot to the portrait format I moved closer to the boat and slightly to the left to pick up shadow on the other side of the keel. This change of position gave more emphasis and shape to the boat, increasing its importance within the composition. In this case the shot in the portrait format is clearly the stronger of the two.

Location: Wooden boat, Ulswater, Cumbria, England. Nikon F4, 35-70mm, Fujichrome Velvia

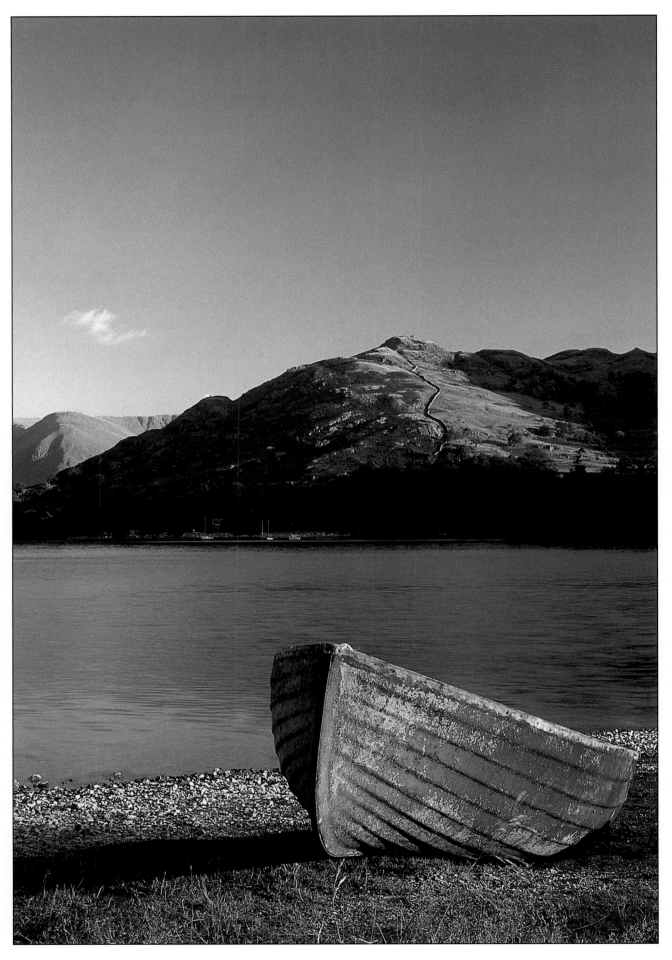

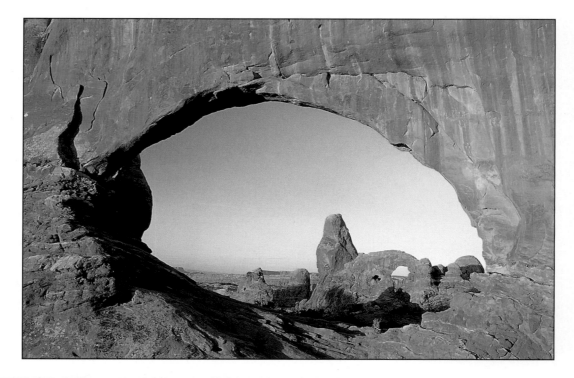

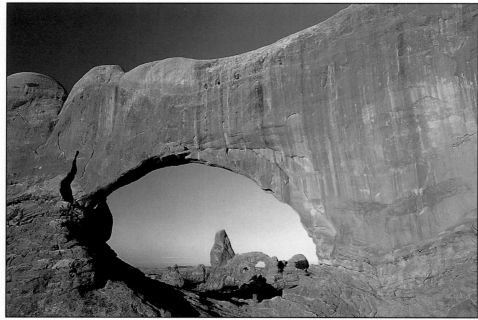

Using a natural frame is a simple and effective way of adding emphasis to a subject and removing distracting surroundings. Here I have used one arch to frame the other one. Of the two shots the one which excludes the sky above the North Window is by far the stronger image.

Location: Turret Arch through North Window, Arches National Park, Utah, USA. Nikon F4, 24mm, Fujichrome Velvia

space as if it were a secondary subject in its own right according to the rule of thirds, it complements the main subject and adds to its impact by removing any other subject which may compete with it.

PERSPECTIVE, PROPORTION AND SECONDARY SUBJECTS

Perspective is something many people find difficult to visualise. It is simply the way in which different objects relate to each other spacially. If two trees are the same height and distance from the camera they appear the same size. However if one of these two trees is twice as far away it will appear to be half the size. Because

our brain interprets this information in three dimensions we know that the tree is further away rather than the same distance but smaller. This ability to comprehend relative proportions of objects is perspective. Similarly if we move perpendicular to these two trees it appears that the tree furthest away has moved less, relative to the nearest tree. Again this is perspective.

When taking a landscape photograph it is not generally possible to arrange the elements of a picture in the conventional sense as you can with a studio still life. However, where the main subject and any secondary subjects are at different distances from the camera, relative perspective can often be used to

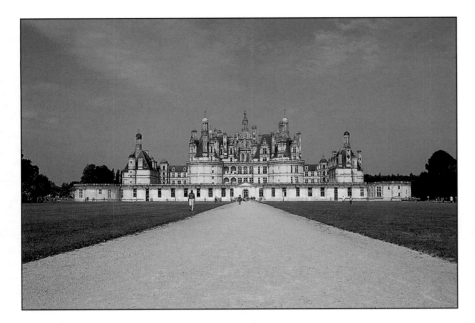

Deciding where to place the horizon is important in determining whether the subject is placed in the foreground or background of the shot. In this shot the horizon is in the middle which makes the shot look flat and uninteresting.

With the camera angled slightly downward emphasising the foreground and reducing the sky in frame, the chateau, although still the subject, is placed in the background. This adds depth to the shot but where this approach is used, it is important to include a foreground which complements the main subject. This foreground is not interesting and detracts from the shot.

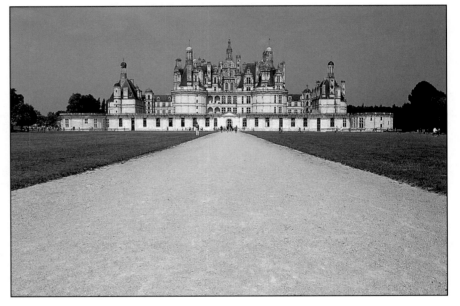

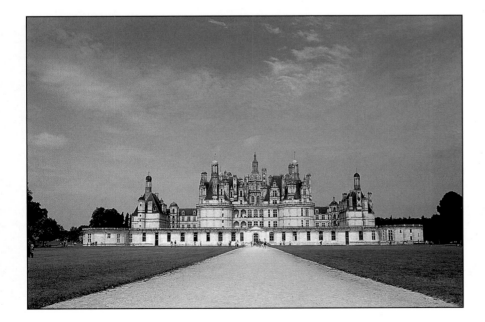

The chateau is placed in the foreground and increases the sky in the frame. This positioning works best when the sky is dramatic or the background is visible behind the subject.

Location: Chateau Chambord, Loire Valley, France. Nikon F4, 35-70mm, Fujichrome Velvia

Railway lines and roads are often used to create depth. Angling them through the frame from the bottom left hand corner is the most effective as the first shot (left) shows. Placing the railway line centrally creates depth but looks static (below). However in this case the dirt track beside the line creates extra interest.

Location: Railway line at Green River, Nevada, USA. Nikon F4, 80-200mm, Fujichrome Velvia

adjust the composition to position objects closer together, further apart, higher or lower relative to each other within the frame. Taking a photograph from a low viewpoint will raise the main subject higher within the frame relative to objects behind it and to the horizon. The subject can then be placed against the sky as opposed to a more confused background. It will, however, exaggerate the foreground so it is necessary to restore the balance to the composition by ensuring that the foreground still complements the main subject. Any element included in the foreground should contribute to the overall composition. If it does not, then leave it out. Conversely a higher viewpoint will raise the horizon within the frame. When the horizon is placed nearer to the top of the frame it will add to the composition to include visual cues and secondary subjects. This will accentuate the main subject by adding depth and perspective. Here the use of natural lines and curves to lead the eye through the foreground to the main subject are important. A line of trees, a road or railway line, or the curve of a river, if carefully placed, take the viewer through the picture influencing the way the eye scans it. These lines create a path through the frame. Generally this works best if the line or curve leads into the frame from the bottom left hand corner on a diagonal towards the main subject.

Secondary subjects introduce scale to the composition when placed at different distances from

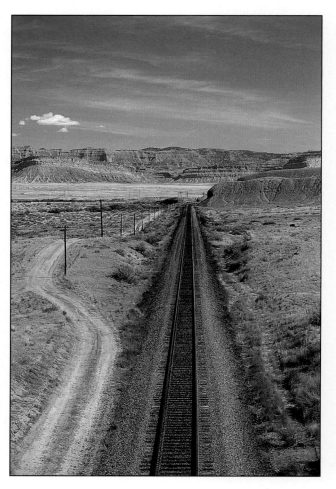

Proportion and Perspective

These four pairs of diagrams show the eye view and aerial view of each picture.

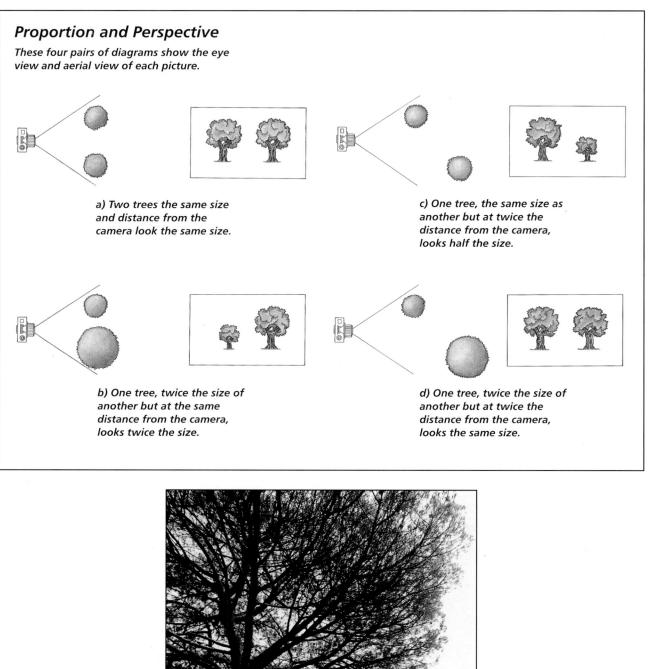

a) Two trees the same size and distance from the camera look the same size.

c) One tree, the same size as another but at twice the distance from the camera, looks half the size.

b) One tree, twice the size of another but at the same distance from the camera, looks twice the size.

d) One tree, twice the size of another but at twice the distance from the camera, looks the same size.

Although they are the same size, one tree appears bigger than the other because they are different distances from the camera. Without the cues to depth and perspective provided by the path and wall it would not be possible to determine whether these trees are the same size but different distances from the camera, or different sizes at the same distance.

Location: Ostia, Lazio, Italy. Olympus OM1N, 28mm, Ilford Pan F

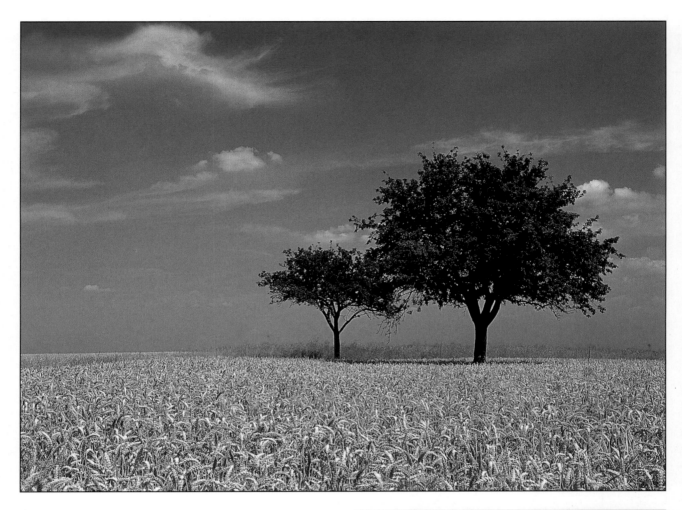

the camera. This is because the brain interprets the size of each secondary subject and, when these are different from the size it knows them to be in comparison to the main subject, it assumes that they are further away, if smaller, or nearer to the camera, if larger. However, having a secondary subject which is larger than the main subject will not lead to effective composition because it will compete directly with it. Secondary subjects which are the same size as the main one not only compete but also make the composition look flat because they remove the visual cues to perspective. Where a subject does not offer these visual cues you should look for colour and tonal contrasts to create the illusion of difference.

SIMPLICITY

A common mistake made in landscape photography is to include too much in the frame. A complex landscape can detract from the main subject. Every element of a landscape photograph should contribute to the whole. If any element doesn't then does it need to be included? The answer is no because it will create conflict and reduce the impact of the composition. Often the simplest photographs are the most effective. The landscape photographer should strive for simplicity with a clear idea of the statement each photograph is making and the mood it is trying to

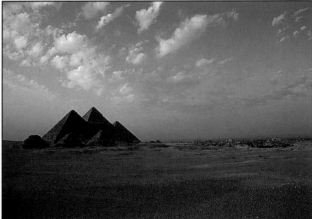

Top: This photograph is effective for its simplicity. Composition follows the rule of thirds and the elements provide contrasting textures.

Location: Hunsruck, Mosel Valley, Germany. Nikon F4, 80-200mm, Fujichrome Velvia

Above and right: The desert provides a featureless foreground for the landscape shot of the pyramids with Cairo in the background. I reframed the shot in the portrait format to exclude the foreground and city in the distance but include as much of the dramatic sky as possible.

Location: The Pyramids of Giza, Egypt. Nikon F4, 35-70mm, Fujichrome Velvia

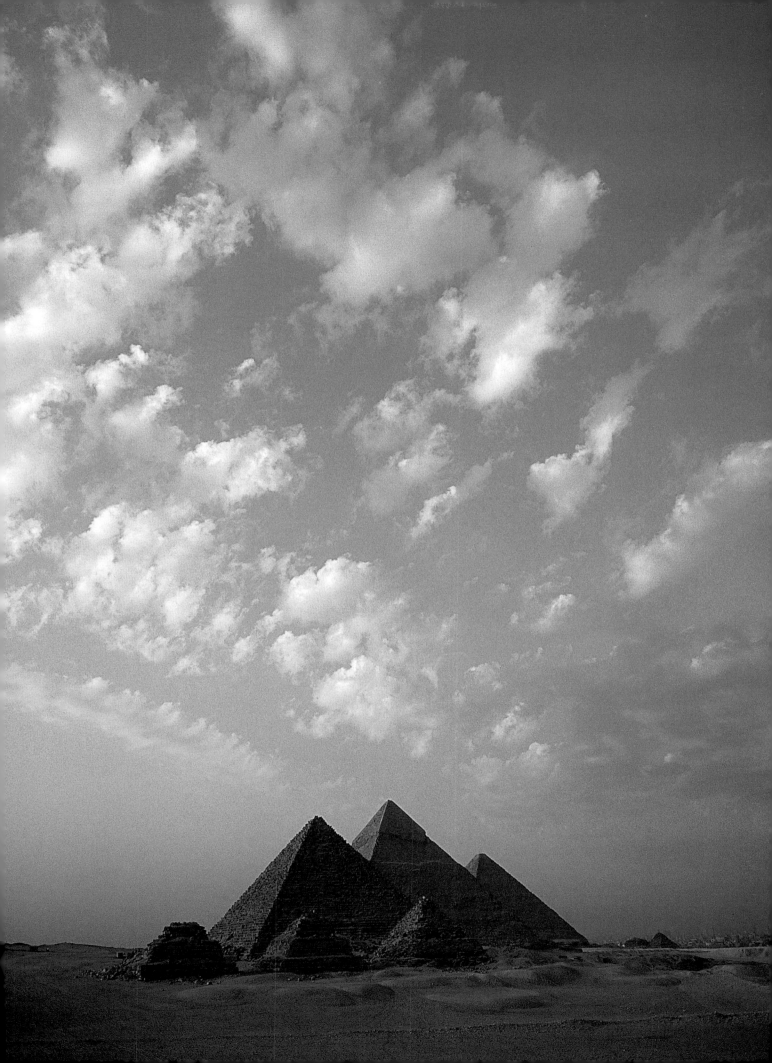

convey. If you don't know why you are taking a photograph or what that photograph is trying to convey, then don't take it!

The best photographs have an immediate impact but also offer something more of interest to draw the observer in. Composition is the key to achieving this but it should not be a constraint to your photography. Every landscape is different and the elements of composition will assume varying degrees of importance for each landscape. Use the guidance of the rule of thirds to experiment and develop your compositional skills, but don't be afraid to be creative in their use, or misuse, whilst always keeping clear your reasons for taking a particular photograph.

Composition may seem complex when you are learning and trying to consider all the elements. As you gain more experience it will become second nature, leaving you free to concentrate on the subject and creative process.

PHOTOGRAPHY MEETS GRAPHIC DESIGN

Design in photography is perhaps most evident when the principles of graphic design come into play. This is easiest to see in black and white photography where shapes, patterns, lines, tones and textures combine without the distraction of colour. These graphic elements are fundamental to graphic design and are everywhere in landscape photography. Used with

The mesa in the background acts as a secondary subject to create depth but the overall composition is poor. By placing the main subject in the centre the shot looks flat while both the area to the left and the foreground contribute nothing to a shot which should have used these unusual colours and shapes to create a strong graphic image.

Location: Blue Mesas, Petrified Forest National Park, Arizona, USA. Nikon F4, 24mm, Fujichrome Velvia

colour they can make for striking images. Sometimes they are obvious, more often it takes a keen eye to spot them and abstract them from their surroundings.

Landscape photography is at its most creative when capturing graphic forms within sharp composition. The graphic image exists on both grand and small scales. Capturing form and patterns can produce intriguing results especially where the normal visual cues to size are hidden in the design. The use of these key graphic elements in combination adds to the impact of a photograph. It is about as far from 'pretty picture' photography as landscape photography gets but can reveal some of nature's and man's most beautiful creations.

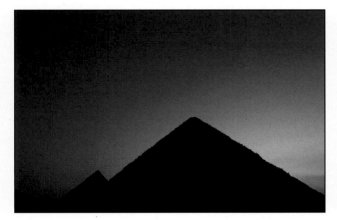

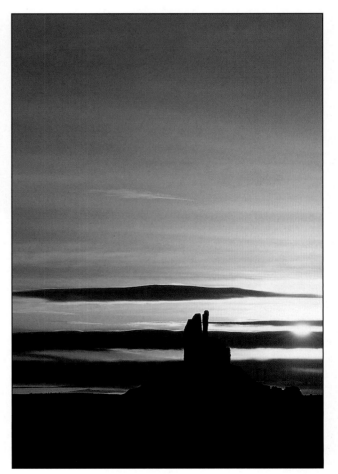

Shape, colour and tone are key elements of graphic design. The shot of the pyramids uses simple angular shapes to make strong graphic images. In the shot of the sign I used colour to provide a graphic, textured background to an otherwise uninteresting subject. Here the colours are so rich that they almost become the subject. In Monument Valley, thin bands of cloud diffuse the sun giving a gradation of tones in the sky behind the silhouetted mesa. These three elements can be used separately or in combination when designing a photograph.

Location: Top - No hunting sign, Nova Scotia, Canada.
Above - Pyramids, Giza, Egypt.
Right - Monument Valley, Utah, USA. Nikon F4, 80-200mm, Fujichrome Velvia

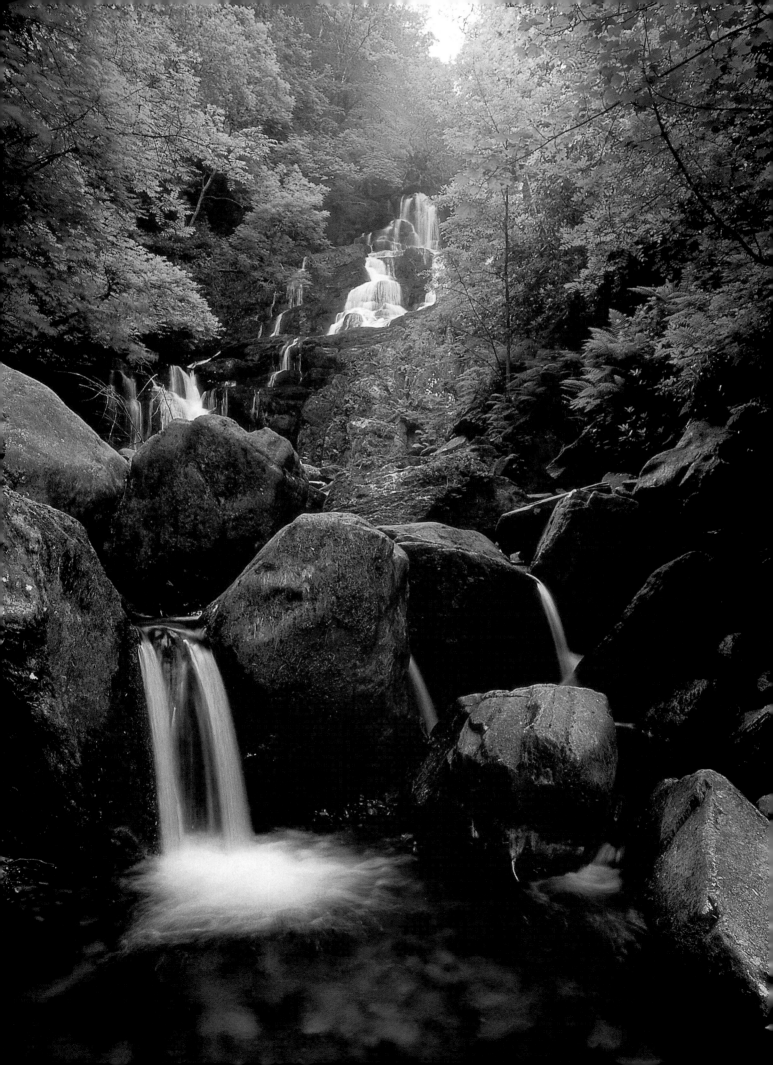

THE NATURAL LANDSCAPE

Many an avid landscape photographer has developed an interest in photography from that first scenic snap taken on holiday through the wide angle lens of a pocket camera. Nature has created a world of marvellous landscapes, mixing colours and shapes in ways which never cease to capture the imagination of the creative photographer. So how do you choose what to photograph?

Grand panoramas can be very impressive to the naked eye but capturing them on film is an altogether different thing. The hardest part of photographing a broad landscape is identifying the subject clearly yet still conveying the magnitude of the scene. Whilst the grand panorama does not necessarily make the best subject, it is a valuable tool in learning to see and compose good landscape photographs.

SEEING A PHOTOGRAPH

The first skill that every photographer must develop, having mastered the basics of technique, is how to see a photograph. Any landscape is a potential photograph, but not every landscape is worth photographing. Knowing what not to take is an important skill which comes with experience. The most common mistake is to try to include too much in a photograph. As a result wide-angle lenses are used inappropriately and the subject becomes too small, confused or lost in its surroundings.

Learning to see a photograph starts with the whole scene, the grand panorama. This panoramic view may contain any number of potential photographs or perhaps just one that works. To identify them we must break the scene up using the guidelines for composition discussed in the last chapter. The first step is to identify potential subjects. Remember that there should only be one main subject and it should be clear what that subject is. Once identified the picture can be framed around the subject. Start by dividing the frame into thirds, placing the subject along the lines of intersection. You should experiment with both portrait and landscape formats to

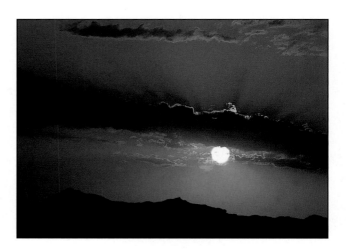

This landscape is beautiful in its simplicity. The frame is divided into thirds horizontally while the cloud has removed the glare from the sun, producing striations of light in the sky in a vertical plane.

Location: Sunset over Sinai, Egypt. Nikon F4, 80-200mm, Fujichrome Velvia

determine which is most effective for a particular subject. Hand in hand with choosing the format is the decision on how much to include in the frame. It is important to remember that everything included contributes to the overall photograph. You must also remember that the more you include, the smaller the main subject will become within that frame.

Ideally the photograph should be framed to fill the viewfinder but in practice this decision may be partly governed by your choice of lenses. If you are restricted in this way, don't worry, you can always crop the photograph after it has been processed.

An additional factor to be considered when framing a shot is to make sure that, unless you have deliberately tried to portray the subject in an abstract manner, the necessary visual cues are included to give an impression of dimension. Many landscape photographs neglect to do this and consequently look flat. Use of foreground is often the key element in creating depth but too often objects are placed in the foreground just for this purpose, with insufficient consideration given to their effect on composition. Foreground should not just be added as an afterthought. It is part of the photograph and

Texture and motion complement the depth added by the use of a wide angle lens.

Location: Torc Waterfall, Killarney, Ireland. Nikon F5, 24mm, Fujichrome Velvia

The first shot (right) is an interesting photograph but the trees divide the frame and detract from its impact. Moving lower and to the left I lost the trees. This position gave a good reflection of the mountains but lacked foreground interest until a man sat on a rock (opposite). The shot of the same lake below is almost abstract and monochrome. Shadow from passing clouds created the dappled effect on the water, giving the shot a textured feel. Although the canoe is small in the frame, the contrasting colour adds an interesting element to a strikingly simple shot which doesn't follow the normal guidelines to composition.

Location: Moraine Lake, Alberta, Canada. Nikon F4, 35-70mm, 80-200mm and 500mm mirror, Fujichrome Velvia

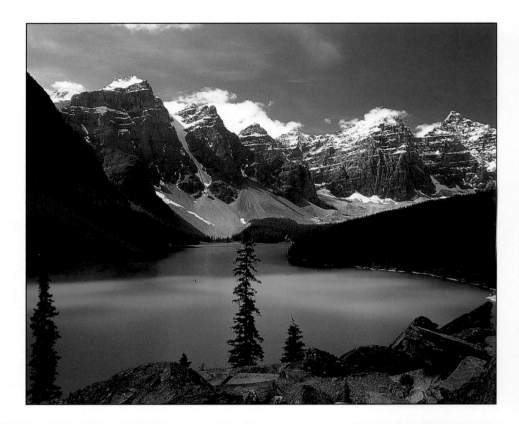

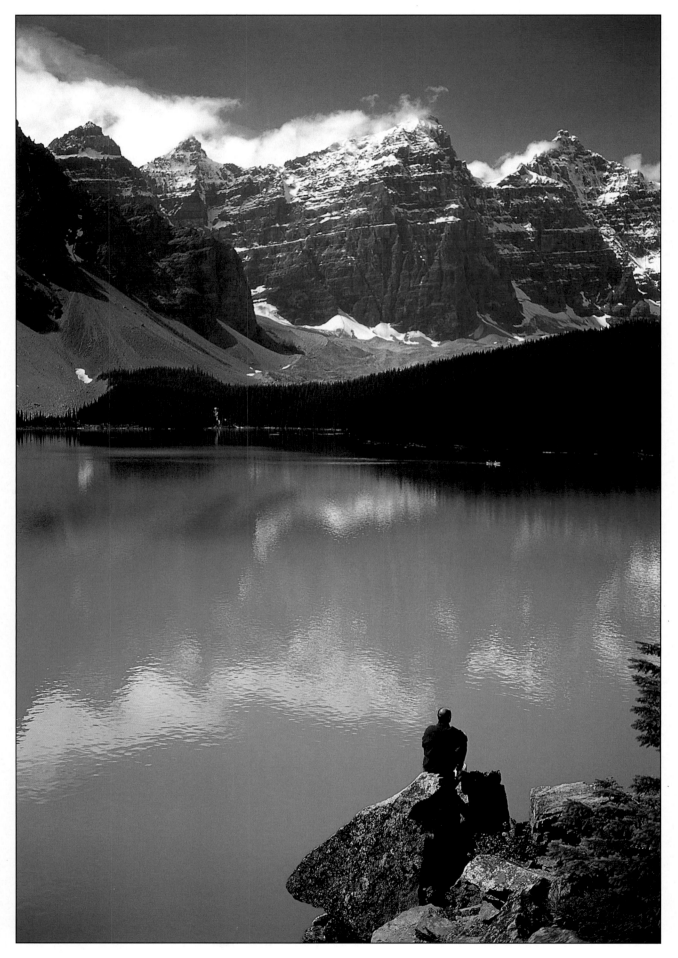

Landscape and portrait formats give two very different shots. In landscape format depth is created by the sweep of the shoreline. The foreground boats create the depth in the portrait format. Both shots work but give a different perception of the same scene. Don't be afraid to experiment with different formats and compositions when you are composing a photograph.

Location: Fishing boats at Blue Rocks, Nova Scotia, Canada. Nikon F4, 35-70mm, Fujichrome Velvia

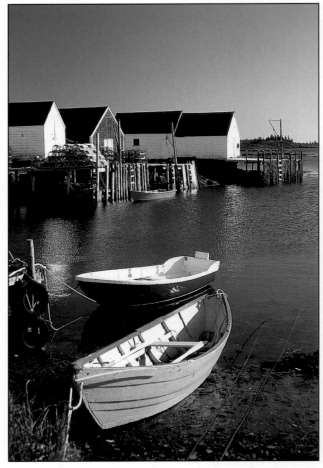

governed by the same guidelines for composition. It should be positioned to complement the rest of the photograph. Furthermore it should add depth without detracting from the main subject. In effect foreground is a secondary subject and as such can be used to create scale and perspective.

Balancing the elements of a photograph is not always easy with a natural landscape because these elements are not usually movable. However, changing viewpoint is a useful tool for adjusting the position of elements relative to each other. When you look at a scene and see a photograph also try to assess what opportunities are available to change the viewpoint. Whether this be just kneeling down or changing position completely, visualise how these viewpoint changes will alter the relative positions of the elements within the photograph.

The approach which I've just outlined may sound

Although this shot has interesting tones and textures it is flat and two dimensional. Shooting at an angle and introducing a secondary subject would add depth and scale.

Location: Car wreck, Sinai Desert, Egypt. Nikon F4, 80-200mm, Fujichrome Velvia

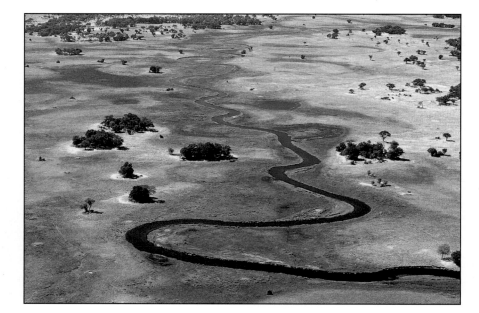

It is difficult to find a main subject when photographing panoramic views. In this aerial shot I have used the winding river as the subject.
Location: Okavango Delta, Botswana. Nikon F4, 80-200mm, Fujichrome RD100

Framing

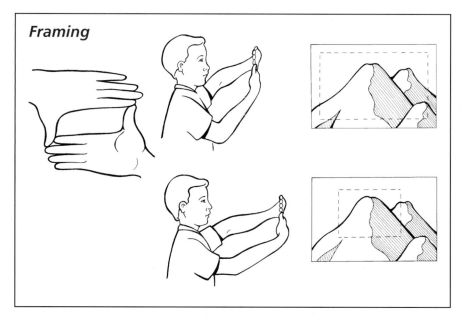

Use the thumb and index finger of each hand to make a frame. By moving it you can alter the frame content to see how this changes with different focal length lenses; close to your face for a wider angle lens, further away for a longer focal length lens.

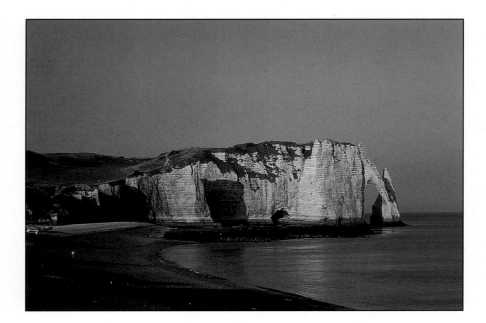

Viewpoint affects perspective. The first shot above was taken on the beach and although I have used the shape of the shoreline to create depth it is still much flatter than the shot taken from the cliffs above. The high viewpoint increases the importance of the foreground. The first shot was taken at dawn. Note how the orange light had disappeared by the time I reached the cliff top – right.

Location: White cliffs, Etretat, Normandy, France. Nikon F4, 35-70mm and 80-200mm, Fujichrome Velvia

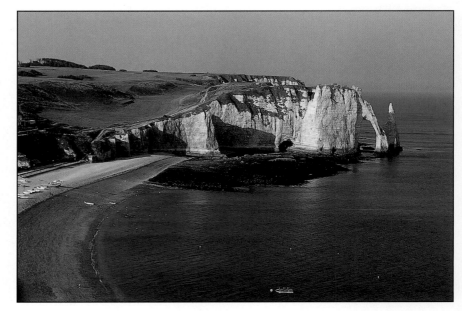

very complicated but as you grasp the basics of good composition it will become easier. The simplest way to practice seeing photographs is to do it without a camera. Go to an interesting location and stand at a good viewpoint. Now using the thumb and index finger of each hand put them together to make a frame, the thumb tip of one hand touching the index finger tip of the other hand. Now simply hold your hands out in front of you and, looking through the frame, move it around the whole scene. It is amazing how much easier it becomes to see a photograph using this simple tool and by twisting your hands through 90 degrees this frame can be used in either landscape or portrait format.

Content of the frame can also be controlled simply by moving your hands closer to or further away from your eyes, the former having the same effect as using a wider angle lens and the latter a longer focal length lens. Using this same technique the effect of

changing viewpoint can also be seen simply and quickly without having to carry a bag full of equipment or changing lenses.

Of course once you've identified the photographs you want to take you can get your camera equipment out and start shooting. When you are learning to see photographs it helps to photograph the whole scene as well, or as much of it as you can get in the frame with your widest lens. This serves as a useful reference, and you may even identify other photo opportunities when you make comparisons with the photographs you found within that panorama.

SEEING THE LIGHT

Light is the very essence of photography so understanding how it alters our perception of a scene or a subject is fundamental. Any subject can be lit in one of three ways relative to the camera position: frontlit, backlit or sidelit. The angle of illumination affects both the way in which we perceive the subject and also the exposure we give it.

Frontlighting is the least interesting direction of illumination but also the most commonly used. When starting photography you were probably told to take your pictures with the sun over your shoulder. This is direct frontlighting and produces little or no shadows. Consequently photographs look flat and two-dimensional but because all areas receive the same illumination the exposure is easy to gauge.

Backlighting is, as the name suggests, the opposite of frontlighting. Here the exposure is the critical factor in determining what the photograph looks like. The side of the subject nearest the camera will be in shadow therefore if you expose for this area the result will be a slightly washed out photograph against a brightly lit background. If, however, you expose for the background then the subject will be seen in silhouette. The extremes in contrast are obviously great between subject and background. Transparency film will pick up less than half the range of contrast recorded by the eye, so what you see is often not what you get on film. Care should also be taken to

Above: With the scene frontlit you can see detail in both the hills and the water but no shadows to create depth.
Top: With backlighting the same scene is transformed. The hill is in silhouette and *the light is reflected off the water hiding detail of the coral reefs below the surface.*

Location: Na Pali coast, Kauai, Hawaii. Nikon F4, 80-200mm, Fujichrome Velvia

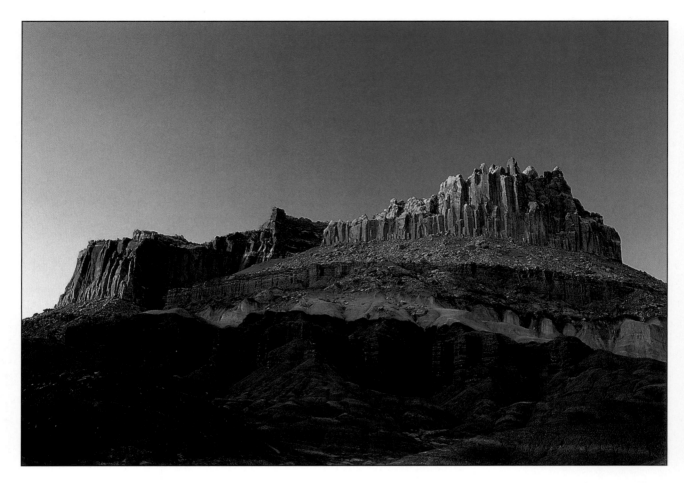

avoid flare when shooting backlit scenes.

Sidelighting produces interesting shadows, giving the subject shape, texture and a three-dimensional feel. These shadows grow in length as the light source nears the horizontal, as at sunrise and sunset when the sun is low in the sky.

Intensity of light is also an important factor in determining how a landscape will appear on film and it is this intensity, coupled with the direction of illumination, which largely determines the mood of a photograph. How light intensity affects mood will be discussed in the next chapter. In the meantime it is important to understand how the direction of light affects a landscape by observing how different a scene looks over the course of a day from sunrise to sunset.

NATURAL LANDSCAPE, NATURAL LIGHT

One of the most interesting aspects of photographing the natural landscape is that the subject is inevitably lit by natural light. Unlike studio photography the light cannot be controlled by the photographer. You are therefore, to some degree, at the mercy of nature but this presents both interesting challenges and creative opportunities.

Natural light is always changing and because of this the chances of the same lighting conditions occurring on two separate occasions are very remote. Every photograph is therefore unique. You only have to look

This shot was taken as the last sunlight caught the top of the mesa. Earlier the whole scene was sunlit but I waited for this moment to capture this band of warm light against a strong sky colour and contrasting *foreground. Try to predict how changing light will alter a landscape and wait to capture the best moment.*

Location: Capitol Reef National Park, Utah, USA. Nikon F4, 80-200mm, Fujichrome Velvia

out of the window to appreciate how the view changes with the time of day, the weather and the time of year. In practice the photographer does have some control over the landscape photograph but this is achieved by deciding whether the subject is best frontlit, backlit or sidelit, then taking the photograph from the viewpoint and at a time of day or year when the desired effect can be produced. This is not as convenient as simply moving a studio light, and even then the weather can ruin the best laid plans, but for me this adds to the excitement of landscape photography.

So how do you make the light work to your advantage? The first step is to understand how natural light changes. In the first chapter I outlined the factors that influence the quality of natural light and how it changes with time. To fully exploit these changes you need to plan your photography. Once you have decided which landscape you want to photograph you will need to determine when you

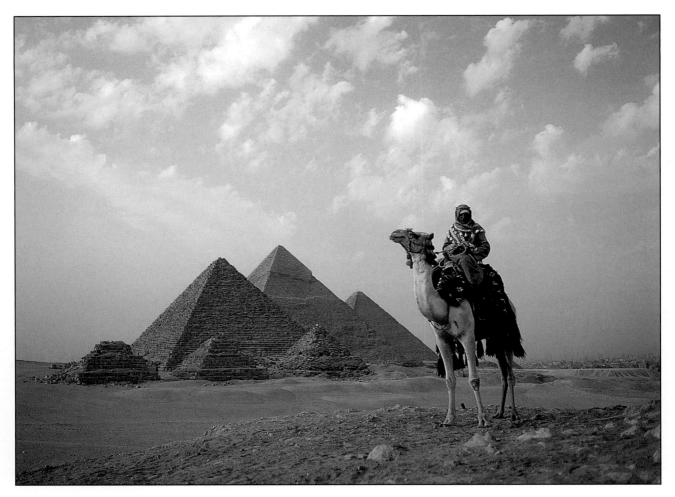

should photograph it to get the desired effect. Obviously if the chosen landscape is somewhere easily accessible you can do a reconnaissance and work out where the best viewpoint is, the orientation of the main subject and therefore whether the lighting is best early or late in the day etc. Often, however, this is not possible so a few simple measures will increase your chances of getting the photograph you want. Firstly if you are visiting your chosen landscape check a map for the orientation of the subject before you get there. This should give you an indication of the best time of day to photograph that subject. For example, if you want to photograph fishing boats in an east-facing harbour standing on the quay in the morning, the sun will backlight the boats and they will be largely in silhouette. However, later in the day the sun will be towards the west, and therefore behind you, and lighting the boats. Similarly if you are in the mountains, getting to the spot where the landscape is best lit at the right time of day may involve a hike beforehand or even an overnight camp, so planning is essential.

Nature can be unco-operative, though, even when you do plan. On several occasions I've gone somewhere at the time of day I judged to be best only to find that just as the light approached its best a shadow is thrown over the main subject by another

From this viewpoint the pyramids would not make an interesting photograph without the Arab and his camel in the foreground. I have positioned them using the rule of thirds, and at an angle to the camera to add maximum impact to the shot.

Location: Arab and camel, Pyramids, Giza, Egypt. Nikon F4, 80-200mm, Fujichrome Velvia

object. There are, of course, many subjects which are easily accessible and can be photographed both early and late in the day. Some of them have also been well photographed so getting something different can present its own challenges.

SUBJECTS IN THE NATURAL WORLD

It is all very well being able to photograph scenes but the landscape is living. Capturing the life within it, whether this be a flower in bloom, an insect, animal or bird, or even a person, gives it both vitality and context. In compositional terms these living elements are nothing more than primary or secondary subjects and as such are a means of creating depth and

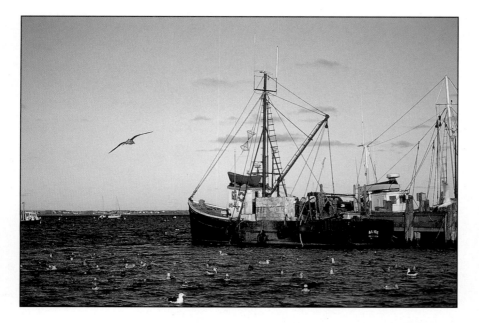

The gulls add life and movement to this shot. They act as secondary subjects creating atmosphere as well as scale.

Location: Fishing boat, Cape Cod, USA. Nikon F4, 80-200mm, Fujichrome Velvia

The woman is the subject of this landscape but it is the flowers which create the mood. The angled band of yellow and a narrow depth of field exaggerate perspective, while the vivid colour against a dark background produces a strong, graphic image.

Location: Butchart Gardens, Victoria Island, British Columbia, Canada. Nikon F4, 80-200mm, Fujichrome Velvia

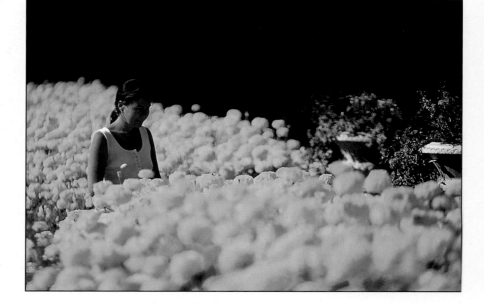

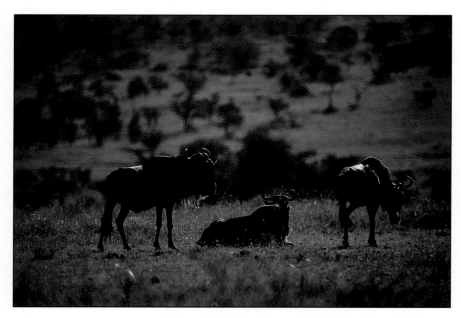

When you include wildlife in a landscape, whether as the main subject or a secondary subject, it is important to frame the shot to provide context. Without the large expanse of background it would not be possible to tell whether these animals are in the wild or in a zoo.

Location: Wildebeest on Masai Mara, Kenya. Nikon F4, 80-200mm, Fujichrome Velvia

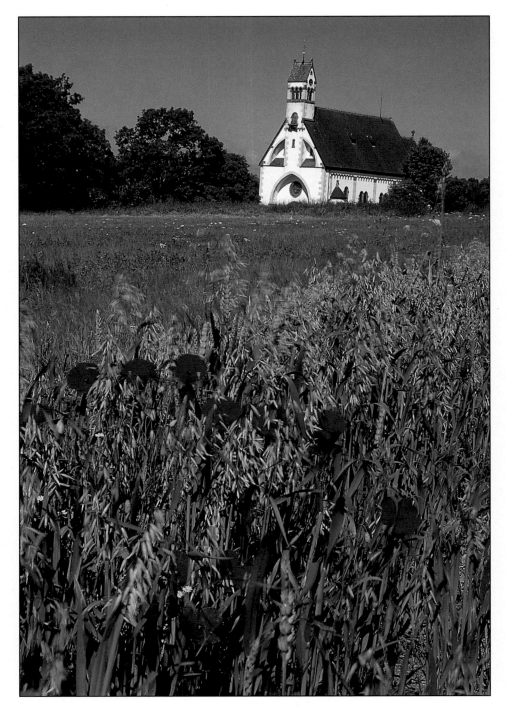

Flora, fauna or wildlife can be used to add movement to a landscape. In this shot the wind has moved the poppies and wheat in the foreground. By using an exposure of $\frac{1}{8}$ sec I have been able to capture this movement as a slight blur, adding a new dimension to this peaceful rural scene.

Location: Church in the Black Forest, Germany. Nikon F4, 35-70mm, Fujichrome Velvia

perspective. However, in visual terms they can literally make a photograph come alive.

Living subjects also offer the opportunity to include movement in a picture. The most effective approach is to use just a hint of movement. In this way a dynamic element is introduced but the subject is still clearly recognisable. The outer leaves on a tree or a foreground flower blurred slightly by movement indicate the presence of a breeze, thus capturing something which cannot be visualised in a motionless scene. Too much movement, though, and the subject becomes just a blur. If the direction of the movement is in a plane which moves towards the main subject this can be very effective, in the same way as a road

or railway line moving through a picture leads the eye from foreground to background. More often than not too much movement just looks messy and introduces a distraction into the frame.

Living subjects can also say something about the character of a scene. A mountain with a hiker in the foreground gives a feeling for the remoteness or inaccessibility of that landscape, while a person in an urban or industrial setting may give clues to the function of that landscape. In both instances the human element defines scale. It is an indicator as to the vastness or otherwise of the landscape being photographed.

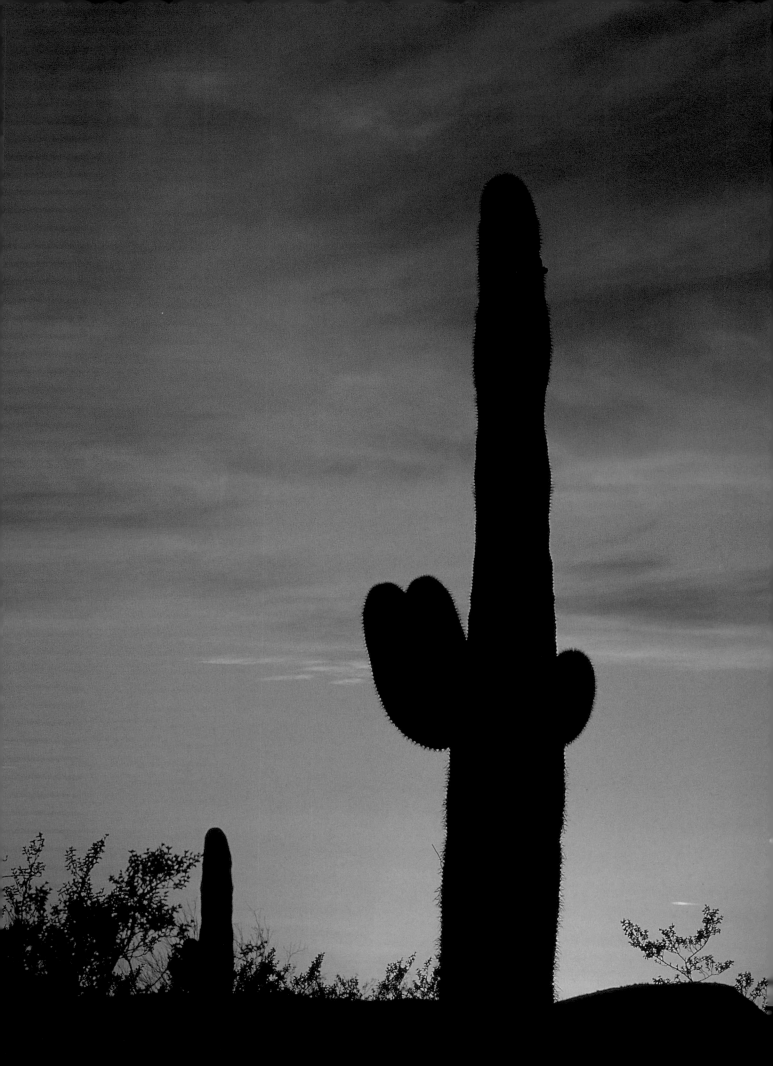

CREATING MOOD

What is it that distinguishes a truly memorable photograph from a good one? Composition alone is not enough to make a photograph memorable. To do this it must come alive, capturing the ambience of the scene, transporting the viewer into the scene itself. It is the difference between seeing and experiencing. Capturing mood in a photograph requires an understanding of how light creates depth and contrast, changing shapes, tones and colours, and capturing movement. Nature provides ever changing moods.

The ambience of a landscape may alter drastically as a single cloud masks the sun, or a stray shaft of sunlight breaks through a cloudy sky. These momentary climatic changes can be as dramatic as the difference between good and bad weather. Even without the extremes of climate the changes in light during the course of a single day can create different moods and the characteristics of film can be used to enhance the final image on film.

It is so important to remember that the natural light which illuminates our landscapes is changing all the time. From dawn to dusk both the direction and intensity of light shifts. From one season to the next the light is different. As the light changes it alters the appearance of the landscape and with this its mood. In turn our emotional response is altered. The skill of the landscape photographer is to first capture mood and then be creative in optimising the emotional response evoked by an image.

As human beings, emotion is a very important aspect of our lives. Our most memorable moments are those which produced an emotive response, be it; joy, excitement or sadness. Of course, different senses play differing roles in evoking those emotions but it is the visual aspects of an emotional response that photography must appeal to.

COLOUR

What visual cues evoke emotion? First and foremost must be colour. We use colour in every aspect of our lives from food to fabrics and decor. The colours that we choose to decorate the walls of a room have a profound effect on the mood that a room creates. For example red and pinks are warm colours whilst blues are cool. Green is a peaceful colour whilst yellow evokes happiness. Colour combination can also affect mood. Certain combinations blend well and produce comfortable feelings while others create unease.

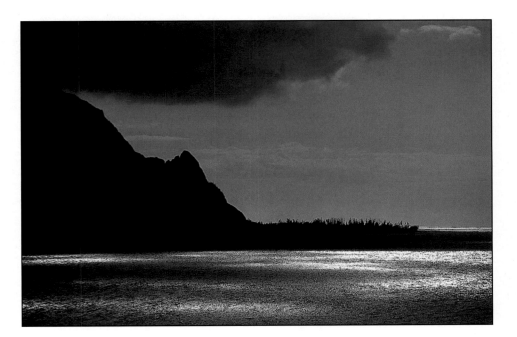

Left: Different colours create different moods. The reds and pinks of sunset are soft, warm colours.

Location: Saguaro Cactus, Arizona, USA. Nikon F4, 80-200mm, Fujichrome Velvia

Right: In bright sunshine this coastline is a band of green outlined by turquoise sea and blue sky. A single cloud transforms the scene. The coastline becomes a silhouette and sunlight reflects in patches off the water creating a silver and grey mosaic.

Location: Na Pali Coast, Kauai, Hawaii. Nikon F4, 80-200mm, Fujichrome Velvia

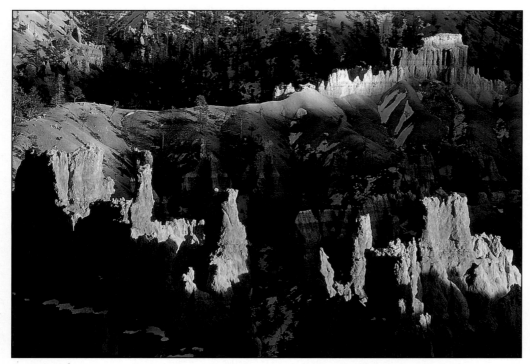

Late afternoon

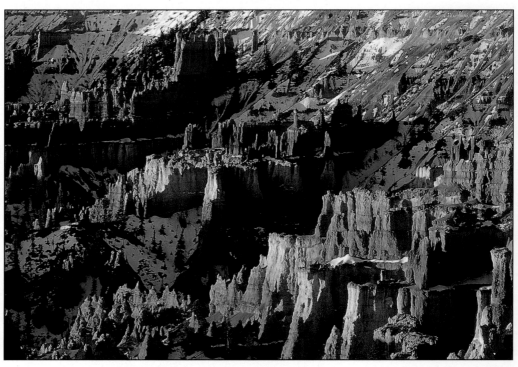

Dawn

In late afternoon, sunlight cannot reach the depths of the canyon but for a moment catches the tops of the ridges. The line of these sunlit ridges creates a path through the frame giving it depth. The mood of this shot is very different from the other two; one taken in the golden light at dawn and the other after sunset. In both shots the deeper parts of the canyon are more visible, making them more complex.

The colour of the light, though, is very different. The light at sunrise gives a warm feel even to a slightly snowy landscape. Without direct sunlight, shadows are minimal and a slightly blue hue gives the photograph a cool feel.

Location: Bryce Canyon, Utah, USA. Nikon F4, 80-200mm, Fujichrome Velvia

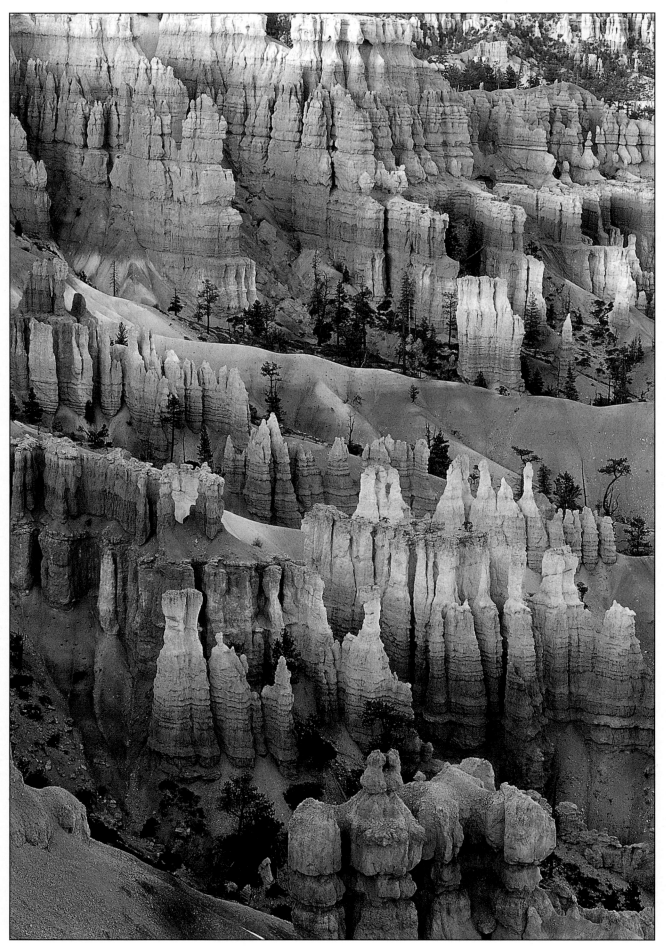

After sunset

Put two complementary colours together and they both look more intense. Indeed, the way in which we perceive colour and the effects which it has on us is a subject in its own right.

The colours that appear in nature all serve a purpose, sometimes to protect, sometimes to attract. Flowers, for example, often have colours which attract the insect that will pollinate them. Here colour is essential to survival. Nature's myriad of colour presents some startling possibilities for the landscape photographer. It is less important to know which colour evokes which emotion than it is to learn to see interesting colour combinations and patterns in the landscape. With this will come a clearer understanding of how colour adds mood to your photographs.

TONES, SHAPES AND PATTERNS

The tones in a photograph are closely linked to colour. The soft subtle tones seen just after sunset seem to blend gently with each other and the absence of harsh shadows adds to the mellow feel of photographs taken at this time. Contrast this with a shot taken in harsher light when similar tones appear almost as a single colour and strong shadows give an altogether bolder feel.

The soft pink light in the sky is reflected in the water, saturating the scene with colour. I deliberately framed the shot so that the areas in silhouette occupy only a small part of the frame. The result is a shot which is predominately pink, giving it a warm feel. The foreground is very important although it is only a minor part of the picture area. Without it the photograph would look two dimensional. In this case the centrally placed horizon adds to the tranquillity of the shot because it is essentially a static composition.

Location: Derwent Water, Cumbria, England. Nikon F4, 35-70mm, Fujichrome Velvia

Shapes and patterns also contribute to the overall mood of a photograph. It is not just the colours making up the shapes and patterns, but the way in which they meet. Sweeping curves, even in strong colours, have a softer, more fluid feel than jagged or angular patterns formed by the same colours. The effect of shape alone is more obvious where it appears in a single colour or shades of the same colour. Patterns appear everywhere in nature and have often been the inspiration for the geometric designs used in architecture and textiles. Including them in your landscape photographs can produce some intriguing images, as well as enhancing or modifying the mood.

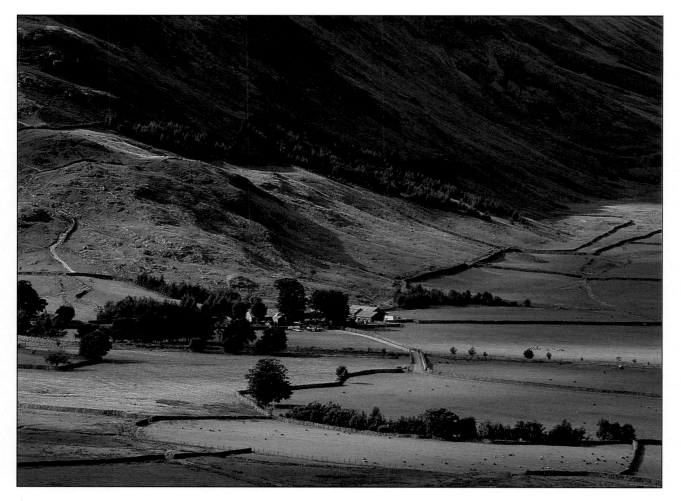

DEPTH AND PERSPECTIVE

We've already discussed the contribution of depth and perspective in terms of composition. In fact, in this instance, the same considerations apply to their effect on the mood of a photograph. Rather than creating mood in their own right it is the absence of depth and perspective which negate the mood-producing effects of colour, shape, weather etc. In other words you can have a strong moody photograph, containing both depth and perspective, but remove these two elements and the same scene will immediately lose some of its impact and moodiness.

SUNSHINE AND STORMS

So you've planned your trip to photograph a particular landscape. You get there in good time and are ready for the light. Then the weather intervenes! Of course, in some parts of the world the weather is easy to predict and the chances of getting caught out are slim but in others the weather changes by the minute and cannot be planned for. For holiday snaps good weather, meaning clear blue skies and sunshine, is a must, but for landscape photography bad weather can make for the most dramatic photographs. Bad weather can be good news for a photographer.

Clear blues skies are relatively easy to photograph

Soft side light has intensified the richness of the greens in the pastoral landscape.
Green evokes a peaceful mood and here the largely monochromatic landscape *is enhanced by the patchwork effect.*

Location: Langdale, Cumbria, England. Nikon F4, 500mm mirror, Fujichrome Velvia

but they convey little in the way of mood simply because they are a large expanse of a single colour. However, once a few fluffy white clouds appear the scene starts to take on a greater depth.

Taking it to the extreme, the same scene with a sky full of dark storm clouds has a completely different feel, an altogether more menacing mood. With clouds come additional changes in contrast as direct sunlight is diffused. This reduced contrast gives weaker shadows but can reveal subtle tones and colours which were not visible in harsher sunlight, in much the same way as the lower contrast light of dawn and dusk create soft pastel colours.

Working in a storm may be difficult and uncomfortable but the rewards can be worth it. Often the most dramatic moments are those just before the storm breaks or just as it passes when shafts of sunlight dart between the clouds. This is a good time to photograph foliage as well because precipitation tends to make the colours more vibrant, especially when a polarising filter is used.

I photographed Mt Olduvai in the very last light before darkness to get this blue silhouette. The outline of the mountain shows that it is volcanic while the shapes of the silhouetted trees suggest Africa. The mood is created by a combination of these shapes and the unusual colour.

Location: Mt Olduvai, Tanzania. Olympus OM4, 80-200mm, Fujichrome RD100

This shot is startling in its simplicity and colour. The red canoe and red clothes of the two rowers stands out against the background because of the marked contrast between two primary colours. I used Fujichrome Velvia for this shot, a film which is noted for its saturated reds and greens. Here the rich, soft-textured green background provides the perfect backdrop for a red subject. Note how I've placed the canoe so that it is travelling into the picture. This creates both depth and dynamism. I've also been lucky to capture the canoeists at the top of the stroke so that they counter balance each other and their oars don't disturb the reflection.

Location: Canoeists on Pyramid Lake, Alberta, Canada. Nikon F4, 80-200mm, Fujichrome Velvia

In late autumn, the foliage colours become muted and these soft tones complement each other. This shot was taken in the middle of the day but the pastel shades have still resulted in a subtle, tranquil photograph. A gentle breeze has caused slight movement of the foliage, giving a textured appearance.

Location: Autumn foliage and lake, Connecticut, USA. Nikon F4, 80-200mm, Fujichrome Velvia

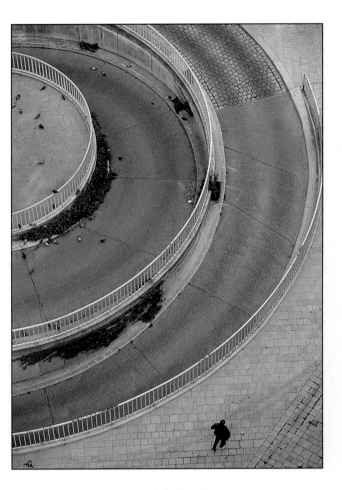

Shapes affect the mood of a photograph. Here a stark subject, the entrance to an underground car park, is softened by photographing it from above to emphasise the graphic shape formed by the sweeping curves.

Location: St Stephensplatz, Vienna, Austria. Olympus OM4, 80-210mm, Fujichrome 100RD

There are weather conditions that do nothing but frustrate the landscape photographer. The worst of these is probably the grey day. The sky is covered in a layer of cloud without definition, colours are muted and everything looks dull and flat. These conditions are to my mind worse than fog or rain, when partly shrouded objects can produce some eerie and haunting images.

A very important skill, which you should try to develop as a landscape photographer, is to try to read the weather. By this I do not mean you should know when it's going to be sunny or rainy but rather you should be aware of changing conditions. Knowing the arc of the sun through the sky will allow you to predict how a subject will be lit at a different time. Knowing the wind direction will allow you to work out where those clouds will be in 5 minutes, whether they will obscure the sunlight or add drama to a sunny scene. These are just two examples but they illustrate how important it is to be aware of the changing world around you. With landscape photography the old adage of being in the right place at the right time has added poignancy because the right place might be somewhere different in 5 minutes' time if you let the weather conditions take control.

Where sunshine and rain occur together there is usually a rainbow, the result of sunlight being refracted by the raindrops. Rainbows can add an unexpected flash of colour to a stormy scene but they are not as easy to photograph as you might imagine. For a start they are transient and no two people see the same rainbow even if they are standing next to each other. A full rainbow is often too wide to capture, even with a 24mm lens, so look for shots that include just part of the rainbow. This will enable you to use the background without it appearing small and distant. To bring out the colours I recommend under-exposing by at least $\frac{1}{2}$ stop but, if you have time, bracket your exposures. Look out for double rainbows, they are surprisingly common but even more transient. You will notice that the sequence of colours is reversed in the second rainbow.

SUNRISE AND SUNSET

That beautiful, soft orangey light at the beginning and end of the day can make for some of the most stunning and moody shots. However, many photographers experience problems when trying to take sunrise or sunset pictures. These problems arise because photographs taken at this time almost always require some exposure compensation. The compensation required depends very much on whether or not the sun is in the frame. Many photographs of sunrise or sunset are of a silhouette against a richly coloured sky and so contain two of the mood-creating elements, colour and shape.

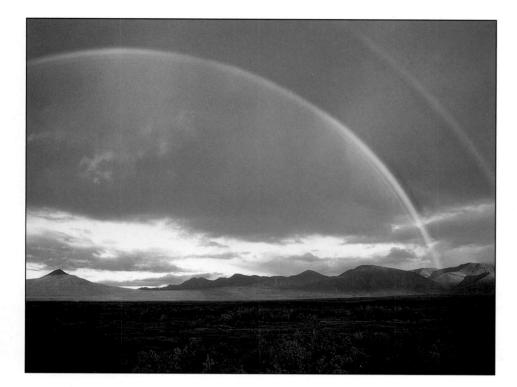

Rainbows add an interesting splash of colour but they are not easy to photograph. This rainbow was so wide that I couldn't get it all into the frame using a 24mm lens. As a result part of the rainbow is cut off in the first shot and the wide angle lens means the distant mountains are very small. Using a longer lens, I composed the second shot to include only a small section of the rainbow in the frame. This gives more intense colours. As a general rule when photographing rainbows you must underexpose the shot slightly to capture these colours.

Location: Rainbow over the Tombstone Mountains, Yukon, Canada. Nikon F4, 24mm and 80-200mm, Fujichrome Velvia

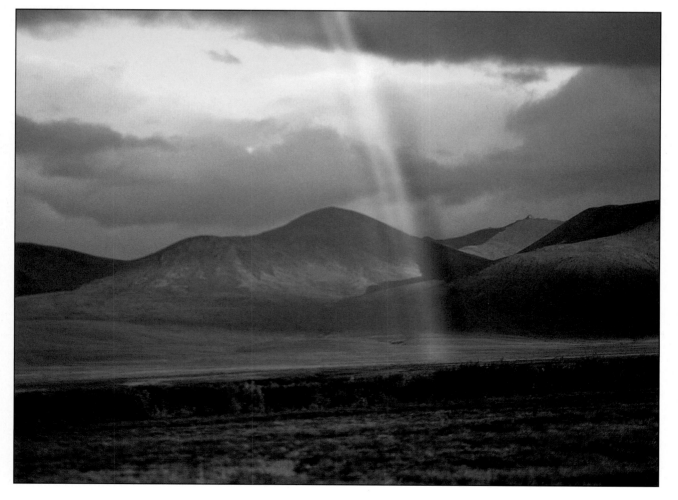

This is a pleasant silhouette of trees against a setting sun, but it is certainly not stunning. The problem, as with many silhouettes, is that it lacks depth because the line of trees are all at the same distance from the camera. The picture therefore looks flat. The only clue to perspective here is the size of the setting sun. A change in position so that the line of trees runs at an angle away from the camera would produce a more interesting shot with both depth and perspective.

Location: Trees at sunset, Surrey, England. Nikon F4, 80-200mm, Fujichrome Velvia

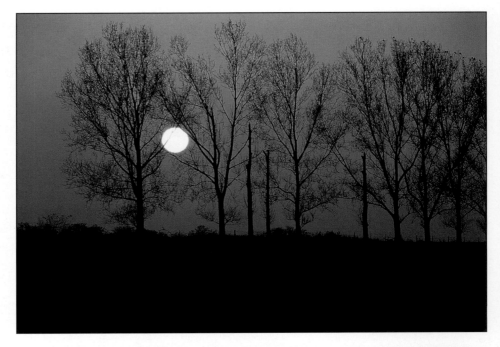

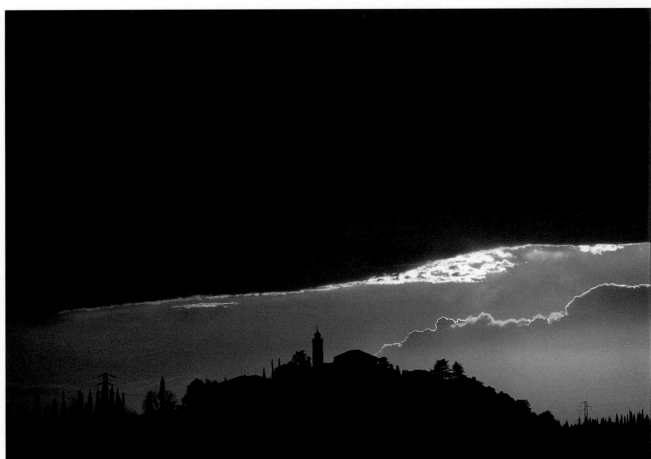

Clear blue skies produce brightly lit images but do little to create mood. The heavy, dark cloud is menacing above this village, silhouetted against the warm light of a setting sun, **and makes the shot much more dramatic and interesting.**

Location: Hilltop village near Vicenza, Italy. Olympus OM4, 80-210mm, Fujichrome 50

Early morning mist or fog can create an eerie mood to the simplest scene. Without the mist this shot would have been uninteresting but these weather conditions add a mystical dimension to a simple shot of Buddhist monks starting their daily routine.

Location: Buddhist monks at Temple, Mae Hong Son, Thailand. Olympus OM4, 80-210mm, Fujichrome 400

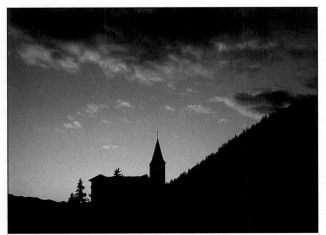

This shot was taken in an east facing valley, the sun rising behind the mountain. As a result the church is silhouetted when the sun is higher in the sky, which is already blue, although the edges of the clouds still catch the last pink light of dawn. The clouds introduce soft contrasting colour and give depth to the shot. When sunrise is lost behind a band of cloud on the horizon use a higher object, or lower viewpoint, to create a false horizon as I have done here.

Location: Davos, Switzerland. Olympus OM1N, 80-210mm, Fujichrome RD100

The mood created therefore depends on effective composition and correct exposure to get good colour saturation in the sky and a strong, clearly defined silhouette against it.

Judging the exposure is not as difficult as it seems if we take a moment to think about the subject and how the camera meters it. Just remember the camera cannot think. It does not know what it is photographing. The meter's sole purpose is to integrate all the light entering the lens and tell you the correct exposure for mid-tone grey.

So let's take the example first where the sun is in the frame. As it is a bright area of light it will dramatically affect the meter reading, therefore biasing it. If you use the camera's meter reading your picture will be underexposed. The sun, the dominant area of light in the frame, will appear exposed near to mid-tone grey and the rest of the frame will be too dark with silhouettes blending into a darkened sky. To correct for the sun's brightness you must overexpose, returning the sun's colour back towards white, lightening the sky and allowing clear definition of the the silhouette against it. I cannot give you an exact exposure compensation, as it will depend on how low, and consequently how bright, the sun is, but a good 'guestimate' would be to overexpose by one stop. This will lighten the sun and sky sufficiently but still retain a strong silhouette. The old trick of taking the meter reading from a similar area of sky without the sun at about 30 degrees to the side will produce much the same result. There are three important things to remember when you are taking photographs including the sun. First, the sun is a subject in its own right and therefore should be

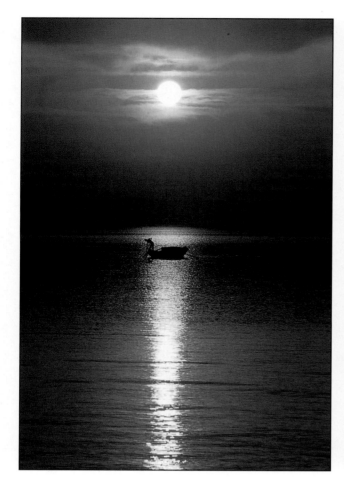

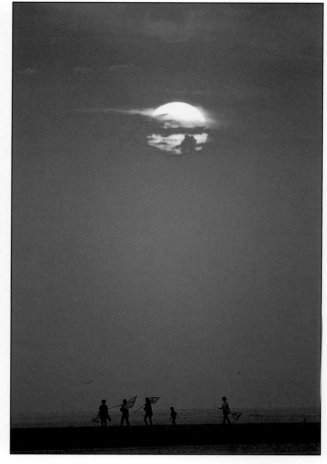

placed carefully in the frame to ensure good composition. Careless placement will affect both impact and mood. Second, including the sun in a wide-angle shot usually results in a small point of light. At sunrise and sunset a larger sun against a vivid coloured sky often has more impact so you may be constrained to using a longer focal length lens. Third, even a weaker sun at the beginning and end of the day can cause damage to your eyesight if you look at it through a lens, so keep this to a minimum. Long focal length lenses magnify the risk even more!

When the sun is not included in the frame, or is below the horizon, the exposure compensation problems are reversed. In this instance the sky will at best be similar in tone to mid-tone grey and the silhouette, especially if it is a large silhouette, will introduce a dark area into the frame. This will again bias the meter reading, but in the opposite way to the sun. The result is an overexposed photograph with loss of colour saturation in the sky and an insipid greyish silhouette. The solution is to underexpose. The degree of underexposure depends very much on the composition but the key is to decide how you want the sky to appear and meter for that. For example if you want it to appear half a stop darker than mid tone then meter the sky and compensate by this exposure increment.

The golden rule with sunrise and sunset shots is to

Above left: This sunset looks like it was easy to photograph but here I faced two problems. The first was exposure so I metered from the sky at 30 degrees to the sun and then bracketed by +/- ⅔ stop to ensure good colour saturation.
The second was caused by the sunset itself. Close to the horizon the sun sinks quickly. I wanted to silhouette the fisherman in the sun's reflection, but this reflection moved with the sun, so to get this picture I had to run along the shoreline between frames, keeping the fisherman in this position. As a result I could not use a tripod but focused on the fisherman to ensure a sharp silhouette.

Location: Fisherman in sunset, near Bodrum, Turkey. Olympus OM1N, 80-210mm, Fujichrome 50

Above right: The Normandy beaches presented different problems to photograph. I chose to photograph them at sunset to portray a peaceful place. They are a long, featureless stretch of sand so I needed to find a subject. A thick band of cloud above the horizon meant that the sun would disappear before it set. It also produced a soft, diffuse light higher in the sky. This cloud created the subtle blue and pink colours and, with the sun higher in the sky, it was not sinking quickly. When I saw the people walking up the beach I set up the camera on a tripod with a long focal length lens and waited for them to walk through the frame. Without them the shot would have lacked a focal point, a main subject. In diffuse sunlight, balanced by the large neutral area, the shot was metered as framed.

Location: Gold Beach, Normandy, France. Nikon F4, 500mm, Fujichrome Provia

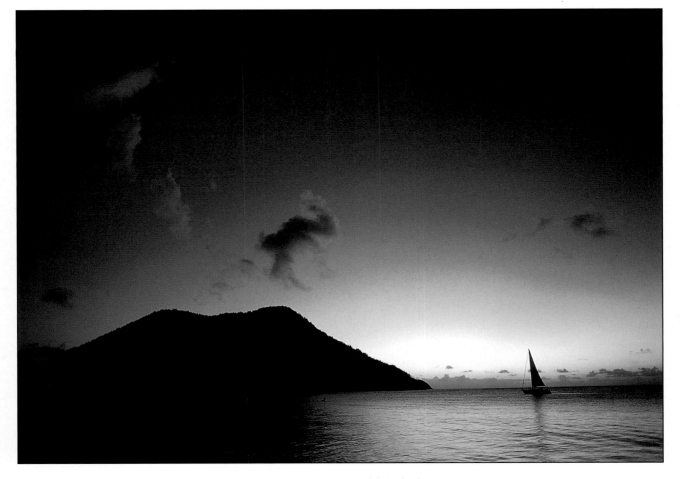

make the appropriate exposure compensation but, if you are in any doubt, then don't be afraid to bracket your exposure by $\frac{1}{2}$ or $\frac{2}{3}$ stop either side of your calculated exposure. That perfect sunset shot will be worth the few frames of film which end up in the bin.

THE LAST LIGHT

The last light is often the most beautiful light of all. Too often photographers pack up their equipment the moment that the sun disappears over the horizon. Waiting another 10 or 15 minutes, the soft, warm, diffused light will often reveal subtle colours and tones which were not apparent in direct sunlight. Silhouettes, too, can become even more striking as the sky graduates from orangey red on the horizon through yellow and magenta to an inky blue black. Sometimes a little after sunset, if climatic conditions are right, the horizon colour will momentarily turn turquoise graduating to deep indigo. Patience is an attribute which the landscape photographer needs plenty of but at this time of day it's particularly rewarded. The same considerations as for sunrise and sunset shots apply to composition and exposure. The light itself will create much of the mood so you can concentrate on composing the shot for maximum impact and exposing to maximise colour saturation around a carefully chosen shape to silhouette.

Before sunrise and after sunset the sky is graduated in tones and colours from red or yellow on the horizon through turquoise and blue to inky black. Often shots taken at these times are more striking than at sunrise and sunset. Here I wanted to capture the colour gradation in the sky. I exposed the shot for the sky, throwing the headland and yacht into silhouette.

Location: Rodney Bay, St Lucia, West Indies. Nikon F4, 24mm, Fujichrome Velvia

SILHOUETTES

For a silhouette to work it must be shot against a background which is sufficiently different in contrast to clearly define the shape of the silhouetted object. Pure silhouettes are essentially two dimensional so shape and composition are important. In the natural world silhouettes are generally shot against the sky, often at sunrise or sunset, or against light reflected from water. The exposure problems associated with this type of shot have already been covered. Sky colour will obviously be a factor in setting mood but the shape of the silhouette will also have a significant role. The same considerations apply to shape as we've already discussed; curves are softer while angular shapes give a harsher or stronger feel. Look out for interesting patterns within the silhouette. For example the branches of a palm tree can form interesting fan shapes which sweep through the photograph.

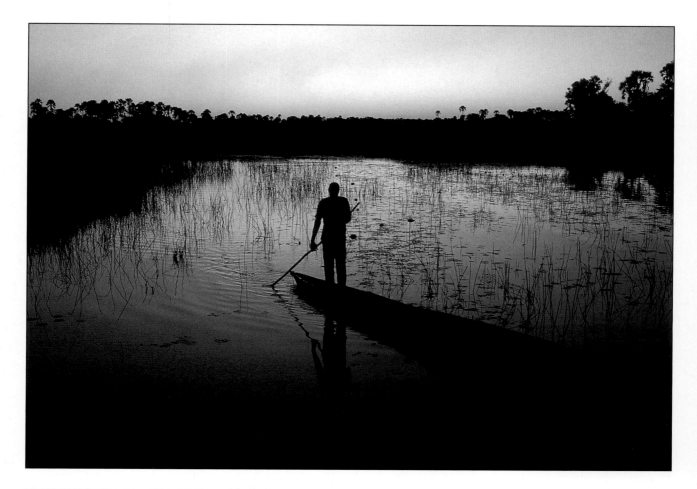

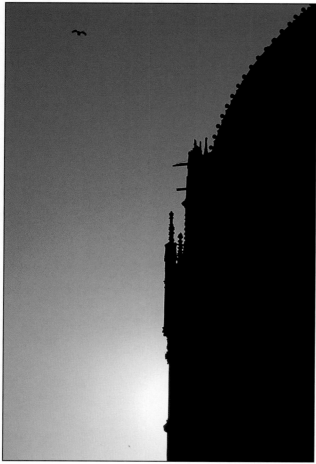

The shot of Pisa cathedral (left) was taken before sunset in warm-coloured light. The silhouette has created the graduated glow in the sky by blocking out enough of the intense sunlight to reduce the contrast between sun and surrounding sky. This has prevented the area around the sun from bleaching to white. The bird in the top left-hand corner adds scale to a two-dimensional scene. The silhouette in the other shot (above) has been used to create depth. Often silhouetted landscapes look flat but here the angle of the mokoro (native canoe) is angled to lead the eye into the picture and towards the subject. His reflection and the angle of the pole add to the dynamics of the shot without taking away the tranquillity of the silhouette.

Location: Pisa cathedral, Italy / Okavango Delta, Botswana. Olympus OM1N, 80-210mm, Fujichrome RD100 / Nikon F4, 35-70mm, Fujichrome RD100

THE MOON

The moon is a tricky subject to photograph simply because it is brighter than it appears relative to other subjects. Of course there is no problem with a moon which has risen before sunset, but in the night sky the contrast between the moon and surrounding sky is beyond the range with which film can cope. Couple this with a lack of contrast between sky and moonlit subjects and you have a recipe for a failed photograph.

There are, however, two ways to photograph the moon. As the moon rises, and while it is low on the

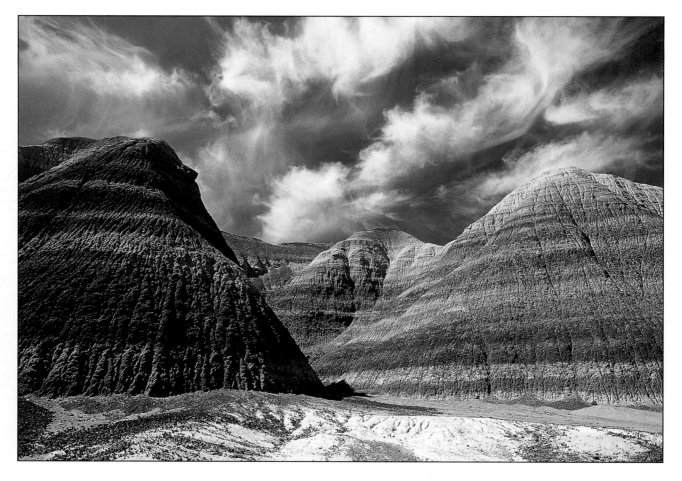

horizon, it is less intense, allowing a limited time window for photography. Exposure here is straightforward as long as you compensate for large areas of sky. If moonrise happens close to sunset there is also likely to be some residual daylight to reduce contrast between sky and moon. One note of caution though, don't photograph the moon in a landscape with a very wide angle lens as it will look very small in the frame and tends to look like a small light.

The second way is to use a double exposure. Photograph the landscape as you want it, leaving room in the composition for the moon. This will work best if the landscape is against a dark sky. Then wait for the moon to rise and take the second exposure of just the moon against the sky, positioning it in the frame where you want it to appear in the final composition. You don't have to use the same lens to shoot both exposures. Using a longer lens to shoot the moon will make it appear larger in the final photograph. The trick is not to overdo this or else your end product is a landscape with an unnaturally large moon.

There's one potential problem which you should look out for with double exposures. Always make sure that you place the moon in a position within the composition so that the light on both landscape and moon are coming from the same direction. For example, don't shoot a landscape lit from the right hand side and introduce a crescent moon lit from the

Amazing cloud formations like this disperse quickly. A polarising filter was essential for this shot because the mesas were lit by strong sunlight. The polariser cut out most of the glare, giving *better colour saturation, and increasing the contrast between sky and clouds.*

Location: Blue Mesas, Arizona, USA. Nikon F4, 24mm, Fujichrome Velvia

left as they will be illuminated from opposite directions giving a confusing image.

CLOUDSCAPES

Cloudscapes can be landscapes in their own right but more often they are the element of a photograph which makes it interesting and unique. Clouds can be used to create depth in otherwise featureless skies. They add interest, creating or altering the mood of a photograph, and should therefore be considered as a key element of any composition.

MOTION

The presence of motion adds a dynamic element to a landscape and consequently changes its mood. A tranquil shot can be transformed by a single element of movement, or movement can be used to convey a scene disturbed by the wind. Motion can be alluded to in three ways: 1) subject blur; 2) frozen movement; 3) posture of living creatures.

Subject blur creates a dynamic, fluid feel especially

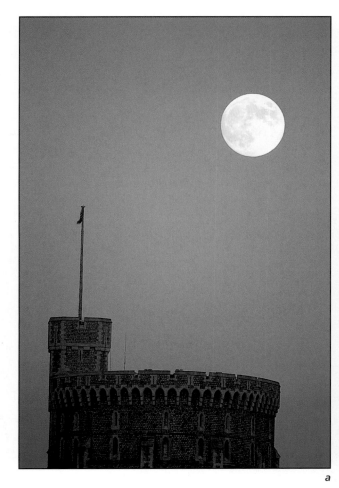

a

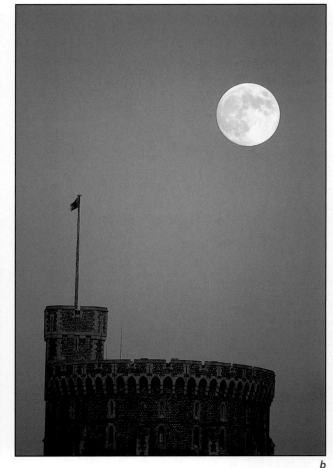

b

when angled through the frame, or a surreal dreamlike feel in the case of running water. Frozen movement must hint at a dynamic element. For example freezing the motion of a speeding vehicle only looks dynamic if the camera is panned to capture it, blurring the background. If both are frozen then it is not possible to tell whether the vehicle is moving or stationary. In contrast freezing the motion of a fluid object, such as water, still retains a dynamic element because the water is captured in a form which is only compatible with it being in motion. The same applies to living creatures. If a woman walking down the street is photographed in a position which is associated with movement, i.e. with one leg in front of the other, then she will be perceived as moving. The same shot taken with both legs near to the standing position will not convey the same dynamic qualities.

ARTIFICIAL LIGHT

There will be occasions when your landscapes include man made structures. Sometimes these will be lit by artificial light. Artificial light is not a problem in its own right although it does have a different colour temperature from daylight. Film is balanced for use in a particular light. Most film is for daylight use but some films are specifically designed for use with tungsten or fluorescent light sources. If you use a

The sequence a to d shows the problems associated with photographing the moon. Although we see detail on its surface when we look at it with the naked eye, on film the moon registers as a bright light source. So unless exposure compensation is made the surface detail is lost. The first shot in this sequence was taken at the metered exposure. Subsequent shots were under-exposed by -2/3, -1 1/3 and -2 stops respectively. With the metered exposure, definition is clearly retained in the castle but the moon is overexposed. Moving through the sequence you can clearly see that as detail appears in the moon it is lost on the castle. In the last shot the moon is correctly exposed but the castle is almost in silhouette. These shots are taken shortly after moonrise. As the moon rises higher in the sky it becomes brighter, increasing in contrast against the surrounding sky.

Location: Moonrise over Windsor Castle, England. Nikon F4, 500mm mirror, Fujichrome Velvia

Right: I saw the moon rise over the mountains in the rearview mirror as I was driving. It was rising so quickly that I knew that it would be too bright to retain surface detail within a minute or so. The shot required a long exposure (6 seconds) to capture the subtle outline of the mountains. With this exposure all but the faintest detail in the lunar surface has been lost.

Location: Moonrise over the Dachstein Mountains, Austria. Nikon F4, 80-200mm, Fujichrome Velvia

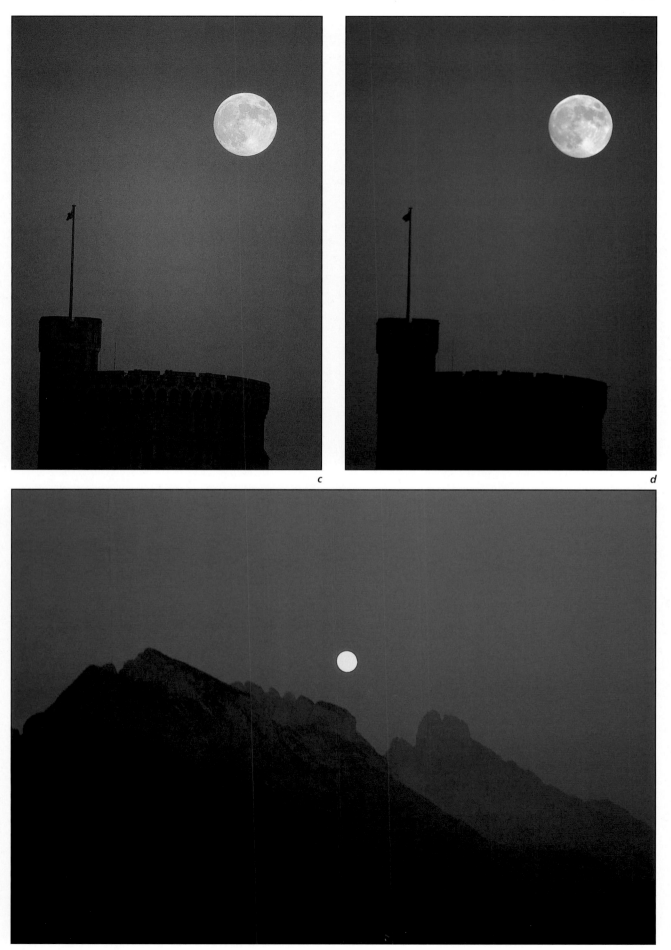

c

d

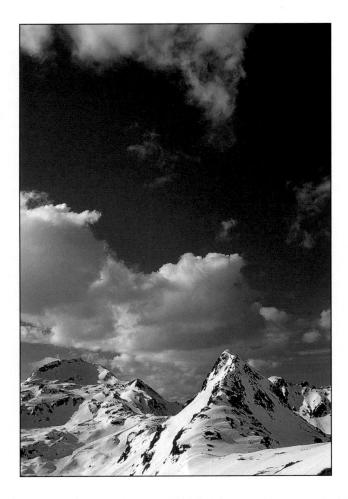

These portrait and landscape format shots of the same scene show the impact which clouds can have on composition. In landscape format the clouds are dramatic, leading the eye into the frame from the top left hand corner. However the mountain range leads the eye from the bottom right hand corner. This causes conflict and detracts from the composition. In the portrait format the line of the clouds is destroyed by placing them in the centre of the frame. The mountain range still leads the eye into the frame but the peak then lifts it upwards into the sky. The small edge of cloud at the top of the frame is important in creating depth. Without it the large area of space would detract from the composition. In the landscape shot both the mountains and the clouds compete to be the main subject whereas in the portrait the mountains are the subject and the clouds complement them.

Location: Obertauern, Austria. Nikon F4, 24mm and 35-70mm, Fujichrome Velvia

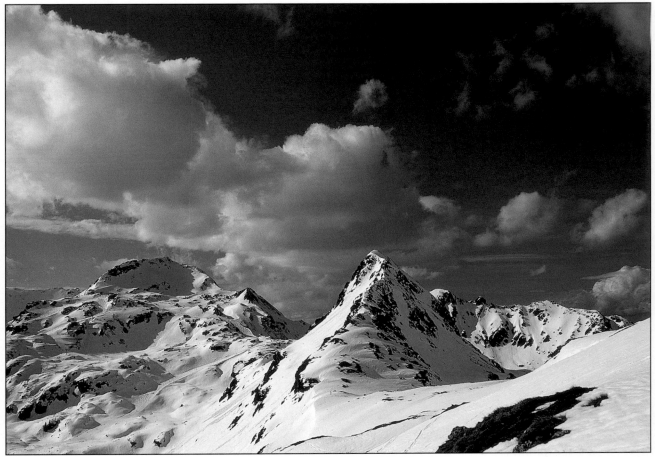

The shutter speed used in these shots is sufficient to convey a chaotic, fluid scene without blurring each moving element so much that it becomes unrecognisable. The first photograph is almost abstract because of the sheer number of flamingoes and the lack of a clearly defined main subject. In the second shot a narrow depth of field was used. This works well for the background, but the flamingoes nearest the camera are also moving, and have blurred slightly, creating the impression that the focal point is behind them. The overall effect is a shot which does not look in focus. It is important to freeze movement at the focal point when a narrow depth of field is used.

Location: Flamingoes on Lake Bogoria, Kenya.
Nikon F4, 500mm mirror, Fujichrome Velvia

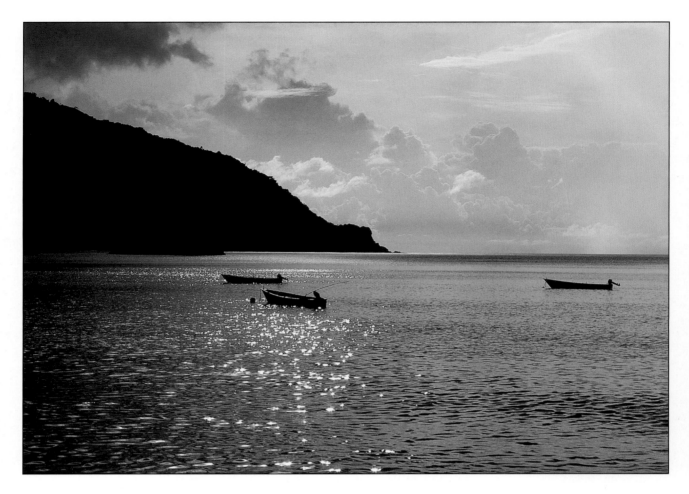

Different films have different characteristics. Ektachrome, known for its bluish hue, is ideal for photographing this landscape with muted colours. The natural starbursts result from using a small aperture.

Location: Boats in Charlotteville Harbour, Tobago. Olympus OM1N, 35-80mm, Kodak Ektachrome 100

daylight film to photograph a building illuminated by artificial light the end result will have a colour cast; green for fluorescent and orange for tungsten lights. Some of the effects achieved by doing this can be quite pleasing so it's worth experimenting.

One particularly interesting way to use these properties of light and film is to photograph illuminated buildings at dusk, when the coloured sky complements the colour cast. Combining daylight and artificial light also weakens the colour cast and produces a flatteringly soft mood for architecture.

THE CHARACTERISTICS OF FILM

Creating mood does not begin and end with nature's contribution. In choice of film the photographer has a tool which can be used to create or enhance mood. There are two key characteristics of film that can be used to this end: granularity and colour saturation. The faster the film, i.e. the higher the ASA rating, the larger the grain size. The difference between a 50 and

100 ASA film is negligible to the naked eye until the photograph is blown up very large, but the difference between 50 and 1600 ASA is immediately apparent. These faster films can be used to create a grainy image which, although it doesn't suit all subjects, can add a diffuse, yet menacing, feel to a stormy scene. This is a technique often used in black and white photography but can also be applied to colour. Faster films do, however, have less colour saturation so with a 1600 ASA film bold colours will become muted, tending towards pastel tones. Again this doesn't suit every subject but don't be afraid to experiment. If you decide to use the characteristics of faster films you may encounter problems if you intend to sell your work as stock photographs. This approach will immediately limit your potential market as most published landscape photographs are of the more documentary style using sharp definition and good colour saturation, rather than this more artistic approach.

Two shots of the same glass fronted office building illustrate dramatically the colour balance of natural and artificial lighting. Both were taken on daylight balanced film. In daylight the only light source is the sun. The glass facade reflects the sunlight and blue skies. At dusk the building is illuminated by three light sources with different colour temperatures. There is still some natural light, the pink light seen in the sky and reflected in the building facade. The outside of the building is illuminated using tungsten light, which gives a yellow/orange colour cast. The lights inside were *fluorescent, which gives a green colour cast, clearly seen in the ground floor windows. The lights in the upper floor offices are also fluorescent. Where they are turned on, the light source overwhelms the reflected daylight. Note the difference in the mood of the two pictures. In bright daylight the building looks pristine, clinical and angular. With artificial illumination and soft daylight it looks much more friendly and less functional.*

Location: Johannesburg, South Africa. Nikon F4, 24mm, Fujichrome Velvia

Colour saturation can also be used in another way to enhance mood. Most films, and especially the slower ASA rated ones, are prone to shifts in colour saturation with long exposures. Fujichrome Velvia, for example, produces highly saturated colours towards the red end of the spectrum making it useful for tonally rich sunset photographs where a scene is suited to warm pinkish hues.

Experimenting with films and pushing them to their limits can result in stunning photography. It is, however, something that's best saved until you become more confident in your creative skills. Develop a style of photography which suits you then experiment with the film medium to refine it, otherwise it is all too easy to let the film limit you instead of you controlling it.

THE URBAN LANDSCAPE

Industrialisation and the growth of population centres has made towns, cities and factories as much a part of the landscape as hills and trees. This urban landscape becomes ever more topical as awareness of environmental issues grows. Architects also often use the shapes of the natural world as the inspiration for their designs so it is not surprising that there are great images to be found in both urban and industrial scenes. The urban landscape, whether beautiful or grotesque, is usually evocative.

SEEING A PHOTOGRAPH

The principles of composition apply regardless of subject, so when photographing an urban setting there is seldom any need to adjust your technique. However, finding an urban landscape from which you can create a good landscape photograph requires a different approach to looking at the subject. When photographing the natural landscape the photograph is usually there in front of you at eye level. The same is true when shooting a city skyline, for example, but for most other urban landscapes you will usually be in the heart of the scene, surrounded by other buildings, and therefore restricted both in terms of viewpoint and working distance. The option to stand back from the subject is seldom available. This places many subjects out of direct line of view. The key to seeing good urban landscape photographs is therefore to increase your field of view. Most simply this can be done in two ways: looking upwards above street level, or finding an elevated viewpoint which gives the option to look either at eye level or downward.

As with the natural landscape, the best way to learn to see the urban scene is without a camera. Try walking down a busy street in a big city and note how many photographs you see by looking as you would normally do at the natural landscape. Now retrace your steps but this time also look up at the landscape above eye level. A whole new world begins to open up and a new skyline appears. Otherwise plain

Facades and roofs are usually the most interesting features of buildings.

Location: Roof of St Stephen's Cathedral, Vienna, Austria. Olympus OM1N, 80-210mm, Fujichrome RD100

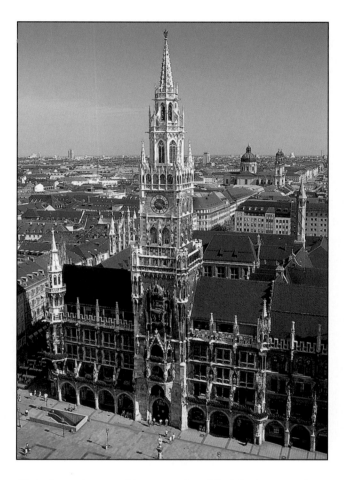

High viewpoints provide interesting views and unusual landscapes. Here the view across the rooftops puts the building into the context of the city. At street level it would have more

than filled the frame and therefore been isolated.

Location: Rathaus, Munich, Germany. Nikon F4, 35-70mm, Fujichrome Velvia

buildings at street level suddenly show glorious facades or roofs.

A major problem with urban landscape photography is deciding on the subject. The compact nature of this environment means that photographs can easily look cluttered with several secondary subjects competing for the viewer's eye. In addition power lines, street lamps and advertising hoardings are often inconveniently placed. These potential

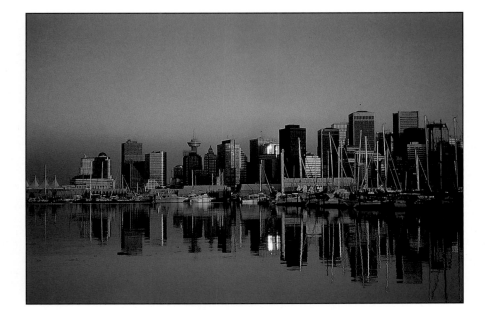

The urban landscape exhibits fascinating changes in mood with different light. Many major cities are built around water and in this shot the reflection of the skyline in the water complements the warm sunlight to give a soft, textured feel to the Vancouver skyline.
Note the warm colours in the building, and the depth and texture created by the shadows.

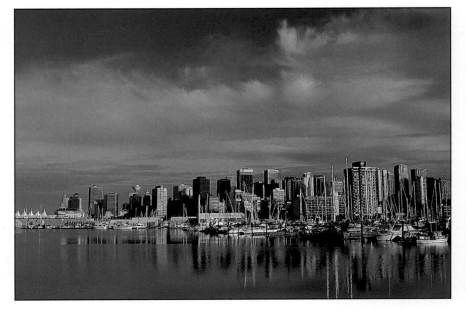

The same skyline, photographed in the middle of the day, looks much more stark with shadows almost absent. The water is also slightly rippled, breaking up the reflection. In this shot interest is added by the textured sky.

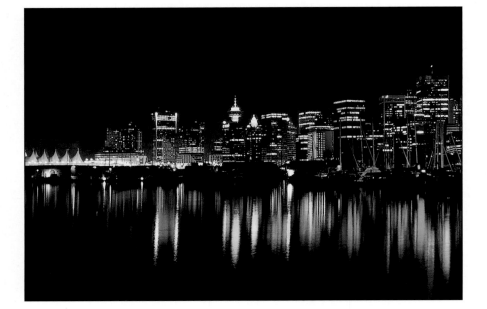

At night the skyline is transformed again. In the absence of natural light the appearance of the scene is entirely man-made. The combination of different coloured artificial lights and the stillness of the water give fascinating reflections. Within a few hours this skyline has been captured in three completely different ways.

Location: Vancouver, British Columbia, Canada. Nikon F4, 35-70mm, Fujichrome Velvia

Right: The shot of Trafalgar Square illustrates the problems of defining the main subject in a crowded environment. What is the subject of this photograph; the fountain, the statue or St Martin's Church? Three subjects compete for the attention of the viewer and the result is a confused, cluttered photograph.

Location: Trafalgar Square, London, England. Nikon F4, 35-70mm, Fujichrome Velvia

Above: The shot of Cannes harbour is also busy but it works much better. The soft lighting makes it richer in both colour and texture. Composition is also stronger with the shot divided roughly into thirds horizontally by the line of boats in the foreground and the town behind. The higher buildings add interest to the composition in a vertical plane and the clouds add depth. This shot works because it captures the mood of the harbour at dawn.

Location: Cannes Harbour, France. Nikon F4, 35-70mm, Fujichrome Velvia

Shooting upwards produces some of the more interesting urban landscapes but causes problems with convergence of verticals. In this shot I have used the steps to lead the eye into the main building.

*Location: Fontainbleu, France.
Nikon F4, 24mm,
Fujichrome Velvia*

problems all test the ingenuity of the photographer. Once the subject has been determined the composition can begin by finding a viewpoint from which the other elements build the photograph around this subject. Most photographs start at street level, but don't be confined to this viewpoint. Gaining access to a higher viewpoint may not always be obvious or easy but it is rarely impossible, and a raised elevation will often exclude a cluttered foreground and reduce the convergence of verticals caused by shooting upwards. The higher viewpoint also produces a view of an urban environment which is unseen by most of its inhabitants because they are usually at street level. The resultant photograph will therefore be a unique view of this environment.

Lens choice also dramatically changes our view of an urban landscape. In general using a wider angle lens is preferable, to give a wide enough view to put a subject in context. However, at close proximity to the subject, these lenses will cause greater distortion of perspective. Conversely telephoto lenses will compress the elements of the picture while reducing the field of view.

CONVERGENCE AND LENS CHOICE

A major problem when photographing an urban landscape is the convergence of verticals, caused by tilting the camera to photograph a tall structure at a relatively short distance from the camera. This short working distance is often a result of the physical constraints placed on the photographer by the close proximity of other buildings. In an attempt to include the whole structure a wide angle lens is often used which exacerbates this problem by increasing convergence further.

The simplest way to see this phenomenon is to put a wide angle lens on your camera and stand facing a tall building, say a church with a spire, at a distance

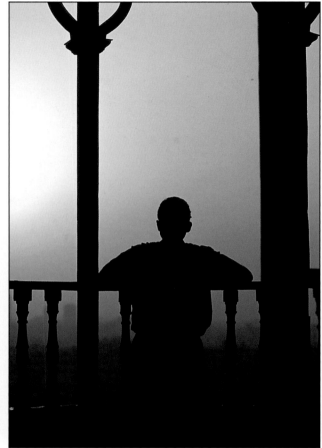

When you are learning to see a photograph within an urban environment start by using a smaller landscape. Within one simple scene I have found three photographs. The first of these three shots shows the man in the pagoda at sunset. Zooming in on this man gives an interesting silhouette with the city behind. The final shot is almost abstract. While I was taking the other shots a bird perched on the top of the pagoda so I reframed to capture it in silhouette against these strong lines.

*Location: Citadel, Cairo, Egypt.
Nikon F4, 80-200mm,
Fujichrome Provia*

where it fills the frame. Place the top of this building in the centre of the frame and note how the verticals converge towards the top of it. Now place the building off centre and in addition to the convergence see how the building appears to lean towards the middle of the frame as one vertical converges more than the other. This convergence will be greater the closer the camera is to the building and the wider the angle of the lens used.

Of course convergence can be used to create great effects, but more often than not it is a nuisance. So how can it be minimised? Using ordinary lenses this can only be done in one of three ways: 1) increasing the distance between camera and subject, which is not always possible; 2) using a longer focal length lens, which may result in exclusion of part of the subject from the frame; 3) viewing the subject

without tilting the lens upwards (or downwards), which is not often practical. An alternative is to use a shift or perspective control (PC) lens. With ordinary lenses convergence occurs because the film plane and the plane in which the subject lies are not parallel, due to the tilt of the camera. As a result, the light from the top of the subject comes from further away than at the bottom. Perspective is therefore altered, with the top of the subject appearing smaller. This creates a perception of depth, analogous to that created when one of two identical trees, at different distances from the lens, appears smaller. In this instance, because the building is a single subject, depth is perceived as the verticals tapering towards the top, the point furthest from the camera, and the building appears to lean away from the camera. PC lenses correct convergence by allowing the front lens elements to move relative to the rear ones, re-aligning the subject and film planes, and removing the need to tilt the camera. The one drawback is that the subject is distorted, appearing to be slightly elongated. The front elements of a PC lens also rotate, allowing this correction to be made even if the subject is placed off centre in both landscape or portrait formats. So why don't we all rush out and buy a PC lens? Quite simply, they are expensive so I wouldn't recommend it, unless you intend to specialise in the urban landscape.

Telephoto lenses produce two effects: they isolate subjects from their environment and compress perspective. In the shot of the mosque I used a low viewpoint. The fort is actually on a hill 200 metres above the mosque. Perspective is also compressed by shooting the buildings in Toronto head on. The glass facade of the building behind reflects the sky colour. This gives it a softer feel and enhances the contrast between it, the old building and the sky. Contrasting old with new can be an effective way of photographing an urban landscape.

Location: Toronto, Ontario, Canada / Mosque and castle, Muscat, Oman. Nikon F4, 80-200mm, Fujichrome Velvia

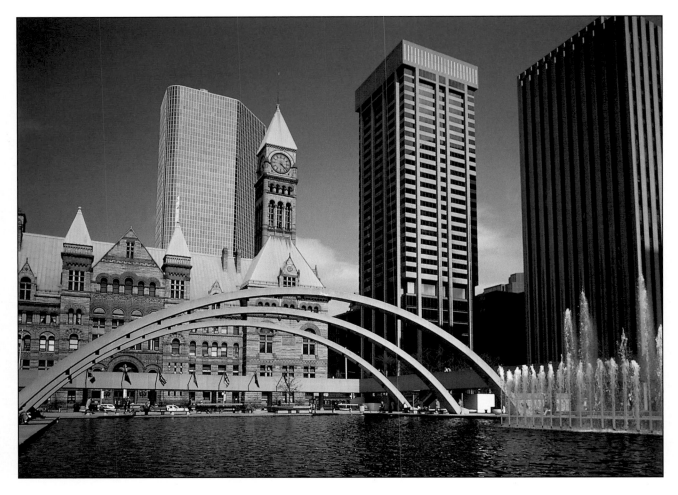

Compare this wide angle shot to the previous one taken with a telephoto. The same two buildings are present but now they are placed in a city centre context, dwarfed by other skyscrapers and set against a foreground. In the telephoto shot they were the subject. With a wide angle they become part of the scene.

Location: Toronto, Ontario, Canada. Nikon F4, 28mm, Fujichrome Velvia

CAPTURING THE URBAN LANDSCAPE

Once you have learned to look at the urban landscape in a different way, you will have to cope with the problems caused by the proximity of buildings, the effect which viewpoint has on perspective, obstructed views and complex shadows.

Close proximity is both a practical and a perspective problem. On a practical level the height of a building often far exceeds the distance that the photographer can stand back from it. This means that even with wide angle lenses it is not possible to include the whole building in the frame. In towns and cities, the streets usually run past the front of a building, this facade being designed as its most interesting aspect. Using the street it is possible to increase the distance between camera and subject by shooting at an angle along it. Although this may produce a more interesting shot than a head-on one it may also result in partial obscuring of the subject or the introduction

of unwanted elements into the frame. This is a fact of life in this environment but often these elements are not as distracting in the final photograph as they can appear at the time of composition, probably because they are in context. Second, the close proximity of objects both to each other and the camera means that a small shift in viewing position can dramatically alter their relative positions. It is therefore worth taking time to find the optimum position from which to photograph an interesting subject. In determining this position experiment with viewpoint and observe how changes in perspective alter composition, complementing or detracting from the main subject.

Similar considerations apply to obstructed views and here a common sense approach is required. If the main subject is clearly fixed then the shooting position is determined by composition and perspective first, but if it is obscured then compromise is the only solution. You must decide whether the composition is still effective from a restricted viewpoint. Each case is individual and sometimes the photograph won't work.

As if the problems of working distance, perspective and restricted views were not enough, the nature of big cities means that much of street level is in shadow for long periods of the day. This presents two problems. First, shooting at street level in direct sunlight may only be possible for a short time each

These two shots illustrate the problems of convergence which occurs when a wide angle lens is pointed upwards to photograph a large subject from a short distance. In the first shot there is slight distortion of the top of the Colosseum and the verticals appear to lean towards the centre of the frame. The CN tower is placed centrally in the frame so rather than leaning it appears to taper towards the top.

Location: Colosseum, Rome, Italy / CN Tower, Toronto, Ontario, Canada. Nikon F4, 24mm, Fujichrome Velvia

day. Second, where sunlight and shadow are mixed the contrast range between the two may be greater than the film will register. Correct exposure for sunlit buildings will then render shadows dark and lacking detail. This is exacerbated by the fact that many sunlit buildings are considerably lighter than mid-tone grey, especially where they have a high building content of reflective materials, such as glass. You might think that the answer is to use a graduated ND filter, but in cities the line of contrast between sun and shadow is seldom horizontal or uniform, such as a horizon, so this is rarely a practical option.

The solution to both problems is a mixture of compromise and careful planning of the time of day when you shoot. Early and late in the day is best suited to shooting skylines, individual buildings which are not too close to others and are orientated to catch this light, the tops of buildings or from an elevated viewpoint. While the light is softer then, the shadows

I used a PC lens for this shot to produce striking results with near perfect verticals despite the difficult angle from which it was taken. Note there is still some parallax.

Location: Parliament buildings, Ottawa, Ontario, Canada. Nikon F4, 28mm PC, Fujichrome Velvia

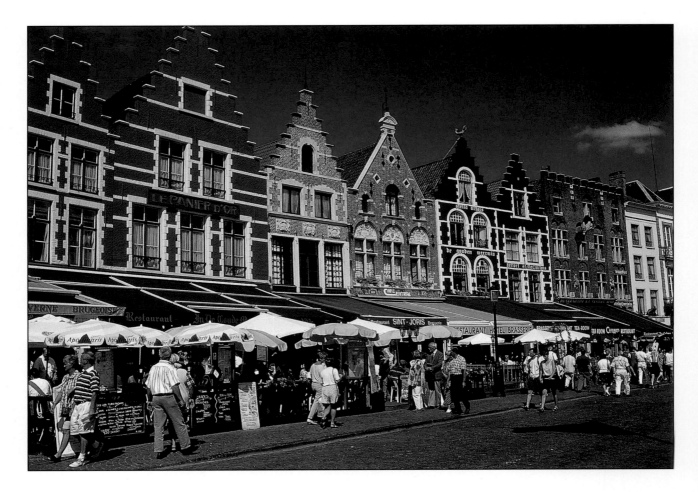

Shooting along the street rather than head on meant that I could include more in the frame. The angle along the street also uses the line of the buildings and pavement to create depth.

Location: Grand Place, Bruges, Belgium. Nikon F4, 24mm, Fujichrome Velvia

Shift lenses correct perspective by moving the front elements relative to the rear elements and film plane.

are also longer. Midday will produce the greatest contrast between sunlight and shadow, so try to avoid this. But during mid morning and mid afternoon there is enough light reaching street level but it is still not too harsh on the taller buildings. Again it's important to know the orientation of the urban landscape so that you know what time of day gives you the required light. In most American cities this is easy to work out because they are laid out on a grid system, but in many older European cities this is not the case. Even with the best planning it's not an uncommon occurrence to find that another building casts a shadow over the chosen subject just when you judged that the light would be best.

SKYLINES

Of all the urban landscapes photographing a skyline is perhaps the easiest as it is nearest to a conventional landscape. For this reason most city skylines are well photographed, and finding a new and interesting shot is a challenge. Against a clear blue sky the skyline can look two-dimensional. This is because visual cues to depth are reduced by photographing head on and from a distance. Generally a different angle just means a slightly different skyline rather than a different perspective.

There are three ways to increase the depth in a skyline photograph. The first is to take it from an

These three shots illustrate some of the options and mistakes that can be made when deciding how to frame an urban landscape. The first shot is the best one of the coal mine. The composition follows the rule of thirds but I have made the mistake of aligning the top of the chimney with the line of the hills. This has the effect of dividing up the scene. A higher viewpoint would have lowered the chimney in the frame relative to the hillside, strengthening the composition.

The second shot is taken closer to the mine increasing its prominence within the frame. Although this works well the angle does not give such a clear view of the shaft heads, which are the most distinguishing feature of a coal mine.

The final shot places the mine in context. As a result it has become a picture of a mining community rather than of the mine itself. Viewpoint has changed the emphasis of the landscape.

Location: Coal mine in the Rhondda Valley, Wales. Nikon F4, 35-70mm, Fujichrome Velvia

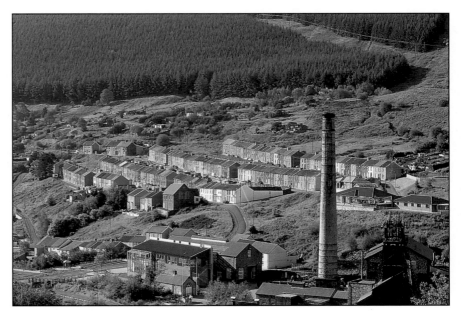

Changing the position produces only a slightly different shot of the same skyline. Although the camera has moved through almost 90 degrees, perspective is altered very little. In fact the greatest difference between these two shots is in the lighting, the sunlight giving the skyline a brighter feel and bringing out the colours of the low level buildings.

Location: Manhattan, New York, USA. Nikon F4, 80-200mm, Fujichrome Velvia

In cities high buildings produce complex shadows, with strong contrast between these shadows and sunlit buildings. The complexity usually prohibits the use of a graduated ND filter to reduce contrast. This shot illustrates the problem. At street level the shadows are heavy and much of the detail is lost, whereas in the sunlit areas the buildings are almost over-exposed. Two approaches can reduce the problem:
1) Shooting along streets which run in the same direction as the sunlight.
2) Finding a higher viewpoint to reduce foreground shadow.

Location: Chrysler Building, New York, USA. Nikon F4, 35-70mm, Fujichrome Velvia

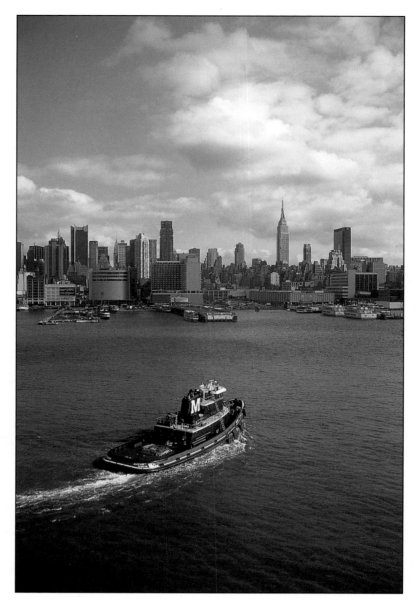

A cruise ship provided a slightly elevated viewpoint for these skyline shots from the middle of the harbour. In the landscape format the tug boat adds foreground interest but the scene looks flat because it is moving in the same plane as the skyline, perpendicular to the camera. Contrast this with the portrait format shot. The tug is moving at an angle through the frame. This angled movement leads the eye from the foreground towards the skyline, creating depth and dynamism.

Location: Manhattan, New York, USA. Nikon F4, 35-70mm, Fujichrome Velvia

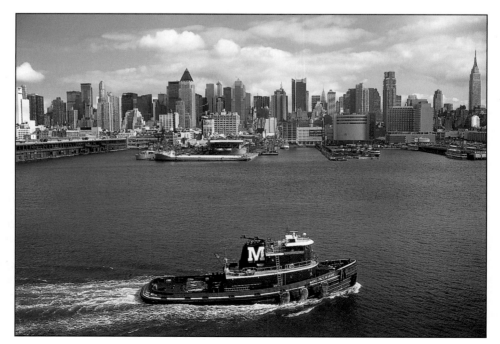

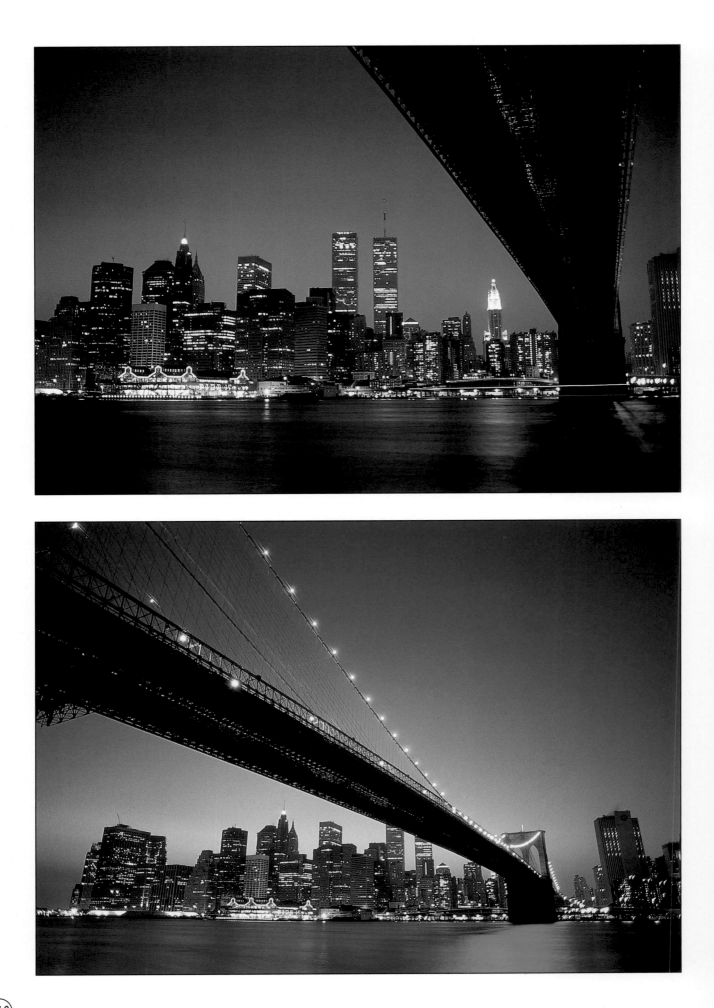

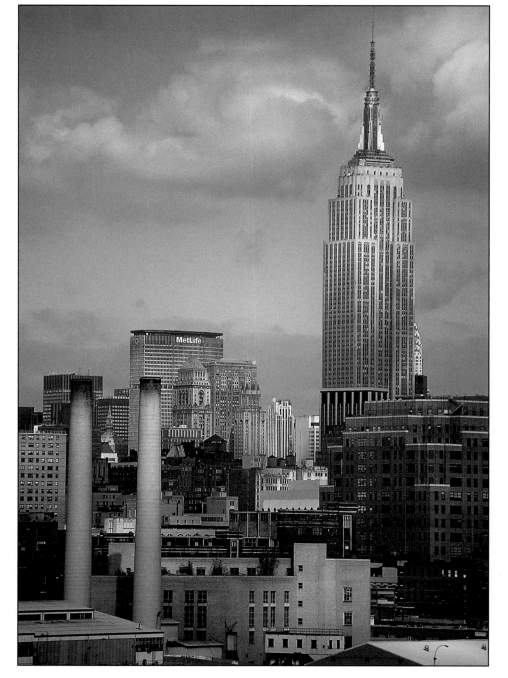

Left: Roads, rivers and bridges can be used to create depth in two dimensional skylines by leading the eye through the frame. In the first shot the Brooklyn Bridge does this from the top of the frame. In the second shot the diagonal angle of the bridge creates greater depth and I have also used it to frame the skyline.

Location: Brooklyn Bridge, New York, USA. Nikon F4, 35-70mm and 24mm, Fujichrome Provia

Right: Urban and industrial landscapes are never far apart and using one as a foreground for the other can produce unusual shots. Manhattan is usually portrayed as gleaming high rise towers but the west side is the old port area. I photographed the old warehouses and factory chimneys as a foreground for New York's most famous landmark. The partly diffuse light and smog have contributed to an unusual and slightly surreal view of the city.

Location: The Empire State Building, Manhattan, New York, USA. Nikon F4, 80-200mm, Fujichrome Velvia

elevated position, making the roofs and facades of lower buildings more visible, both in front of and between the taller ones. This will give the scene a layered effect and therefore greater depth. The second is to do the opposite. A low viewpoint closer to the skyline will introduce a small amount of convergence, especially with a wider angle lens, but is a good example of how a little convergence can be used to enhance a photograph. Remember though that the closer you get to the skyline, the fewer buildings will be visible. A problem with the latter approach is that many of the most impressive city skylines front on to water. This is usually restrictive. The shot must be taken from either the near shoreline, which is usually too close to capture the whole skyline, or from the far shore. This may be too distant without a long lens which in turn will compress perspective. The best viewpoint is then found in the middle of the harbour or river, causing problems both with access and then camera movement. The third approach is to use a feature of the landscape to lead the eye through the picture, creating the depth from foreground to the skyline. A good example of this is to use a bridge, although a river or road may work just as well, angled across the frame from the bottom corner. Where it is possible to reach the shoreline below the bridge it can be used to frame the skyline by shooting up through it from underneath.

Sunny days in cities can create problems with smog and heat haze. Both will cause a photograph to look

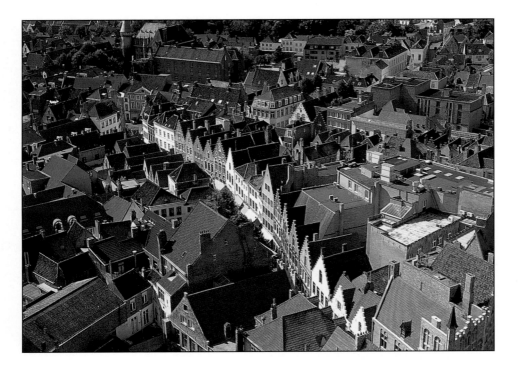

From a high viewpoint the shadows add texture and depth, emphasising the sweep of the road through the frame. From a low viewpoint clouds can be used to achieve a similar effect.

Location: Bruges, Belgium. Nikon F90X, 80-200mm, Fujichrome Velvia

washed out, especially where the colours of buildings are light or similar to each other. A UV or polarising filter will reduce this effect but the only real solutions are to reduce the camera-to-subject distance as much as possible and shoot early in the day before the haze or smog intensifies. Clouds can play an important part in creating depth in a skyline photograph. A sunny day with a few fluffy white clouds in the sky adds depth, funnelling the eye from the top of the photograph into the skyline. They should be considered as a key element of composition.

There are two times of day when skyline shots take on a mood and subtlety usually only seen in the natural world. The first is obviously in the soft light of sunrise or sunset when buildings catch the warm orangey light and seem to glow. At this time depth is also added by the long shadows cast by a sun low on the horizon. For the second the photographer needs to change position so that the sun is behind the skyline. At dusk when the sun has set but there is still an afterglow in the sky, the city at night rapidly comes to life with artificial illumination. For a few minutes at this time the graduated colours in the sky create depth and complement the silhouetted outline of the artificially lit buildings. This extra light also allows relatively short exposures, reducing the problems of reciprocity failure and exposure compensation, experienced when longer exposures are needed to silhouette the same skyline against a night sky. This time of day is one which is frequently ignored. So often I have seen photographers pack up their equipment as soon as the sun sets when waiting a few minutes longer gives the most amazing gradations of colours in the sky.

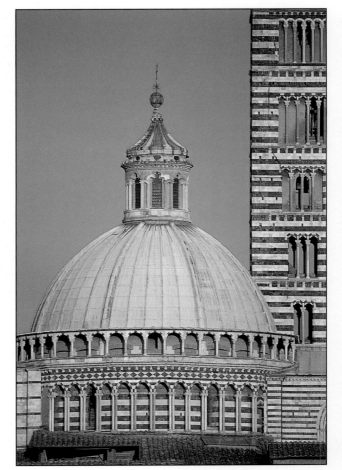

A long lens abstracts a subject from its surroundings. Tight cropping around the tower and dome of the cathedral emphasise the texture and pattern created by the two coloured marble.

Location: Il Duomo, Sienna, Italy. Nikon F5, 500mm, Fujichrome Velvia

A slightly elevated view adds depth to a landscape. From another building both the courtyard and the mountains behind the monastery are visible, creating a layered effect with foreground, subject and background.

Location: St Anthony's Monastery, Red Sea Coast, Egypt. Nikon F4, 35-70mm, Fujichrome Velvia

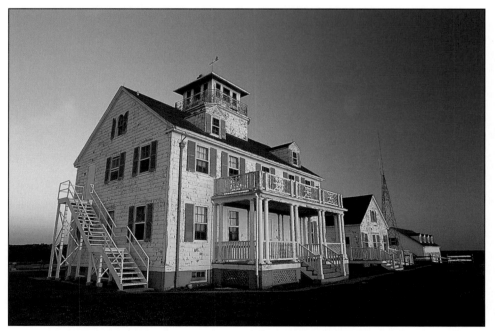

When the sun is low in the sky, shadows can create problems with urban landscapes. This isolated coastguard building was perched on top of a hill. As a result it is directly lit by the rising sun, capturing the orange glow on the white panelling. Note how the contrasting shadows give the shot depth.

Location: Cape Cod, USA. Nikon F4, 24mm, Fujichrome Velvia

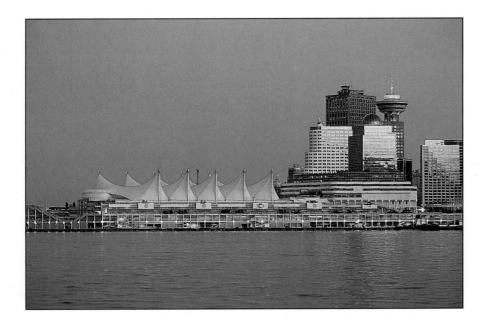

At dusk, urban landscapes are transformed by artificial light. This sequence shows how the mood and colour of a scene changes. The first shot was taken at sunset and is almost entirely lit by a pinkish natural light.

Ten minutes later, with the last natural light disappearing, the buildings are lit by artificial lights, producing a colour cast on the daylight balanced film.

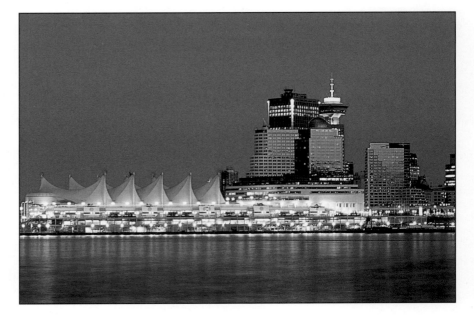

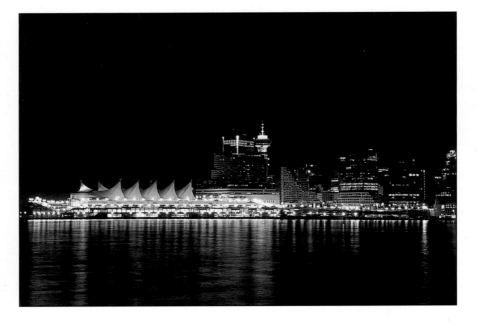

After dark the only light source is artificial light. Note the different colour casts produced by different colour-balanced light sources. Many of the buildings lose definition against the sky unless their outer edges are lit, reducing the impact of the skyline. I have deliberately zoomed out in the last shot to increase the skyline and its reflections, adding more light to the scene.

Location: Vancouver, British Columbia, Canada. Nikon F4, 80-200mm, Fujichrome Velvia

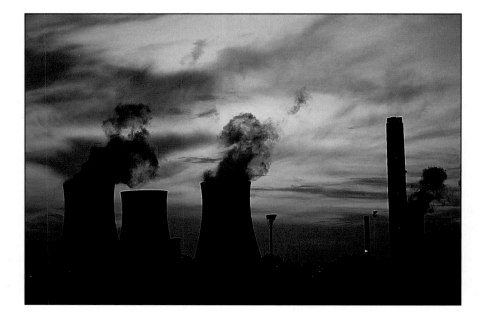

Light changes rapidly at dawn and dusk as these two photographs, taken 10 minutes apart, clearly show. In the first shot the silhouette of an otherwise ugly building looks dramatic against the sunset. The emissions from the giant chimneys are the same colour as the clouds, which reduces the perception of pollution.

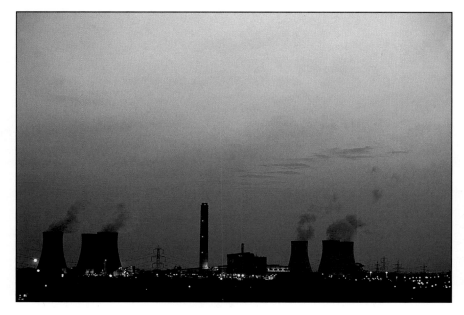

In the second shot the power station is silhouetted against the soft pinks and blues of the dusk sky. I used a wider angle lens to increase the sky area and introduce as much softly coloured light as possible.

Location: Didcot Power Station, Oxfordshire, England. Nikon F4, 500mm mirror and 80-200mm, Fujichrome Velvia

BEYOND CITYSCAPES

Urban landscapes go beyond cities and towns to include the industrial. Here photographic styles diverge to reflect either the harsh, often grotesque, character of industry associated with urban decay and pollution or an altogether more romanticised picture which seems to complement the surrounding natural environment. Both the shapes of structures, and how we choose to emphasise or de-emphasise them, play a large part in determining the category into which any particular photograph falls. The area in the middle is simply documentary photography.

Whichever approach you favour, or to which a particular industrial landscape best lends itself, the principles of composition apply just as in the natural world. Vivid colours and angular shapes create a much more confrontational image than curves and soft pastel hues. Many photographers choose black and white film when shooting a harsh industrial environment because shapes and tones, without the distraction of colour, can be more effectively used to accentuate either discord between something man made and the natural environment, or our perception of what is ugly or attractive. The colour medium should not be neglected though, because there are powerful associations between certain colours and decay or age, for example, rust.

The more environmentally friendly style of industrial photography is best suited to the softer light at either end of the day. These are not easy photographs to take because industrial sites are designed to be functional rather than aesthetically pleasing. It is worth considering techniques which reduce the impact of the structure beyond the obvious ones of composition. For example, the use of a faster film, which has less colour saturation and is more grainy, produces a much softer image. Filters have a roll to

Harsh industrial landscapes can be portrayed in a softer manner by photographing them as silhouettes. There is very little that is attractive about an oil well, so I shot this one against a setting sun. I under-exposed by -1 stop to darken the sky, and keep rich colour in the sun and the well-head flame.

Location: Oil well in the desert, Dubai. Nikon F4, 500mm mirror, Fujichrome Velvia

Above: The shape of the telecommunication satellite dishes lends itself to a silhouette shot. I used two dishes, pointing in different directions, as a main and secondary subject. Both the angle and the relative size of these two dishes add depth to an otherwise two-dimensional shot.

Location: Telecommunications Dishes, Oxfordshire, England. Nikon F4, 24mm, Fujichrome Velvia

Right: Most industrial landscapes lack colour which tends to make them look less attractive. Colour can be introduced either by photographing in soft light, or by using a coloured background or foreground. In this shot I used a field of sunflowers to add colour and to create a more environmentally friendly image of the mine.

Location: Assisi, Italy. Olympus OM1N, 80-210mm, Fujichrome RD100

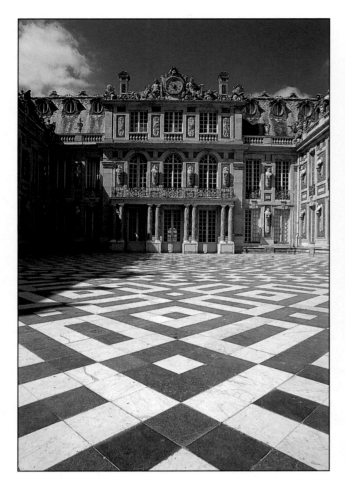

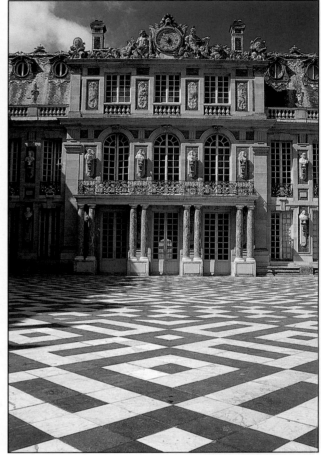

Warm up filters are often used to photograph urban landscapes as buildings can appear dull and cold. One shot (above right) was taken with an 81a filter. Contrast this with the other shot (above left) and the *effect of the filter can be clearly seen, especially in the white areas.*

Location: Palais de Versailles, France. Nikon F4, 35-70mm, Fujichrome Velvia, 81a filter

play here too; an 81a, b or c filter will warm up a scene while a light fog or mist filter will soften it dramatically. It's worth experimenting with all these options just to see the effect that they have, both individually and in combination.

DETAIL IN ARCHITECTURE

Within the obvious urban landscape is a world which is much less photographed. We all too often take the buildings around us for granted without looking closely at the architecture. Consequently we miss a plethora of photographic detail which can form interesting foregrounds to our pictures or photographs in their own right. Look closely at the buildings which you choose to photograph and these photo opportunities will begin to appear, sometimes to complement the main subject and sometimes juxtaposed, as in the old contrasting with the new. Architectural detail extends beyond the obvious building facades to include the less obvious: railings or

Right: This is more than a photograph of a flag. Look closely at the background and you will see that it is made of glass. The brickwork, the typical brownstone of New York, is a reflection. So in one photograph I have captured two contrasting elements of the architecture.

Location: 5th Ave, New York, USA. Nikon F4, 80-200mm, Fujichrome Velvia

Above: Night shots require long exposures, so motion shows up as moving light. In this shot an exposure of 20 sec was required to correctly expose the Colosseum. This resulted in the headlights recording as streaks of light.

Location: Colosseum, Rome, Italy. Nikon F4, 80-200mm, Fujichrome Velvia

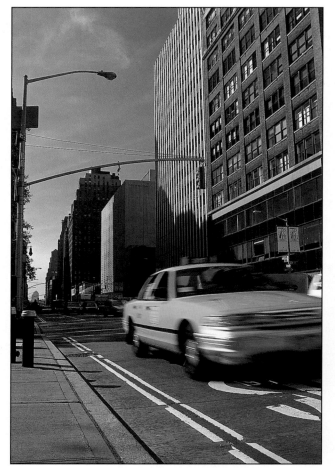

Left: I wanted to photograph a New York street but capture the hustle and bustle of the place so I took this shot with a shutter speed of $1/15$ sec to blur the taxi's motion. Angling this movement across the frame creates depth and adds a dynamic feel to the photograph.

Location: Taxi on 6th Ave, New York, USA. Nikon F90X, 35-70mm, Fujichrome Provia

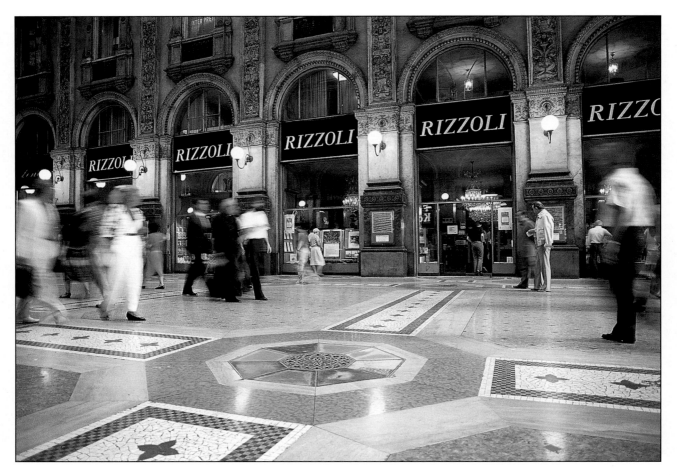

a pavement, foliage on stonework or a sign. The possibilities are almost limitless. Detail provides both added interest and context.

CITY LIFE

Urban landscapes are living landscapes. They not only change as the old is knocked down and replaced by the new, but they also have a dynamism created by their inhabitants. A peaceful skyline shot may be a reflection of an aspect of a city but it does not say anything about what the city is like beneath the surface. This is best captured by two components of a metropolis: people and movement. Taking good shots of people in an urban landscape can be tricky, as it is difficult to compose a picture which doesn't look contrived or in which the human content isn't a distraction. Urban landscapes including people tend to fall into two categories. Either they are observational, in other words the people are moving through the scene interacting with the environment rather than directly with the camera, or they are much more intrusive and interactive. With the latter the person or people become much more the focus of the picture and there's a fine line between such an urban landscape and a candid portrait.

Movement in the urban setting is characterised by people too, but also most obviously by its transport. The slight blurring of a taxi as it moves through an

When photographing movement in people, choose a shutter speed sufficiently long to allow the blurring which indicates motion but not long enough to make them unrecognisable as people. A shutter speed of $^1/_4$ sec was used for this shot.

Location: Shopping Galleria, Milan, Italy. Olympus OM4, 35-80mm, Fujichrome 100RD

urban landscape turns that photograph into a dynamic shot, rather than the much more static one either without the taxi or with its motion frozen by a faster shutter speed. The movement can also be used to create depth. Placing that movement on a diagonal through the frame towards the camera creates convergence in the lines of this foreground object, without any marked effect on the more distant urban landscape behind, and actively leads the eye through the frame. This is still an urban landscape photograph as long as the area behind the taxi is clearly identifiable. Reduce the depth of field too much so that the background loses definition, or shoot from an angle which doesn't define the setting, and it becomes simply a picture of a taxi. The exposure time required to produce a hint of movement in an object moving rapidly towards the camera can be as fast as $^1/_{30}$ sec, dependent on subject speed.

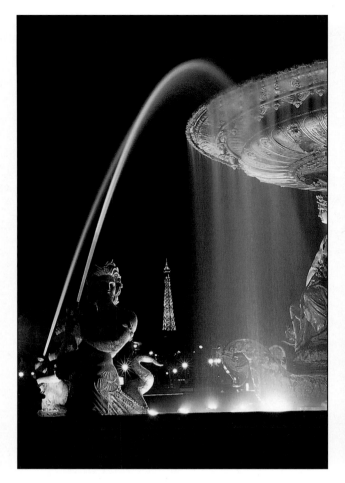

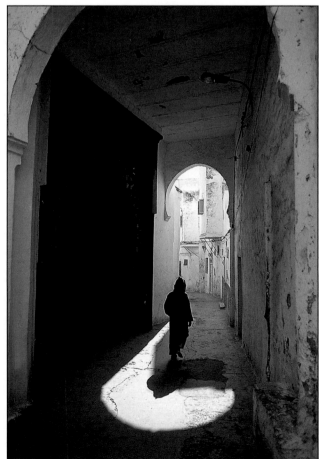

Left and above: Water is used as an architecturally interesting feature but it can also be used in photography to create mood in urban landscapes. Both these shots of the Eiffel Tower were taken through the same fountain. During the day the scene is brightly lit and a fast shutter speed freezes the motion of the backlit water droplets. At night a much longer exposure is required and the water shows up as a ghostly blur in the artificial lights.

Location: Place de la Concorde, Paris, France. Nikon F4, 35-70mm, Fujichrome Velvia

Top right: Wildlife adds interest to this bleak environment.

Location: Khan el Khalili, Cairo, Egypt. Nikon F4, 35-70mm, Fujichrome Velvia

Right: Photographing people in an urban landscape usually means that they are the main subject. The photograph should therefore be composed to show the urban setting around the subject to avoid the photograph becoming a portrait. In this shot I wanted to capture the atmosphere of the narrow streets so I set it up using the sunlight through the archway to frame the subject. I waited for the moment when a single figure walked through the frame. Although the motion has been frozen, the subject's posture indicates movement.

Location: Fez, Morocco. Nikon F4, 35-70mm, Fujichrome Velvia

Different light sources produce different colours on daylight film but the appearance of an urban landscape at night is also determined by the intensity of light. Tower Bridge is brightly lit and I have photographed it against a naturally lit sky. As a result the exposure for this shot was relatively short and any colour cast less noticeable.

Location: Tower Bridge, London, England. Nikon F4, 35-70mm. Fujichrome Velvia

A subject moving in a plane perpendicular to the camera will need a slower shutter speed. Obviously the more movement you want, the slower the speed, so experiment with a range of exposures to see which gives the most pleasing effect. With any photograph where you are trying to capture motion you will need to use a tripod so that everything else other than the moving object is pin sharp, free from camera shake and photographed using the greatest depth of field possible.

An extension of the use of people in the urban landscape is to photograph them showing movement. This may be slight, as in the case of the taxi, or much more pronounced. Here the scene should be exposed for the environment, not the people. A slow shutter speed will then reduce the people from clearly defined shapes to almost unrecognisable, ghostly blurs. To achieve this effect in a well-lit scene it may be necessary to use a neutral density filter to allow exposures of 1 second or greater. The trick is to get enough movement to make the people semi-transparent, while not allowing so much that they become unrecognisable as human. This effect occurs because the moving subjects do not register on film in any one place long enough to appear as a solid mass. The result can be dramatic but to achieve this you will need a shutter speed at minimum between $1/2$ and 2 seconds, and bracketing exposures is essential to ensure an optimal result.

As cities expand further into the natural landscape, so wildlife increasingly integrates with human life and opportunities to use it as a subject in the urban setting increase. Some birds and mammals are commonplace, others much more elusive, but all present opportunities to add an unusual focus to an urban landscape photograph.

Water is also used in architecture to produce reflections. I took this shot of the Louvre (above) at night to remove distracting reflections and add emphasis to the glass pyramid. In daylight glass fronted buildings (left) often produce interesting reflections.

Location: Pyramid at the Louvre, Paris, France / Reflection of building, Vancouver, Canada. Nikon F4, 24mm, Fujichrome Velvia.

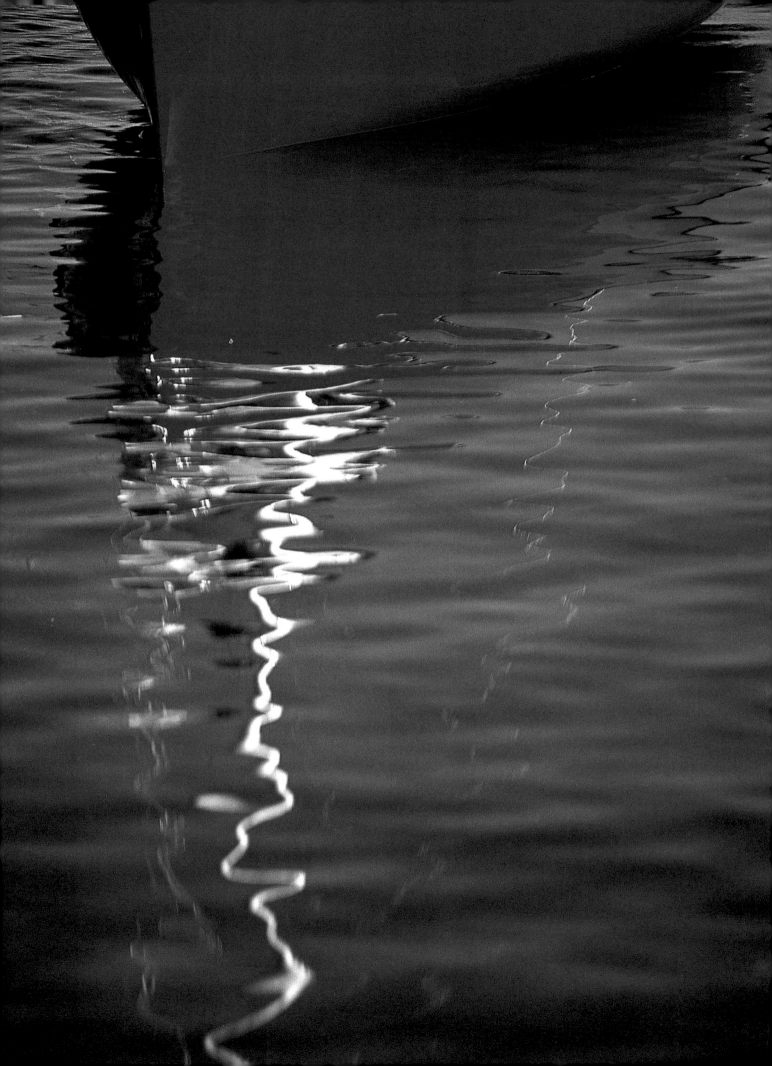

THE ABSTRACT LANDSCAPE

An abstract landscape is one in which the subject is isolated from its environment. By definition then abstract landscapes are found as smaller landscapes within the grand panorama. The abstract landscape is a world of colours, patterns, shapes, tones and textures which combine to make a picture. Composing an abstract photograph is unlikely to follow the guidelines of composition which have been a recurrent theme throughout this book. So how do you begin to photograph the abstract landscape?

SEEING A PHOTOGRAPH

Learning to see abstract landscapes can be frustrating. It requires patience and a willingness to experiment. Taking abstract photographs develops your observational skills and, in turn, will benefit your photography as a whole. When you are looking at a large landscape it is easier to miss the smaller landscapes within it. We have already discussed how to look for them earlier in this book. However, this was done from a perspective which uses the guidelines of composition. The abstract landscape photograph takes this a step further, as it's necessary to break these guidelines to remove the subject from context.

Look for patterns and shapes formed by the interaction of colours in the scene. In some instances the colours themselves will form the patterns, in others the contrast between them will delineate shapes. Once again all this can be done without a camera but if you have problems finding these

Patterns make good abstract images. They are common in both natural and man-made landscapes. I discovered these boats by chance but the patterns formed by the lines of seats made them an obvious choice as an abstract shot. Patterns need not be geometric and in this case the slightly irregular lines add interest.

Location: Essaoira, Tunisia. Nikon F4, 80-200mm, Fujichrome Velvia

patterns then view the scene through a telephoto zoom lens. This will allow you to zoom in and out on the landscape, narrowing your field of view and removing distracting elements from the scene.

Patterns are everywhere in nature, from the veins on a leaf to a valley of ploughed or planted fields, and man has copied many of them in his architectural designs. Often they are geometric but this need not necessarily be the case. When you are learning to see shapes and patterns it is easiest to start with a close up landscape. Choose a small landscape which includes interesting colours. Remember you are abstracting this landscape from its surroundings, so exclude the sky from the composition. Flowers or foliage, especially in autumn, make a good subject.

There are two approaches to abstract photography which you should bear in mind when you're learning to see abstract pictures. The first is to look for contrast in colour which makes one element of the scene stand out from its surroundings. Make the contrasting

The red hull of the yacht gives this shot a strong graphic feel and immediately draws the eye, contrasting in colour with the white mast and deep blue water.
I framed the shot so that the mast and hull divide the composition into thirds both in position and colour.
The angular shape of the hull dissolves into a softer reflection and the meandering reflection of the mast. When you're learning to take abstract shots don't be afraid to experiment with compositions around strong colours like these. Remember there is no right way to take a photograph like this, so try different compositions until you find one that works.

Location: Essex Harbour, Connecticut, USA. Nikon F4, 80-200mm, Fujichrome Velvia

Abstract photographs, by definition, take the subject out of context. These images mix lines and colours in reflections. In the first shot (right) the reflection of autumn would have been more easily identifiable in still water, but a slight breeze rippling the surface of the lake adds a surreal element. White and pink light catch the ripples in the second shot (below), painting shapes with lines of light. It's important to remember that, as with abstract art, individual images are a matter of taste.

Location: Reflection in lake, Connecticut, USA / Ripples at sunset, Sognefjord, Norway. Nikon F4, 80-200mm, Fujichrome Velvia

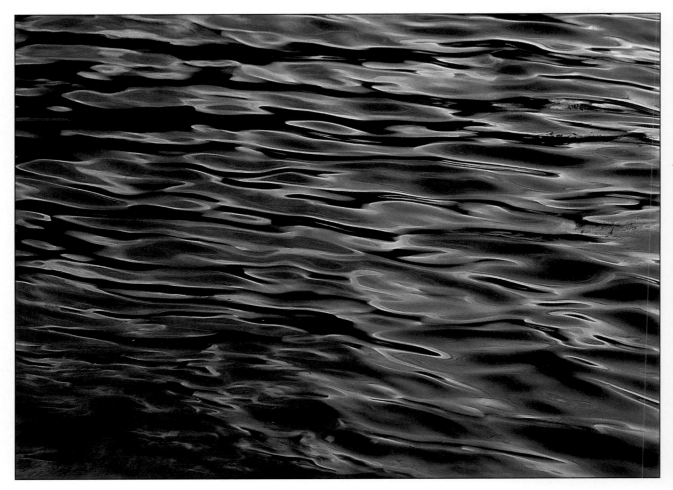

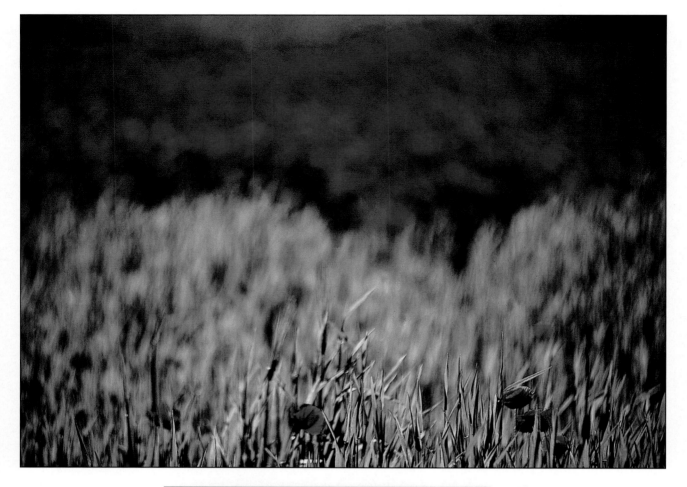

There are many ways to photograph a subject; in this case poppies against a green background. In the first shot (above) back-lighting produces vibrant reds and greens. The foreground poppies are isolated using a narrow depth of field and contrasting colours. In the second the lighting is much more subtle. Here the single poppy in focus is delineated from the background using a narrow depth of field and texture, rather than colour.

Location: Poppies in Oukameiden Valley, Morocco / Poppies in Burgundy, France. Nikon F4, 80-200mm and 105mm macro, Fujichrome Velvia

Colour, shape, texture and patterns combine with depth of field, light and shadow to determine composition. These key elements of abstract landscapes can be found in the simplest of subjects.

Location: Dune grass, Cape Cod, USA. Nikon F4, 105mm macro, Fujichrome Velvia

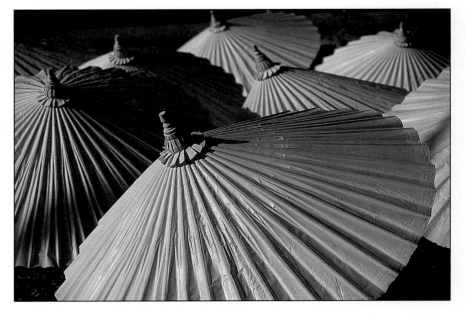

These paper umbrellas were drying in the sun and their shapes were emphasised by lines of light and shade. I used a low viewpoint and tight cropping to remove the background and allow the shapes of the umbrellas to become the subject of the photograph.

Location: Umbrella factory, Chiang Mai, Thailand. Olympus OM4, 80-210mm, Fujichrome RD100

This shot captures the tones in the delta where the melted ice washes down from the Glaciers which form the Alaska / Yukon border. It was taken through the window of a helicopter on fast film. The subtle tones of the grey capture the gentle flow of the shallow water as it meanders down to the lake below, but it could also be seen as a completely abstract image.

Location: Kluane National Park, Yukon, Canada. Nikon F4, 80-200mm, Fujichrome Provia

I collected these different coloured autumn leaves and arranged them to make these photographs, placing them in very shallow water at the side of a stream to make the colours more vibrant. The two shots are simply two different arrangements of the same leaves, using the red leaf as the main subject. These images are two dimensional so the composition is defined by the way in which the different components combine in shape and colour.

Location: Autumn leaves, New Hampshire, USA. Nikon F4, 105mm macro, Fujichrome Velvia

colour the subject of your photograph and use the surrounding area to make its shape and colour stand out. The second is to look for uniform patterns and use the textures of the different elements in that pattern to give it dimension. Once you have begun to see abstract photographs in a close up landscape you can start to broaden your horizons again and look for opportunities to abstract a photograph from a wider landscape.

COMPOSING AN ABSTRACT PHOTOGRAPH

Once you've identified a potential abstract landscape, how do you set about composing the photograph? The biggest problem which most photographers experience is how to compose a photograph when the subject does not lend itself to a composition based on the 'rule of thirds'. Worse still the other compositional tools which create depth and

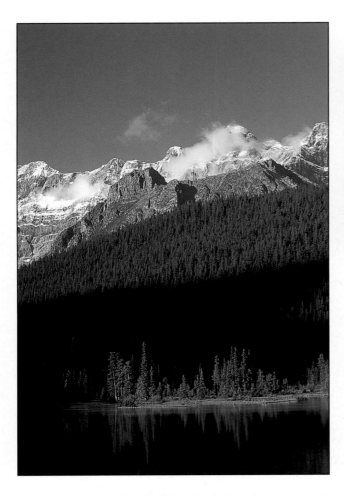

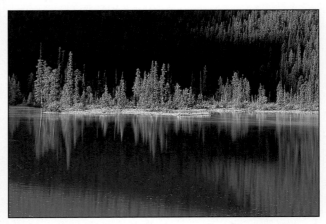

Seeing an abstract image in a large landscape is a skill which takes a keen eye and practice to develop.
These two sequences of photographs show how I found abstract landscapes in panoramic views. The first shot in this sequence of three shows the overall scene. The shot of the lake and the mountains is pretty, but the most interesting elements are the trees and their reflection. In the second shot I isolated these elements but the sunlit area around the trees is a distraction. In the final shot I have come in tighter. The trees are completely isolated against a dark background, giving a crisp image and sharp reflection in the still water.

Location: Waterfowl Lake, Alberta, Canada. Nikon F4, 80-200mm, Fujichrome Velvia

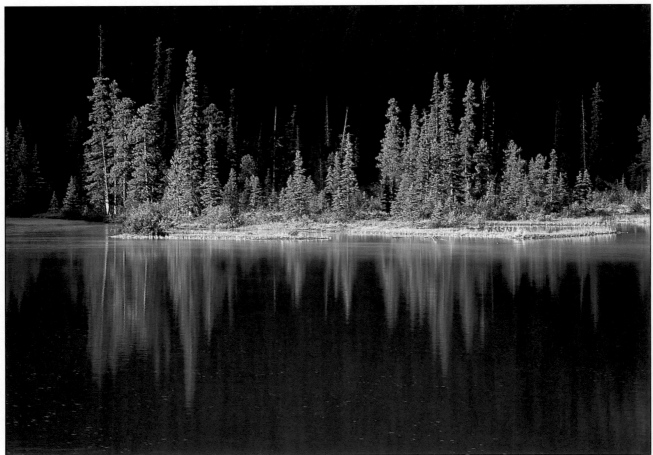

Many old French villages have faded advertising painted on walls. In the first shot of the whole scene the abstract image is not immediately obvious but I thought that the mural was an interesting feature, so I took a second shot excluding the other buildings and the road sign. In this shot the detail of the mural is clearer but it is neither an urban landscape nor an abstract one. In the final shot I used the most interesting elements of the mural to compose an abstract; the faded writing, the blue and yellow bands and the diagonal marks in plaster. The end result is a subtle composition of colours and shapes.

Location: Mural, Montbard, France. Nikon F4, 35-70mm and 80-200mm, Fujichrome Velvia

perspective may also be absent. Indeed, the scene may be largely two-dimensional. Remember here, though, that you are not dealing with a conventional landscape but one in which the subject is removed from context. Depth and perspective create context and are therefore not essential components of an abstract landscape photograph. It will succeed or fail solely on the subject matter and the way in which the elements of colour, tone, texture and shape are used to construct patterns, giving the end product subtlety or dynamism. These elements are the same as the ones used to build conventional landscape photographs but they are used without the support cues to scale given by depth and perspective. A photograph must therefore be tightly constructed if it is to be effective.

Think carefully about how you frame a shot. It's just as important to determine the subject of an abstract photograph as it is with any other. You must, however, broaden your conceptions of what constitutes a subject in the context of an abstract photograph. Remember that patterns are subjects in their own right, as is a shape or a contrasting colour or texture. You should construct your photograph to reflect this. Use lines to lead the eye through the frame and space to balance the composition, just as in an ordinary landscape photograph.

The image of the olive tree (above) uses textures, with very little contrast, to create a photograph from neutral colours. It looks like an impressionist painting. To capture the delicate colour and texture in the wheat (top opposite), I used a macro lens. A narrow depth of field throws all but a few ears out of focus, allowing a faster shutter speed to limit movement.

Location: Siena soil, Tuscany, Italy / Wild Wheat, Alberta, Canada. Olympus OM1N, 80-210mm, Fujichrome RD100 / Nikon F4, 105mm macro, Fujichrome Velvia

COLOURS, SHAPES AND PATTERNS

Contrast is an essential tool in an abstract composition. Contrasting colours or tones define shapes and, together with contrasting textures, they give a three-dimensional feel, a depth, to what might otherwise appear to be two-dimensional. Colours and shapes which blend to give recurrent themes form patterns. Uniform or geometric patterns tend to occur more at a macroscopic level whereas irregular patterns dominate in a larger landscape. The obvious exception to this is where the pattern is man made, particularly in agriculture and architecture. Patterns, regardless of origin or type, are a fundamental feature of abstract photography. When you are shooting abstract landscapes you should be constantly on the look out for combinations of colours, shapes and textures which form patterns.

Colour can be used in either the subject itself or as a background to make a neutral coloured subject stand out. In the shot of the logs I used the latter approach. This turquoise water provides a strong background which increases the definition of the logs, producing an interesting pattern of brown and grey lines. Photographing this shot from above removes any cues to perspective and helps to turn the pattern itself into the subject. In the shot of the dates, colour is the subject. The contrast between the red dates and the yellow stems defines the shape of both and creates texture.

Location: Logs on Morraine Lake, Alberta, Canada / Dates in the market, Muscat, Oman. Nikon F4, 80-200mm, Fujichrome Velvia

135

The abstract quality in this shot has been created by movement. I heard these birds take off from the reeds behind me and, focusing as I swung round, took the shot while panning. As a result everything in the shot is out of focus except for the birds. This works as an abstract landscape because the birds are effectively isolated from it by focus and panning.

Location: Birds in flight, Okavango Delta, Botswana. Nikon F4, 500mm mirror, Fujichrome Velvia

The texture of the sandstone provides a canvas which increases the definition of the pattern in the rock. The colours are a part of that pattern.

Location: Sandstone rock, Petra, Jordan. Olympus OM4, 80-210mm

Skies can make interesting abstract photographs as cloud formations momentarily take on recognisable shapes. In this shot the clouds have formed a slightly surreal shape of a flying bird. For this to work as an abstract shot though only sky must be included in the frame, again to avoid introducing context.

Location: Clouds over Grasmere, Cumbria, England. Nikon F4, 80-200mm, Fujichrome Velvia

These curves of cactus leaves, emphasised by their yellow edges, create interesting shapes. Isolated from their surroundings, lines and curves can become the subject in abstract photography.

Location: Cactus, Transvaal, South Africa. Nikon F4, 105mm macro, Fujichrome Velvia

One technical point which must be considered is exposure. There are distinct benefits from using a hand-held meter for abstract photography. Most TTL camera meters are calibrated for photographs which contain a range of lighter and darker areas, such as a standard landscape with one-third sky and two-thirds land. Abstract photographs often don't contain the same tonal range, so most will require a degree of exposure compensation. The hand-held meter measures incident light independently of the colour or tonal range of the subject. It is therefore less easily biased when photographing an unconventional subject. If you are using your camera's TTL meter then it is a wise precaution to bracket exposures.

ABSTRACTS THAT WORK

So the abstract landscape differs in two fundamental ways; seeing and composing the photograph. Seeing it requires you to hone your observational skills. Once you do this you will be surprised at the abundance of abstract photo opportunities. Rather than being a handicap, the most exciting thing about shooting abstract landscapes is that most of the conventional guidelines to composition can be disregarded. This leaves the photographer with a blank frame of film on which to create something unique.

Abstract photography is a hard discipline to master. Don't get disheartened if it takes time to develop your skills. You will inevitably have failures but a willingness to experiment will enhance your creativity and improve your photography as a whole.

FOUR INDIVIDUAL VIEWS OF LANDSCAPE

The three essential prerequisites for an interesting photograph are good technique, good composition and creativity. Technique can be learnt by understanding the tools of the trade; the equipment, film and its interaction with light. Compositional skills can be acquired by using the 'rule of thirds' as a starting point, and as a guideline, to develop a feel for the way in which the components of a picture fit together. Creativity, on the other hand, comes directly from the photographer. It is an expression of your individual style combined with your observational skills. At the beginning of this book I emphasised that there is no right or wrong way to photograph a landscape. The decisions made when taking a photograph are based on all three prerequisites, but individual style is the key factor which distinguishes a photographer's work.

DEVELOPING A PHOTOGRAPHIC STYLE

If you ask different photographers to photograph the same scene, the chances are they will all approach it differently. This individual approach is their photographic style. To demonstrate this I asked four amateur photographers – Conor Caffrey, Natasha Kandlekar, David Holmes and Debbie Jacobs – to take some landscape photographs. I chose two different subjects: an urban landscape and a natural landscape. The only brief that these photographers were given was the subject. Choice of film and equipment, and

Conor's second shot also uses movement. Big Ben is silhouetted against a spectacular sunset. However the overall composition is weak. The main subject is placed too centrally and the area to the right of the frame is confusing. Too many lights and an uninteresting skyline unbalance the composition and detract from the subject. Well known urban landmarks are usually recognisable by their shape. A less recognisable building, even against this amazing sunset, would not create the same impact or identify the city.

when and how to take the photograph were left entirely to them.

The two subjects were: the Houses of Parliament, in London and Durdle Door, on the south coast of England.

1. The Houses of Parliament: Situated on the north bank of the river Thames by Westminster Bridge, they face the river on one side and back on to a busy square, which offers restricted views, on the other.

2. Durdle Door: The Dorset coastline is known for its white cliffs and arches of Purbeck limestone carved by the sea, the most famous of which is called Durdle Door. A narrow path leads from the top of the cliffs above the arch down to the beach.

Conor used a low camera angle to capture the streaked lights of a London bus. Positioned diagonally across the frame, they add a strong dynamic element to this shot taken at dusk. The remaining natural light is just sufficient to outline

Big Ben against the sky, but a long exposure of approximately 5 seconds was required to capture the motion of the bus as a blur. A crane intrudes into the background but it does not detract from the overall impact of the shot.

Photographer	Subject	Camera	Lens	Film	Weather	Time of day	Time of year
Conor Caffrey	Houses of Parliament	Pentax Z10	Pentax 28-105mm	Fujichrome Velvia	Partly cloudy	Early evening	Autumn
Natasha Kandlekar	Houses of Parliament	Nikon F90X	Nikkor 35-80mm	Fujichrome Velvia	Partly cloudy	Late afternoon	Winter
David Holmes	Durdle Door	Pentax KM	Pentax 28-130mm	Kodak Ektachrome 400	Overcast	Early afternoon	Autumn
Debbie Jacobs	Durdle Door	Pentax SFX	Pentax 50mm	Fujichrome Velvia	Sunny / some clouds	Early evening	Summer

Left: This shot, in direct sunlight, illustrates some of the problems posed by an urban landscape. Even before sunset nearby buildings throw shadows across the subject but Conor has used this shadow to frame Big Ben in the angle of the roof. The soft light on the clock tower contrasts with the shadow, and dark sky above, to produce a striking and unusual image.

In his final shot (above) Conor has used a feature of the construction work, a wire fence, to find an unusual view of Big Ben. Again he has used the recognisable shape of the clock tower but created a more abstract image by shooting it through the fence, using a narrow depth of field.

Urban landscapes can be untidy, and when Conor and Natasha photographed the Houses of Parliament, nearby construction work resulted in cranes on the skyline close to Big Ben. This restricted the viewpoints available so they both chose to photograph this landscape in the soft light at the end of the day to minimise the intrusiveness of the construction.

On the day that David chose to photograph Durdle Door, the weather conditions were changeable and by the time he arrived most of the area was already in shadow, the sun partly hidden by a growing band of cloud. Grey skies and weak sunlight produced muted colours and reduced shadow definition. These rapidly changing conditions meant that David had to work quickly to capture the remaining sunlight. The weather conditions were considerably better when Debbie photographed the same scene. Her aim was to capture this coastline in soft, warm sunlight so she had to wait for the right light.

It's interesting to compare the differences in this set of images from two different places and four different photographers. The weather obviously played a part in differentiating Debbie and David's photographs, but even allowing for this, they both chose to shoot Durdle Door from completely different viewpoints. When Conor and Natasha photographed the Houses of Parliament their options to find different viewpoints were a little more restricted, yet despite this they still managed to take shots which convey different moods and aspects of the subject. In doing so they followed their own creative instincts.

EXPERIMENTING WITH STYLE

What determines the style of a photograph? Quite simply it is the creative way in which light is used to translate a landscape on to film. In essence then it is the bringing together of all the points discussed in this book.

The components which influence style are diverse and numerous; the focal length of the lens, film speed, B&W or colour film, viewpoint, time of day, weather conditions, framing, length of exposure, motion etc. all contribute to the appearance of the final image. Viewpoint alone comprises many facets such as camera to subject distance, position of camera and subject relative to the light source, camera height relative to the subject and so on. Change any one of these components and the photograph, the end product, changes.

With so many things to consider you can be forgiven for wondering how you go about developing a photographic style. When you start taking photographs this isn't something which need concern you. At this stage you will be more constrained by technique, but as you master this, and your

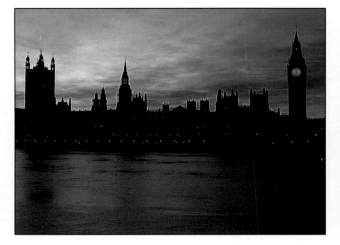

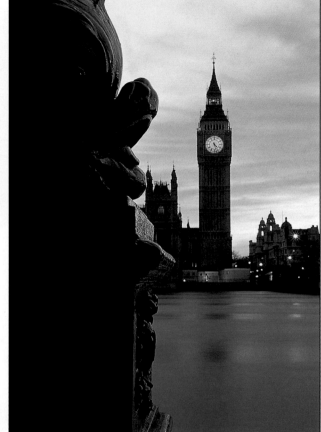

Natasha has used a different viewpoint to exclude the bridge but include the whole of the building, using the reflection of the sunset to add light to the foreground. Removing the elements which gave Conor's image a dynamic quality emphasises the architecture of the buildings and the skyline.

This silhouette creates a balance within the composition, giving the landscape a tranquil feel, enhanced by another stunning sunset. Raising the camera angle slightly to include more sky, so that the river fills only the bottom third of the frame, would strengthen the composition.

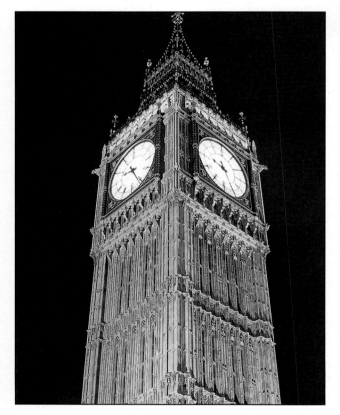

Shooting across the river, Natasha has used the ornate base of a lamp post as a foreground. Though painted black, it catches the pink light of sunset. Careful

framing has excluded the wall. With a limited depth of field she has used a recognisable landmark, Big Ben, to create an interesting image.

Natasha's final shot was taken after dark from a point near the base of Big Ben. Tilting the camera upwards has caused only slight distortion of perspective because a telephoto lens was used. Strong artificial

lighting has resulted in a colour cast but shows up the fascinating architectural detail on the clock tower. This shot has a slightly unreal feel to it and looks a little like a colour negative.

compositional skills improve, developing an individual style to your photography is important if you are to add that unique quality which makes your photographs stand out.

Individual style is a personal expression of your own creativity. To some people creativity is a natural gift, just as others are good organisers or communicators. For those lucky ones, developing a photographic style is second nature, it will start from the moment they take their first photographs. For most of us, however, developing a photographic style is a more gradual process requiring experimentation.

Having read this book you should be in a position to experiment with your photography. The most important consideration is to focus on something which you enjoy. There is no point in developing a photographic style just to be different if you don't enjoy it. This will inhibit your creativity in the long run. Your early photographic work will already have the basic elements of a photographic style, so before you go any further it's worth examining your pictures and thinking about the way they were taken. Look for recurrent themes in both subject matter and the way

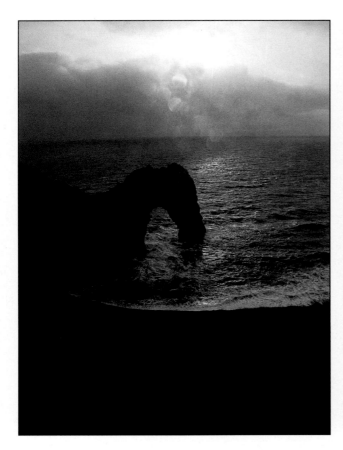

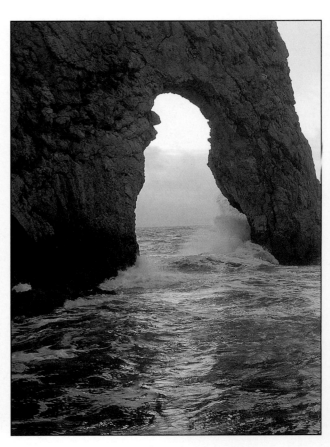

Taken from the cliffs above this arch, David has used a high viewpoint to create depth by raising the horizon so that the arch silhouettes against the sea. The beach below joins the arch to the mainland, creating context. Reflected sunlight catches the waves right up to the beach, adding texture to the sea. Tighter cropping to exclude the dark area at the bottom of the frame would strengthen the composition. Direct sunlight on the lens has caused flare but, in this instance, it adds texture to the clouds.

Taken from the beach, David used the arch as a natural frame to capture the waves braking against the rock. The sun was positioned behind the arch to shine through it, illuminating the waves all the way to the beach. Although this is back lit some detail was retained in the rock by over-exposing by +1 stop.

you set up shots. For example, do you take photographs using a particular element, say water or flowers, or do you use a particular technique, say landscapes using a telephoto lens? If you are unsure which direction to go in, it's a good idea to look at other photographers' work, not to copy what they have done because this would defeat the object, but to get a feel for the multitude of techniques and approaches which can be taken. If you like a particular style then experiment with it and see how you would adapt it into something original.

David framed this shot using the sweeping curves of the waves breaking on the shoreline and the cliffs behind to funnel the eye into the people on the beach. Note how the points where these curves meet the edge of the frame, and the position of the people, fall roughly on the lines of thirds. Unfavourable lighting conditions give a shadowless landscape, despite good composition.

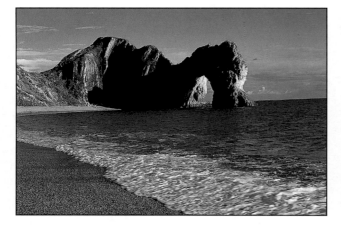

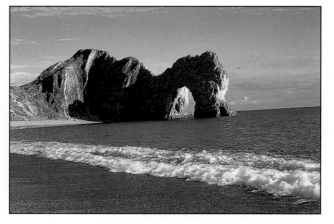

Although the arch itself is in shadow, the side catches the sunlight, framing it against the sky and creating a three dimensional feel. Debbie has created most of the depth in this shot (above) by using a low camera angle so that the diagonal band of the waves, as they break on the beach, lead into the frame from the bottom edge. Compare this to the second shot (above right), which is identical except that the waves have not yet broken, and consequently make a less angled line across the frame. Although this still creates some depth, it actually detracts from the composition because it appears to cut the shot in two.

A STYLE OF YOUR OWN

Developing a style is all about experimenting with your photography. Don't be afraid to make mistakes because from these mistakes you can learn and improve. I am a completely self taught photographer. I learnt my photography just as you are doing, from books, from looking at other people's photographs and from observing the world around me. Most of all, though, I learnt from taking photographs, some of which were good, many of which were bad. Throughout this process my photographic style has evolved and continues to do so.

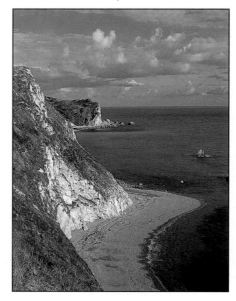

Debbie took this shot from the cliff to capture the sweep of the coastline. This angle doesn't give the same dramatic composition as in David's shot but, the cliffs in the distance and the clouds create depth. Again the key elements fall roughly on the lines of thirds.

Debbie's last shot was taken into the sun from the beach. This is a difficult photograph to take because it requires exposure compensation and careful positioning to avoid flare. She exposed for the highlight detail which required an exposure compensation of only $+^1/_2$ stop. This approach captures the scene in an unusual way and retains gradation from white, caused by glare from the sun, to blue in the sky. Had this scene been exposed for mid tones then a $+1^1/_2$ to 2 stop compensation would have been required and the sky would have bleached out.

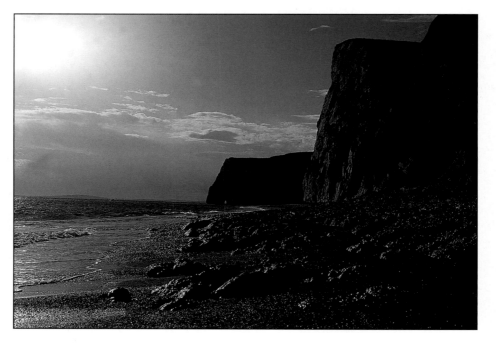

INDEX